Frith's Travels

FRANCIS FRITH'S TRAVELS

A photographic journey through Victorian Britain

Text by Derek Wilson

in association with
The Francis Frith Collection

J. M. Dent & Sons Ltd
London Melbourne

This book is set in 11 on 12 pt Monophoto Baskerville
Printed in Great Britain by
Jolly & Barber Ltd, Rugby, for
J.M. Dent & Sons Ltd
Aldine House, 33 Welbeck Street, London W1M 8LX

British Library Cataloguing in Publication Data

Frith, Francis
 Francis Frith's travels.
 1. Photography, Artistic
 I. Title II. Wilson, Derek
 779'.092'4 TR652

 ISBN 0–460–04670–5

CONTENTS

Acknowledgements

Without the enthusiastic co-operation of two people this book would have been quite impossible. Claude Frith, Francis Frith's grandson, gave me access to his family papers, including fragments of an autobiography by his grandfather and brief journals by Mary Ann Frith, his grandmother. These have been quite invaluable in piecing together the details of Francis's life and in working out what made him 'tick'. The vast majority of the extant negatives are now the property of The Francis Frith Collection and the rescue of these priceless negatives is a story in itself. John Buck, the managing director, gave unstintingly of his time, as did several of his colleagues, particularly Peter Turner. The putting together of the pictures for this book involved, among other things, processing several negatives which had lain unused for many years. A few photographs came from other sources and in tracking down these I was assisted by the National Maritime Museum, the Victoria and Albert Museum and John Hillelson. In tracking down details on some subjects I was aided by 'pop' Blades, Messrs Smiths Gore, The Shakespeare Birthplace Trust, the Cyclist Touring Club, Allhallows Museum Honiton and Andrew Bowman. My sincere thanks to them all.

Unless otherwise stated, quotations from Francis and Mary Ann Frith are all taken from the Francis Frith Papers.

THE COMPULSIVE TRAVELLER

The platform was a bustle of excited activity. The London and South Western Railway's Exeter–Barnstaple train was disgorging its passengers. The paintwork glistened, brass fittings gleamed, flowers were radiant in the neat window boxes, porters hurried to open carriage doors under the watchful eye of the top-hatted station-master. The passengers alighting from the smart brown wagons with the GWR monogram (the LSWR were obliged to use Great Western rolling stock because the line was broad gauge and their own carriages were standard gauge) in gold were a mixed crowd: farmers and their dressed-up wives returning from a day out in Exeter; well-to-do holidaymaking families come to enjoy a quiet few weeks at the seaside; soldiers returning on leave from London, Durban or Calcutta – all equally remote from this quiet Devon town only now feeling the first touch of Victorian progress. Those wishing to travel further along the coast from Barnstaple would have to hire one of the fleet of carriages waiting outside the station, for the new Ilfracombe line was still a-building and would be for another year.

Suddenly, in the midst of all the activity, there was an explosion of even greater human energy. A small man in abundant whiskers was organizing the disembarkation of his entourage – a wife and six children aged between eleven years and six months, two servants and four professional assistants. Soon the Frith household stood on the platform like an island lapped around with portmanteaux, travelling rugs, hat-boxes and hampers. The man with the whiskers was busy commandeering porters – one to hire a fleet of horse-drawn carriages, another to convey the luggage and still more to unload from the train, with great care, an assortment of heavy wooden boxes and odd-shaped bundles fastened with leather straps. Gradually, with a palaver that would have done justice to visiting royalty, Francis Frith and his family were conducted from the platform, to their conveyance and whisked off at a dignified trot towards their holiday home.

It was there one evening three weeks later that Mrs Mary Ann Frith began a private journal:

'... Baby is now $6\frac{1}{2}$ months old, and I think I speak truthfully when I say hers has been a happy little life so far. I must try and give a little résumé of it, being quite alone this evening, the dear Papa is at Lynton on a photo-journey and I and all my children at Northcote Villa, Ilfracombe, they all asleep in bed ...' [*The Journal of Mary Ann Frith*, M.S. in the possession of Mr Claude Frith]

The Friths were always on the move and the year 1872 was no exception. The reason for it lies in the words 'the dear Papa is at Lynton on a photo-journey'. Francis was one of the great pioneer photographers. He took his cameras, his assistants and his family to foreign lands and he established the largest photographic business in

the world. But his major claim to fame is that he set himself to create a complete photographic record of the British Isles. Francis Frith and the company he had founded at Reigate were intent on capturing a permanent record of every city, town and village, every mansion and scenic view the length and breadth of these islands. The scope of the project is breathtaking. Even today, when travel is fast and easy and when a professional photographer's gear can be transported in a medium-sized suitcase, it would be a bold man who would undertake such an enterprise. For Frith, with his cumbersome, brass-bound cameras and tripods, his bottles of developing fluids and his boxes of glass plates (each of which could only be carried with difficulty by two men) it was a mammoth undertaking.

Historically, it was an undertaking of the first importance. The mid-nineteenth century was the first time that a pictorial record of Britain and its people had been at all feasible. For some years artists and scientists had been experimenting with ways of fixing a camera obscura image but it was only in 1839 that three important developments were announced. In France, Louise Daguerre revealed to the world his daguerreotype process which produced a permanent, but reversed, image by exploiting the light sensitive qualities of silver iodide. Across the Channel, William Fox Talbot demonstrated how a photographic 'negative' could be made and then, by contact printing, transferred to another sensitized paper to give a true image. It was the Englishman's 'calotype' process (as it soon came to be called) which marked the real beginning of photography, but a growing body of excited followers took up the new hobby and experimented with various methods of treating the camera plates and transferring a positive image to paper. Meanwhile, the astronomer, Sir John Herschel, made in that same year the first photograph on a glass plate treated with silver carbonate. It was the bringing together of the work of Herschel and Fox-Talbot which resulted in the wet-collodion process, the fastest and simplest method of producing photographs yet discovered. This involved exposing a glass plate covered with a wet preparation of chemicals which was then immediately developed and fixed in a dark room. Pictures could now be taken in minutes which had earlier required exposures of an hour or more.

The impulse for the development of the new technology had come initially from artists, particularly those interested in meeting a growing demand for portraiture among the new bourgeoisie. There were men like Herschel who saw its scientific potential. As the century advanced both aspects of photography developed. We are all familiar with the sentimentally posed studio portraits beloved by our Victorian forbears and by the development of the camera's artistic potential in the hands of pioneers such as Julia Cameron and Peter Emerson. Scientific photography went its own, increasingly specialized, way. Results of experiments could be graphically recorded for the first time. Cameras were soon being linked with telescopes and, later, with microscopes. But photography had also grabbed the imagination of the man in the street. It is difficult for us to realize the impact made by this novelty a hundred or so years ago. For a modest outlay it was possible to buy a picture of some person or place as that person or place *actually was* – not a painting (out of most people's price bracket anyway) or a print, conveying an artist's interpretation, but verisimilitude. Realism and truth were of immense importance to the Victorians. We know that the camera *can* lie but our ancestors did not know that and they were impressed and intrigued by the man with the tripod, the brass-bound mahogany box and the black cloth. That is why some of the pioneer photographers were not men of art or science, but businessmen, men who saw the financial possibilities of the new medium. The earliest and greatest of these commercial photographers was Francis Frith.

Business sense and industry were in his blood, for Francis was born, in 1822, into the family of an upright, pious provincial tradesman. Francis Frith Senior was a cooper and a member of the Society of Friends. That meant that his wife and children (one boy and two girls) enjoyed a comfortable but simple lifestyle, that their thoughts and deeds were fenced by a firm and clear,

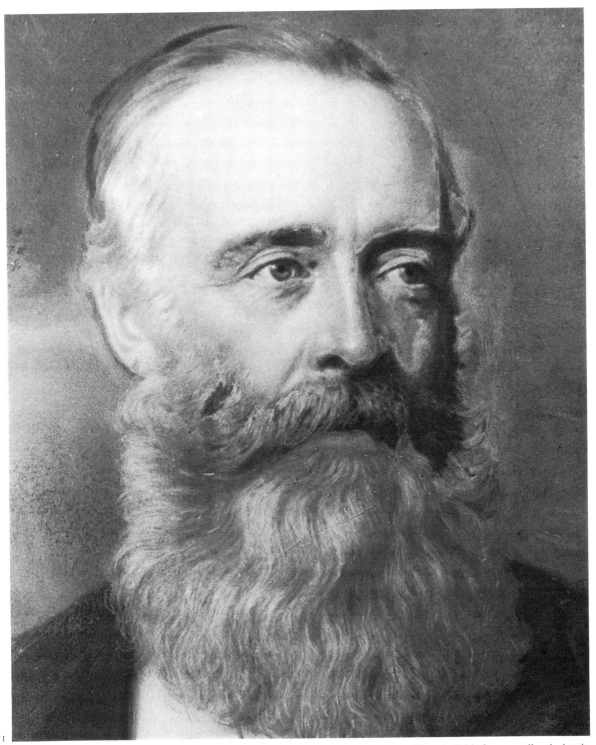

I

Francis Frith from an oil painting in
the possession of Mr Claude Frith.

though not necessarily repressive, set of moral laws, that they were expected to find their friends among other Quaker families and that the fixed marks of their domestic routine were daily prayers and the weekly 'meeting'. As the only son, Francis was spoiled, probably even more so after the death of his elder sister in 1837, the year that the adolescent Victoria ascended the throne. Francis was then thirteen and had known both happiness and misery. Happiness was for him the carefree meanderings of a solitary young boy through the Derbyshire Dales. Viewed through the rose-tinted spectacles of adult reflection, this golden age was set amidst 'fields and streams and green lanes … where I wandered and fished and "muttered my wayward fancies" through long summer days of half-unconscious happiness, drinking in at every pore of nerve and soul the poetry of nature'. Young Francis had a talent for painting and drawing and took a real delight in the country-side around his native Chesterfield. Like his Quaker faith this love of landscape was a passion which remained with him throughout his life. Misery came to him (or, at least, was later associated in his mind) with boarding school. At the age of twelve Frank was sent to Camp Hill school in Birmingham. It was a Quaker establishment; Frith's parents were not going to allow the tender plant of Frank's religion to be subjected to the icy blasts of disbelief or (almost as bad in their eyes) Anglicanism. Frank did not find the atmosphere congenial:

'Nothing, surely, but a good stock of animal spirits, and youthful carelessness of the "inalienable rights of mankind" can make boys happy under the iron tyranny and taskwork of boarding-school life … If I have a nightmare, I dream of going back to school.'

The boy put little energy into his studies and, inevitably, gained little of value from them. He emerged from Camp Hill at the age of sixteen, scarcely the polished young gentleman that his parents had hoped for. He was, he later reflected, 'grievously deficient in exact, general and polite knowledge, a deficiency which I have bitterly regretted in later life'.

Francis left school with no inkling of what he wanted to do in life. His father had by now retired and there seems to have been no question of the boy becoming a cooper. Yet a trade he had to have. The Friths' brand of Protestantism required it: the Christian must employ mind and body in gainful labour for the glory of God. Victorian convention demanded it: a man must strive to adorn that station in life to which he has been born. And so young Francis was apprenticed to a manufacturer. He does not tell us in what line of business his employer was involved, simply that he was boarded with his master and that he made good progress. His parents sold up and moved to the city so that their son could remain within the bosom of his family. This protective-ness was to have unfortunate results. At an age when he should have been exploring the world for himself, he found himself unable to break loose from the shackles of parental love and care. The result was a build-up of resentment which Francis seems to have harboured to the end of his life. There is little in his writings about his feelings for his mother and father but such comments as do appear leave little doubt that cosseting had a negative effect: 'It is scarcely fair to a child, and certainly not for his comfort or good, that parents should live so ostensibly only for their offspring, half forgetting what they owe to themselves and society'. Francis certainly did not make the same mistake when he had children of his own.

The young man who dutifully worked in the factory and the warehouse felt keenly that he was wasting his time: 'I reaped no benefit from my long years of hard and faithful labour, except a glowing testimonial on the flyleaf of an illus-trated book, and I had learned nothing that was of further value to me except the art of steady, hard work, and the mechanical trick of posting ledgers and casting up figures.'

But there was more than an unspoken resent-ment eating away at Francis's wellbeing. He was restless and confused. He totally lacked enthusiasm for trade but he applied himself to it with that strong sense of duty – 'stern daughter of the voice of God' – implanted by his upbringing. At work and in the city's streets and parks he met other companions, men and women who were not

This page from Frith and Co's catalogue indicates the extent of Francis's photographic activities. During his 1873 visit based in Ilfracombe he travelled as far as Minehead and Dunster to the east and Bude to the south west. The columns on the right indicate the sizes of plate exposed at each location.

Friends. He liked them, for all their rough humour and bawdy songs. But the folk at the weekly meeting did not approve. In the end the counsels of the godly prevailed; Francis foreswore the company of his worldly associates. But the inner conflict continued. After five years Francis had a nervous breakdown.

Inevitably, his parents supervised his recovery. The doctors advised rest and travel, so the Friths made an extensive tour of Britain. The next two years were vital to Francis. He discovered the beauty of his native land, capturing his feelings in sketches and verse. He emerged from his mental labyrinth with a clear-cut personal faith and a determination to enter business on his own account. May it also be that he began his study of photography during those long months of recuperation? In 1843, when Francis completed his apprenticeship, the early work of Fox-Talbot and Herschel had been publicized and many enthusiasts were grappling with the problems of the infant technology. Francis, who was interested in science and was also an amateur artist, may well have been intrigued by the possibilities of photography.

The man of twenty-three who emerged from his unfortunate crisis was hard-edged, disciplined and morally strong. He was a little below average height and now sported a full 'Tennysonian' beard. He was a perfectionist, demanding the highest standards of himself and often imposing impossible burdens on others. He was destined to be a 'loner', a man who found it virtually impossible to work for an employer or even with a colleague. He had to run his own show and he did just that for the best part of half a century. But he was a man not without inner tensions. The fact that he became the great pioneer of popular photographic printing who undertook tasks that would have daunted others may blind us to the realities of his character, which was not without elements of paradox. In some ways Frith represented the contradictions of early nineteenth-century British life. The Industrial Revolution involved, on the one hand, the exploitation of God-given talent and genius to enrich the lives of all. On the other it fostered the pursuit of wealth and success, often by very ungodly methods.

Most thinking Englishmen were proud of the effort and ingenuity which had carried Britain to the very front rank of industrial and colonial nations. They lived in an exciting age of breathtaking innovation and change – railway lines were threading their way across the land; piped water was brought to town after town; gas lighting appeared in the streets; London boasted the world's first underground railway; and, in 1851, the nation's achievements went on view to the world in the Great Exhibition. But in the midst of all this technical progress lay squalor, crime and human exploitation. It was exposed by Charles Dickens, the world's most popular novelist. It was attacked by preachers and social reformers like Lord Shaftesbury. The very spirit of the age was questioned by the Romantic poets:

The world is too much with us; late and
 soon,
Getting and spending, we lay waste our
 powers:
Little we see in Nature that is ours;
We have given our hearts away…
 [Wordsworth, *Miscellaneous Sonnets*, I,33]

Frith, who was virtually a perfect pattern of the Victorian self-made man, shared this unease:

…the spirit in which money earning work is done is very often and largely a cursing spirit. It may easily become a means of crushing out the little germ of generous, true, spiritual life and noble aspiration which God and nature have planted in a man. That it actually does complete the moral and even intellectual degradation of thousands, no thoughtful person can doubt… There is an amazing amount of deceit and untruthfulness in trade – it is a sordid, low, vulgar, spiritual condition, a life of menial toil and drudgery upon a narrow, pulluted stream…

Such was the attitude with which, Frith assures us, he embarked upon his entrepreneurial life.

In 1845 he moved to Liverpool where, in partnership with another young man, he began a wholesale business. If, as seems likely, this was a grocery business it was a shrewd and well-calculated move. Liverpool was a 'boom' city with a rapidly increasing population. In 1840 Samuel Cunard had begun steamship crossings to New York and there was now a regular and busy transatlantic traffic. The land of promise attracted thousands of poor emigrants who crowded the dockside to take advantage of the cheap passages ('Six Pounds Full Dietary') offered by the shipping agents. Liverpool also attracted a flow of Irish families fleeing from the potato famines in their native land. With an increasing citizenry to feed and crowded ships to be victualled, a Liverpool grocery business could scarcely fail.

It was hard work, however, particularly for one who evinced 'a profound contempt for the commercial mind, pure and simple, and a horror of having my soul murdered in the moral purlieus of the haunts of trade'. In fact, we should be unwise to take too seriously Frith's protestations of distaste for wealth and commercialism. During his working life he started and was extremely successful in three major businesses. By his midthirties he had amassed a considerable fortune and could, from that time on, have devoted himself to 'that absorbing devotion to religious thought and study to which I was strongly inclined'. The truth was that a part of him revelled in the challenges and compensations of commercial life – the competition, the bargaining, the gradual achievement of recognition and admiration.

After five years, Frith wound up the grocery business amicably. It may be that partnership had become irksome or that he had seen a better opening for his talent and capital. He now put his share of the profit into another venture. In his memoirs he does not tell us what it was (he is extremely reticent about his commercial affairs which he regarded as of much less importance than religious study and spiritual reflection) but family tradition suggests that it was printing. At last, he was entirely his own master and he thrived on his new-found freedom. The scope for an industrious and brilliant young business was enormous. Liverpool's flourishing merchant community needed all manner of printed material – business cards, stationery, handbills,

posters and the like. Within a very short space of time Frith's company had become one of the two leading printing firms in the city with a turnover of £200,000 a year.

There seems little doubt that Frith had by now taken up photography as a hobby and that he was interested in the potential connection between the new technology and printing. From the beginning it had been one of the major objectives of the pioneers to discover a means of transferring a photographic image to a metal plate from which it could be printed. A Frenchman, Firman Gillot, made the vital break-through in 1850 and Fox-Talbot perfected the technique of photogravure two years later. In 1854, an Austrian, Paul Pretsch, patented in Britain a variant of this process and set up the first photomechanical printing process. By that time Frith was among the small coterie of British photographers. In 1853 he was among the founder members of the Liverpool Photographic Society and in 1856 some of his portraits were displayed in an exhibition in London. In that same year he sold his printing business at con-siderable profit to his only real competitor and became, at the age of 34, a gentleman of leisure with considerable private means.

For a man of Francis Frith's temperament leisure could have nothing to do with idleness. He had already decided to devote his time to serious photography and had even chosen his first project: he would visit and take pictures of Egypt and the Holy Land. Within months of selling his business he had transferred himself, his parents and their belongings to a fine country house in Surrey, collected together all his equip-ment, planned his itinerary and set sail for the Levant.

He was climbing on a bandwagon. Never had there been more interest in these lands of heat, mystery and romance. Daring travellers had penetrated these regions whose very sands and crumbling walls spoke of biblical stories and ancient kingdoms. Henry Layard had been one such. In 1839 he had forsaken his office stool to wander the deserts in Arab dress to find remains of the long-lost empires of Mesopotamia, and he had thrilled all Europe with his discoveries of the

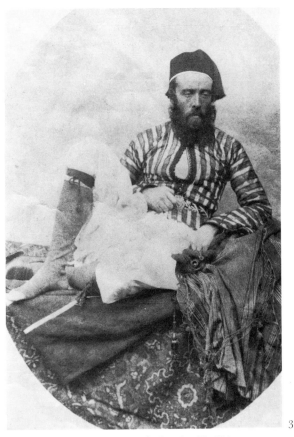

3

Francis Frith in Turkish costume during his visit to Egypt in 1858.

great Assyrian bas-reliefs of Nimrud which had lain beneath the sand for twenty-seven centuries. Where bold spirits blazed the trail wealthy tourists followed. Many visitors flocked every year to the relatively accessible temples and tombs of the Nile valley. Several books had been written describing the attractions of exotic places just beyond the frontiers of civilization (Africa, of course, was still the unexplored 'Dark Continent'). Mostly they were illustrated with engravings from artists' drawings but in the 1840s and 1850s the first books of travel and adventure containing daguerreotypes and photographs appeared. They were avidly sought after by readers throughout Europe.

Frith resolved to cash in on this burgeoning market. It was not simply a commercial decision. Frith was a restless soul who longed to be on the

move. The years of mere 'money earning work', confined to his city printworks, had been irksome. From this time onwards he would be almost continually travelling. The artistic and technical challenges of photography intrigued him and, of course, as a practising Christian, he had a particular interest in biblical lands. Yet the fact remains that, for all his affected disdain of trade, he had an instinct for business. Within the space of four years he had made four journeys to Egypt, Palestine and Syria. His pictures were published in seven separate works for some of which Frith also supplied the text. He wrote in a somewhat arch, self-congratulatory style that we now find quaint:

> Do not imagine, my readers, that your artist kept a diary of his feelings; he never *could* get beyond the second page of such a record: and here at Philae, he had indeed other work. During his stay the rising sun saw him, encumbered with "baths" and bottles, scrambling up the bank from his dahibieh, by the base of this "Bed of Pharaoh"; and as the declining rays gilded its capitals, he was observed climbing frantically to the top of the great pylon, camera-frame in hand, to "use up" the last streak of light. They were hard days' work; but how delightful, how rich – to him – in their results!
>
> [*Egypt and Palestine Photographed and Described by Francis Frith*, (1858–60), Vol II, '"Pharoah's Bed", Philae, from the Great Temple'].

The combination of exploration and pioneer photography was, indeed, hard work. The traveller had to bargain for supplies, to expose himself and his precious equipment to attacks by brigands, to suffer the discomfort of extreme heat and sandstorms, to trust untrustworthy local guides and porters, and to perform his field chemistry in almost purgatorial conditions. The wet-collodion process demanded that Frith's squares of glass were prepared immediately before exposure and developed immediately afterwards. This usually meant working in a small, stifling, dark tent in which the temperature was well over 100° F. He recorded that sometimes the collodion actually boiled when he poured it onto the plates.

But he produced startling results and won instant fame. By the time he returned from his second expedition in May 1858 he had been hailed as one of the most outstanding photographers of his day. Exhibitions of his works were held. He gave lectures illustrated by magic lantern. He wrote magazine articles. He received prize medals and won much critical acclaim. And he fell in love. The object of his affection was Mary Ann Rosling, a young woman sixteen years his junior, of impeccable Quaker parentage and suitable in every way to receive his affections. He wooed her with ardour and persistence. 'I should never have thought of asking for her hand,' he later insisted, 'until I almost knew that she would give it. Men ... who "propose" before they have taken any reasonable pains to win deserve to lose'. This courtship doubtless partly explains why Francis spent over a year at home before returning for his third, and last, visit to the Levant.

This really was a pioneering venture. Frith travelled far up the Nile, carrying by camel his camera and plates to regions where no photographer had been before. He ventured into the disputed borderland of Egypt, Nubia and Ethiopia and claimed to have reached the Sixth Cataract, not far from the junction of the Blue and White Nile at Khartoum. Unfortunately, the photographic record casts some doubt on this, as no Frith pictures are known to have existed of views above the Third Cataract, more than 700 miles downstream from Khartoum. Perhaps Frith indulged himself in traveller's hyperbole; perhaps the difficulties of carrying his heavy equipment became too great. Whatever the truth, it should not detract from Frith's very real achievements under appalling conditions:

> ... we were devoured by thousands of sandflies; the water very bad and the heat great. I worked hard and took some fine pictures. I still get landscapes with the smallest aperture of the view lens in four

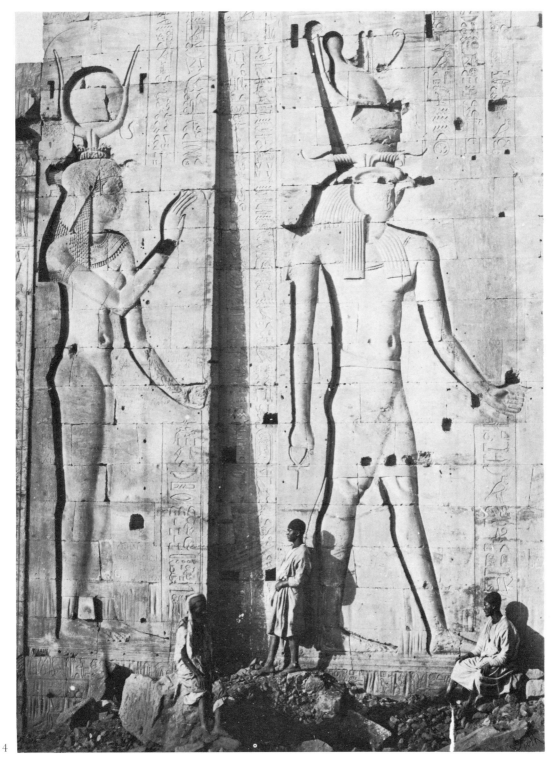

4

Colossal sculptures at Philae

seconds, and have taken capital pictures in the heat of the day. I should imagine the temperature in my little tent could not be less than 130° Fahrenheit ...

[F. Frith, article in *Photographic News*, III, (1860), p. 279].

In the summer of 1860 Frith came home and turned his back forever on the life of foreign adventure. Explorers crossed the deserts and jungles of Africa and Asia. Photographers followed in their wake, bringing to an enthralled public actual pictures of strange lands and peoples. But Frith devoted the second half of his life to recording the sights of his native land and left its shores only for trips to the continent. It was a definite decision, arrived at, like all Frith's decisions, with a clear head, and one which he even celebrated in verse:

> ... And I think, with a sigh, I'll abandon
> the rest
> For a home in old England, the last and
> the best.
> Then away with thee, poet, philospher,
> fool –
> To the terrible clime of thy birth,
> The place where thy boyhood was
> tortured at school,
> The still dearest spot upon earth;
> To the green little isle with the weeping
> skies
> And the girl whom you left with the tears
> in her eyes.'

Many travellers have harboured such romantic thoughts about their homeland, and have returned only to be afflicted with 'itching feet' after a few months or years. It was not thus with Francis Frith. Restless he certainly was and he seldom stayed in his own house for more than a few months at a time. But from now on he confined his movements largely to the British Isles. He married Mary Ann, settled with her in Reigate, and in the same town established a photographic business, F. Frith and Co. Here he produced for sale prints taken on his foreign travels and he also toured the estates of the wealthy who wanted England's most famous photographer to take pictures of their fine mansions.

It was not long before the grand design evolved of undertaking a complete photographic record of these islands. Nor is it difficult to see how such a mammoth task occurred to Francis Frith. He had already travelled Britain fairly extensively and his photographer's eye must have noted hundreds of 'views' which he longed to capture. But even the well-to-do Frith could not contemplate devoting himself to years of labour and exposing tens of thousands of plates purely to satisfy his own whim. The project had to be commercially viable. It was one thing to take pictures of manor houses and castles for rich clients. It was quite another to photograph town streets, village greens and tracts of countryside for the general public. Would anyone buy such 'views'?

The answer was that they would and did. The time was exactly right for Frith's grandiose scheme. There was a widespread interest in the new photography, and the strange man who set up his tripod and camera outside the town hall or the inn never failed to attract a crowd. When the results of his labours were made available for a few pence there were many people who bought them as mementoes or to send to distant friends and relatives. But mild curiosity would not in itself have been sufficient to ensure Frith a market for his wares. What did guarantee his success was the railway.

A prodigious spate of building by scores of small companies during the 'railway mania' of the 1830s had given Britain a basic network of lines by 1840. The impact of this development was profound and multi-faceted. In 1845 Disraeli, in his novel, *Sybil*, drew attention to the fact that 'the Privileged and the People formed Two Nations'. He might with equal truth have divided British society into other categories: the Urban and the Rural; the Static and the Mobile. By 1850 half of the population lived in towns, a state of affairs not caused by the railway but certainly facilitated by it. That meant that, broadly speaking, fifty per cent of the people were familiar with factories, lamplight, piped water, shop windows crammed with attractive luxuries and

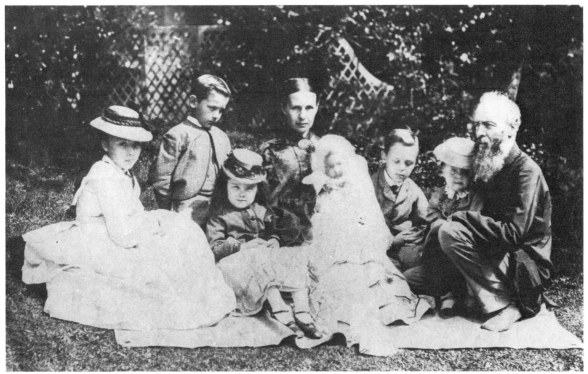

5

the clatter and bustle of 'progressive' commerce-oriented life, while the other fifty per cent lived and died without venturing more than ten miles from their own front doors.

The distinction was well drawn by Thomas Hardy:

Five decades hardly modified the cut of a gaiter, the embroidery of a smock-frock, by the breadth of a hair. Ten generations failed to alter the turn of a single phrase. In these Wessex nooks the busy outsider's ancient times are only old; his old times are still new; his present is futurity.
[*Far From the Madding Crowd*, Ch.22 (1874)]

Those who did venture away from home by railway train found it a novel experience to be whisked through the countryside at speeds in excess of fifty miles per hour:

Everything is flying. The hop gardens turn gracefully towards me presenting regular avenues of hops in rapid flight, then whirl away. So do pools and rushes, haystacks,

Francis was a devoted husband and father. He hated to be parted from his family which is why he took them on his photographic trips as often as possible.

sheep, clover in full bloom delicious to the sight and smell, corn sheaves, cherry orchards, apple orchards, reapers, gleaners, hedges, gates, fields that taper off into little angular corners, cottages, gardens, now and then a church ... Now a wood, now a bridge, now a landscape ...
[Charles Dickens, *A Flight* (1851)].

Travellers now became aware of their own land in a new way. They could see the prestigious public buildings and broad streets of the rapidly growing towns. They could go in search of places that had hitherto been only names – Cornwall, the Lake District, Wales, Scotland. Among the urban population there developed a nostalgia for the peaceful life of green fields and leafy lanes.

Artists and publishers were not slow to cash in

on this heightened awareness. Every time a new railway line or extension was opened a collection of prints was produced (often available singly as well as bound in volumes), illustrating not only the engineering feats of the builders but also the places of beauty and interest now made more accessible to the public. By 1860 people of quite modest means were buying cheap topographical engravings, some to form collections, others for a variety of reasons both intellectual and sentimental.

If engravings, why not photographs? All Frith's publications to date had appealed only to the relatively well educated and well-to-do elements of society. His first Middle East pictures, for example, *Egypt and Palestine Photographed and Described*, appeared in twenty-five parts at ten shillings each. Ten shillings was more than an agricultural labourer's weekly wage. The books sold well and for some years Frith continued to publish views bound together with text. *The Book of the Thames* appeared in 1867, as did *Dovedale*. But Frith knew that he could increase his turnover a thousandfold if a means could be found of marketing individual views. Moreover, preparing and mounting photographs ready for the printer was a time-consuming and labour-intensive affair. Frith found it difficult to keep pace with the demand for some of his books. There were, therefore, several arguments in favour of exploiting his craft in a new way. Yet probably what appealed to Frith most was the challenge: once more he was to be a pioneer, to undertake something so bold that no one else had either conceived it or attempted to execute it.

Setting up his new business venture was also expensive. Not only did Frith have to hire and train a team of photographic assistants (since, clearly, the comprehensive survey was more than one man could accomplish), he also had to employ sales representatives who would tour stationers' and newsagents' shops with the Frith collection of souvenir views.

We have already described the palaver of a Frith photographic tour – the equipment, the assistants and the family that Francis took with him. Having established a base in a suitable hotel, the photographer sallied forth in a pony and trap to explore the locality and select his subjects. The actual business of taking the pictures was both a practical and an educational exercise, for Frith insisted that his assistants should master his own technique in detail. Every type of picture had different rules which must be observed. Sunlight and clouds must be correct for the rural views. Movement must be kept to a minimum in a townscape; Frth preferred to work to a forty-second exposure in external scenes but had to shorten this if there was a risk of blurring caused by human or animal motion. Frequently a member of the entourage was included in a picture to improve its composition, add a point of interest or provide an indication of scale. Where 'locals' were the subject of a photograph they had to be artistically posed and made to keep still for the necessary length of time. The characteristic that Frith impressed above all other on his associates was patience. It was vital to take time and trouble over finding the best viewpoint:

> A photographer only knows – only he can appreciate the difficulty of getting a view satisfactorily into the camera: foregrounds are especially perverse; distance too near or too far; the falling away of the ground; the intervention of some brick wall or other commonplace object, which an artist would simply *omit;* some or all of these things (with plenty others of a similar character) are the rule, not the exception.
>
> [F. Frith, *Egypt and Palestine Photographed and Described* (1858–60) Vol I Introduction]

Having set up his apparatus, the photographer must then wait for the best atmospheric conditions. Frith once took four hours over a single exposure in a cathedral interior. We do well to remind ourselves of the difficulties the early photographers laboured under when we look at the excellent prints which are still taken from Frith's glass plate negatives. They are a tribute not only to his technical skill but also to his ability to impart it to his assistants.

Frith would also have claimed that his photo-

6

Frith at 'Brightlands', Reigate in the later years of his life.

graphs were works of art. He was himself an amateur painter of no mean ability and in the current argument about the status of the new pastime (i.e. whether it was an art form or merely a mechanical science) his views were quite clear.

> Your most accomplished artist, if he will stoop to the task, will ever be your best photographer; and your skilful 'manipulator', if he be possessed likewise of a grain of sense of perception, will never rest until he has acquainted himself with the rules which are applied to Art in its higher walks; and he will then make it his constant and most anxious study how he can apply these rules to his own pursuit.
> [Article in *Photographic News*, Vol I, (January 1859), p.208]

In the same article Frith abhorred the amateur who took six dozen pictures a day, and gave the somewhat drastic advice that all poor quality glass negatives should be destroyed. These words were written before Frith and Co set out on their mass production of British views.

Do we detect here an element of hypocrisy? Did the businessman in Frith triumph over the artist? Was the protesting photographer hoist on his own petard? Well, yes and no. It is obvious that Frith took great pains over composition and content in his pictures and certainly most of the earlier photographs in the collection reveal a true painter's eye. What else could transform a group of urchins playing in a dingy backyard into a pleasing picture? Then there was the re-touching that Frith and his craftsmen undertook in the studio. To heighten the impact, areas of shade and light were intensified, edges made crisper, unimportant details removed or masked. Sometimes two negatives of the same location were superimposed in order to achieve a more dramatic result. All these processes demanded hours of close, eye-straining work and Frith cer-

tainly would not have bothered with them had he only been interested in obtaining accurate views. Indeed, the fact that he was prepared to compromise the camera's once undisputed virtue – truthfulness – indicates that Frith was very concerned with making good pictures. Yet, it must be admitted that, as the years went by and demand for souvenir views increased, a larger proportion of Frith and Co's output was concerned with recording actuality rather than with arranging it.

Francis Frith was the first man fully to exploit the commercial possibilities of photography. His work was soon being sold in over 2,000 shops throughout the country. But there were other sides to the Reigate business – foreign views, commissioned photography for architects and house owners, studio and location portraiture, magic lantern slides, frames and other accessories, etc. Frith even gave lessons to eager amateurs and aspiring professionals. After the initial years of establishing the business, success was rapid and Frith added another fortune to the one he had made in Liverpool.

Diverse as his activities were, it was 'Frith's Postcards' that maintained his name as a household word long after the personal fame acquired in the 1850s had evaporated. Strictly speaking, the picture postcard as we know it did not come into being in Britain until 1897 when, by Act of Parliament, certain restrictions on their use were lifted. But that legislation was the result of steadily growing demand. In 1870 the Post Office introduced the plain postcard which could be sent at half the letter rate ($\frac{1}{2}$d). It was an instant success; in the first year, 76,000,000 cards were sold. Understandably, the government wanted to preserve its monopoly of this lucrative market. Non-official cards could only be sent at letter rate. Furthermore, no writing other than the name and address of the recipient was permitted on the plain side. Thus, any holidaymaker wishing to send home a Frith souvenir view could either enclose it in an envelope or send it with his brief message scrawled across the picture. It was the popularity of the photographic card that forced the Post Office to yield. In 1894 they officially recognized the picture postcard by per-

mitting it to be sent at the cheap rate and three years later they abolished the restrictions on the written message. By that time collecting photographic and decorative cards had become an immensely popular hobby. Without a doubt Frith and Co contributed largely to this minor social revolution.

The founder of the firm just lived long enough to see this acceptance of a phenomenon he had pioneered thirty-seven years before. He and Mary Ann brought up a family of eight children (five boys and three girls) in their large rambling house called, appropriately, 'Brightlands' in Reigate. There they lived the happy, secure life of prosperous, middle-class Victorians. Religious faith was important to them. They regularly attended the Quaker meeting and were often invited to worship with Friends in other parts of the country. The frequent photo-tours were often combined with speaking engagements and visits to Quaker meetings. Mary Ann records, for example, that in July, 1878 'on the 14th, 15th and 16th Frank had meetings at Lancaster and the kind Friends with whom he lodged invited me to go with him for the last meeting ... Mr and Mrs Hadmen and their daughters were very kind and pleasant ... and the meeting was very nice and good – Mr Pollard spoke on the 23rd Psalm and my dear husband's subject was living faith'.

Once the success of the photographic business was established its founder gradually disengaged himself from its day-to-day running. Or perhaps it would be truer to say that other pursuits took up more of his time. He applied himself to theological study and wrote books about Quakerism and Evangelical Christianity. He expressed himself also in verse and in painting. All his creative output had about it a self-assurance, a down-to-earth realism. His religious opinions were as well-defined and unequivocal as the landscapes he created on canvas or on glass. We get the impression that doubt was a stranger to him.

'I do not greatly value the guesses that novelists make for us at imaginary characters. I am of opinion, indeed, that an habitual study of such false and fictitious models incapacitates the mind from a true estimate of real, living character, as

7

it certainly does of real life.' The fragmentary personal writings by Francis and his wife which have been preserved by their descendants reveal a man, on the one hand earnest, genuinely religious and morally firm; we feel that Francis Frith never suffered fools or ditherers gladly. On the other hand we see a devoted family man who enjoyed picnics and celebrations and who took his wife and children with him on his travels whenever possible because he hated to be parted from them. 'A life without love, and domestic joys and cares and the discipline of child-life,' he wrote, 'is sorrowfully incomplete. Marriage gives solidity, purpose and energy to life ... I reckon the real substance of my life to date from my wedding day.'

The travels were prodigious. The Frith entourage seems to have been almost incessantly on the move. As well as the tours to various parts of Britain, Frith made photographic forays to Switzerland, the Italian lakes, the Rhine, Italy and Scandinavia. The house at Reigate saw the family infrequently; poor Mary Ann seems to have lived most of her married life in a wide variety of rented houses and must have been constantly supervising the packing and unpacking activities of a succession of servants. Some time in the 1880s the family took to wintering abroad, usually in the south of France. Despite the evidence of his bustling activity, Francis's health appears not to have been robust and he sought warmer climes. Even during the summer months, however, Francis was frequently away from Reigate.

Gradually the children grew up and left home. Alice married a London tea dealer. Mabel's husband, Herbert Crosfield, was a local notable who was a member of Lloyds and served a term as mayor of Reigate. Susan, the tomboy of the family, dedicated herself to nursing. Of the boys, Edgar was tragically drowned while on a visit to Norway in 1883 at the age of nineteen. Julius became an engineer and spent his working life in Manchester. Only the two older, surviving brothers, Eustace and Cyril, remained in the photographic business. Neither seems to have left much mark upon it and, indeed, Eustace was more of a country gentleman than a businessman. But the extremely successful pattern established by Francis Frith continued. The Frith photographers, well trained and much travelled, recorded faithfully the passing Victorian scene. Hundreds of thousands of glass negatives were stored in the Reigate premises. Year after year they were re-issued or touched up to remove obvious anachronisms (for example, it was necessary to 'shorten' ladies' dresses in the 1920s and paint in their legs). The stock was constantly being added to. Unfortunately, from time to time, old plates were destroyed to make room for new ones but the continuing success of the business ensured that a remarkable collection survived. By 1972, when Frith and Co ceased trading, the importance of this collection was

appreciated and, though it more than once came close to being destroyed or dispersed, it was eventually preserved and survives as a unique pictorial record of a bygone age.

The founder of the business died in Cannes in 1898 and was buried there. His life had spanned the whole Victorian era. He was born three years after the future queen and died three years before her. In many ways he epitomizes the epoch. In the popular imagination it is an epoch that has a static, 'set-in-aspic' appearance – a leisurely age of top hats, hansom cabs and long skirts. In fact it was a restless age, an age of rapid change, an age conscious of technological progress and social development. Frith's photographs show us clearly this changing scene.

Of the 60,000 surviving glass-plate negatives made by Francis Frith and his team only a fraction have been chosen for this book. In making the selection we have had two objectives in mind. First of all, we wanted it to be representative of the range of Frith and Co's activities. The existing archives contain scenic views, townscapes, posed groups, pictures of buildings and a few examples of studio work. Some photographs are immediately attractive, even breathtaking, in their artistic skill and subject matter. Others are at first sight, frankly, dull. It would have been easy to exclude all examples of the latter. Instead, we asked ourselves the question 'why was this photograph taken?' And always we found that, by looking more closely at the picture, intriguing details began to come to light. Frith's was, after all, a commercial operation. Neither Francis nor his assistants wasted time taking pictures that would be of no interest to the buying public. Secondly, we tried to choose pictures representative of various aspects of late Victorian life. We have grouped them thematically and tried to provide in the accompanying text some guidelines that readers may find helpful. But the arrangement and the author's text are quite arbitrary. The pictures stand by themselves and will say different things to different people. That is their charm. That is the secret of their success. That is essentially why they formed the basis of the first major commercial photographic enterprise – and a highly successful enterprise it was.

1
A NATION AT WORK...

The pace and complexity of change in Francis Frith's Britain was quite staggering. Basically the age was one of transformation from a predominantly agricultural to a predominantly industrial country. The nation that went proudly on display to the world in the Great Exhibition of 1851 had already become the 'workshop of the world'. Twenty-seven per cent of the working population were employed in factories while only 18% were occupied in farming. By the time Frith died, 77% of the British people lived in towns, and the number working on the land had fallen to 8%. These figures assume still more dramatic proportions when we realize that during this half century the total population almost doubled. Young men and women were attracted to the towns in increasing numbers to improve their lot. They wanted secure jobs rather than farm work, most of which was intermittent and dependent on the vagaries of weather, harvest and market demand. The unprecedented mobility of population was made possible by the steady extension of the railway network. In 1853 the railway companies recorded 100,000,000 passenger journeys. Fifty years later the annual figure was 1,167,000,000. Population movement was not all one way. Hand-in-hand with the growth of urban settlement went a growth of nostalgia for the countryside and, thus, the beginnings of another new industry – tourism.

It is customary when thinking of Victorian, industrial life to envisage squalid, noisy factories crammed with machines and people. Certainly such establishments existed and working conditions were but slowly improved by a succession of factory Acts. Yet the majority of workplaces were not overcrowded. The average number of employees in manufacturing companies was between fifty and sixty. Any mill-owner employing more than 150 was a 'big man' indeed. This 'golden age of British capitalism' was one of many small, competing enterprises. The skylines of northern textile towns were punctuated with the chimneys of rival mills. Factories, workshops and mines were, for the most part, small by modern standards. The same can be said for the proliferation of service industries which provided the necessities of a growing population and a bur-

geoning commerce. Whole new streets of shops were built and were still further supplemented by thousands of street traders. There was a growing need for engineers, mechanics, labourers, accountants, shipbuilders, dockers. There were more schools and, therefore, more teachers; more hospitals and, thus, more doctors and nurses.

The growth of the entrepreneurial and professional middle class led to an increased demand for servants. During our period, the numbers of men and women in service more than doubled from the 1851 figure of 900,000. Mounting prosperity was by no means shared but its effects did percolate down through most levels of society.

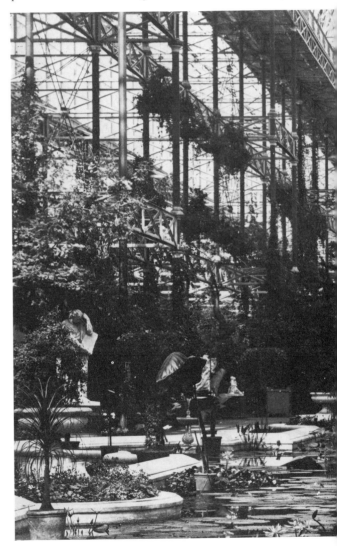

Broadly speaking, there was work for all, and especially for those prepared to leave their traditional communities to go in search of it. Unemployment fluctuated wildly because, like other commodities, labour was at the mercy of market forces. For example, in 1858 unemployment hit an all-time high for the century of 12%. Yet, by 1860 it had fallen to 2% and, a couple of years later, it stood at 8%. On average, however, less than 5% of the employable population were out of work for any length of time.

Alongside all these new activities, many of the old crafts persisted. The fishing industry, for example, was never more prosperous. The number of sailing and, later steam, trawlers increased. Not only did a growing population mean a greater demand but also railway transport meant that fresh fish could be conveyed far inland. But locomotives had by no means conquered all. On the roads the horse was still king and that meant work for blacksmiths, ostlers, wainwrights, wheelwrights, draymen and carters.

All these working people upon whom depended the success and prosperity of a Britain never more successful or prosperous, passed before Frith's cameras.

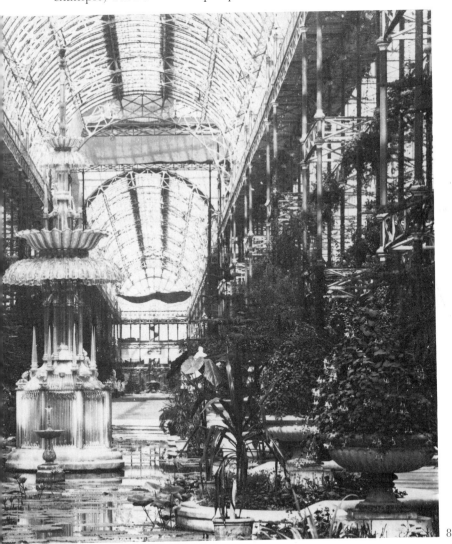

The Crystal Palace. Joseph Paxton received a knighthood for this incredible structure built in Hyde Park to house the Great Exhibition. It was the world's first pre-fabricated building of cast-iron and glass and audaciously expressed the confidence of British industry and commerce. The confidence was well-placed: over the next quarter of a century Britain, already the world's leading manufacturer, increased her exports (principally textiles, coal, machinery, iron and steel) fourfold. It was *Punch* that dubbed the exhibition centre the 'Crystal Palace' and the name was very apt. Its magical appearance struck all visitors:

> 'A blazing arch of lucid glass
> Leaps like a fountain from the grass
> To meet the sun!'

> (William Thackeray)

8

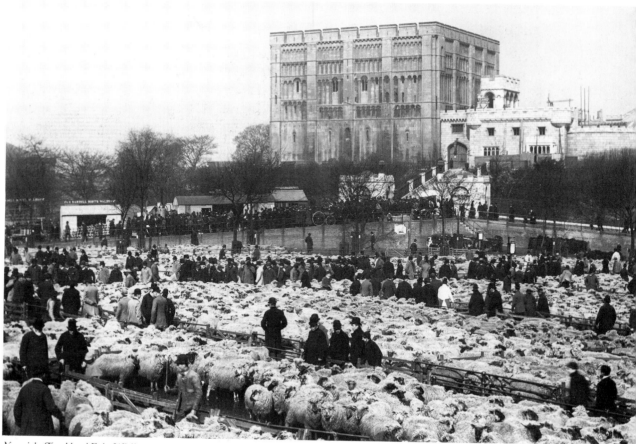

9

Norwich, Tombland Fair. While exports of manufactured goods rose, so did the import of foodstuffs. Foreign nations paid for British produce with wheat, meat, butter, cheese, eggs, sugar and tea. Agricultural production was cheaper in America and the developing countries of the Empire. This was bad news for the home producer. Prices obtained at market for these sheep in 1891 (all driven 'on the hoof' along miles of country lanes) were 40% down on those realized in the peak year of 1873. Rider Haggard, the author of *King Solomon's Mines*, was a Norfolk landowner. In *A Farmer's Year*, written during the last year of Francis Frith's life, he described, in detail, the appalling conditions of farm labourers, 'some retained against all economic reason by charitable employers, others dismissed with a shrug by landlords who claim that they are being "impoverished" by faceless market forces'.

10

Ormerod House, Burnley, Greater Manchester. The decline of agricultural employment did not inevitably mean a drift to the towns for all ex-farm labourers. The growth of an entrepreneurial middle class, building itself country mansions, provided estate employment for many. Burnley and other cotton towns had sucked much life from the country but the textile barons who bought and extended Ormerod House wanted to look out over neatly-mown lawns and meadows. Cutting the grass by horse-drawn mower was a pleasant summer occupation. Other countrymen were employed as gamekeepers, rat-catchers, lodge-keepers, gardeners, foresters and general estate workers.

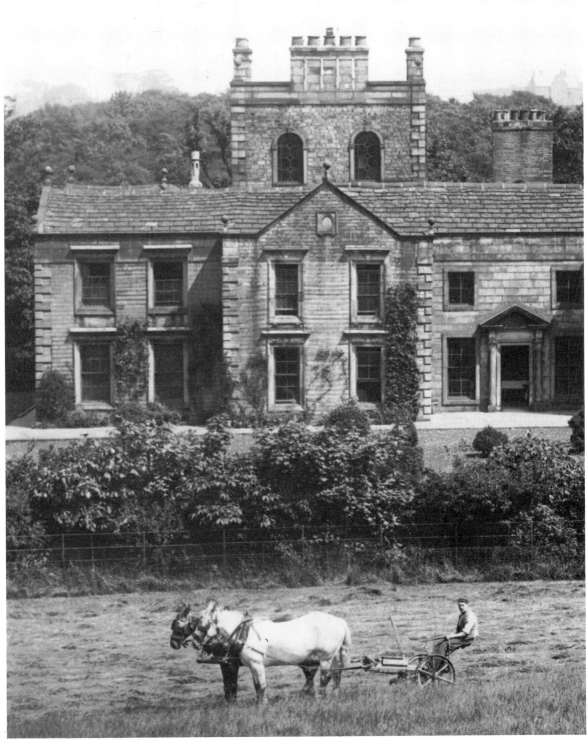

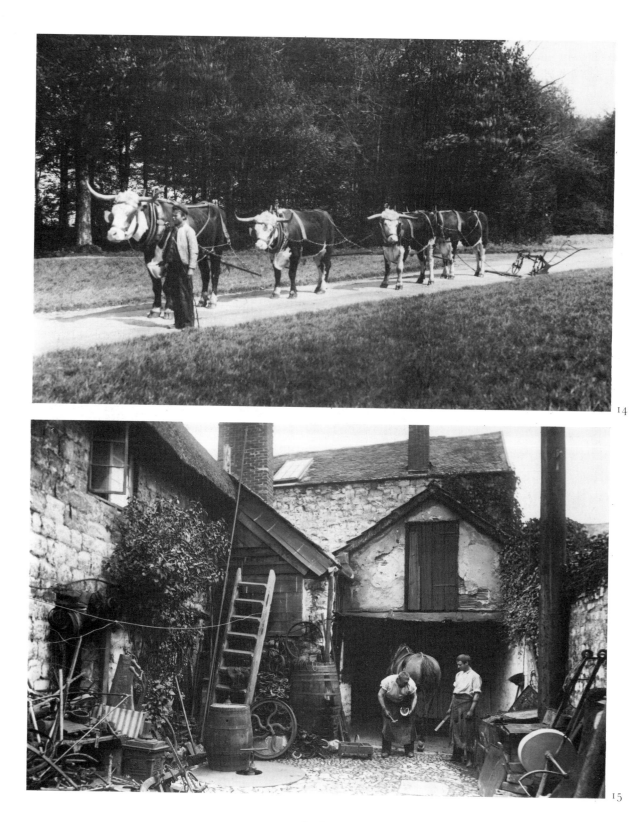

14

15

14

Near Cirencester, Gloucs. Ox teams must have been a rarity even a hundred years ago. They were only suitable for ploughing on light, stony soil such as parts of the Cotswolds. This magnificent team was spotted by one of Frith's photographers near Cirencester in the 1890s.

15

Lyme Regis, Dorset. 'Beneath the spreading chestnut tree, the village smithy stands.' Each village had its blacksmith. Small towns, like Lyme Regis, had more than one. The smith was the lynch-pin of the whole rural economy and was called upon to shoe horses, mend farm carts and gentlemen's carriages, sharpen implements and fashion replacement parts for agricultural machines. As the number of horse-drawn vehicles decreased and wheelwrights began to go out of business many blacksmiths mastered that craft also.

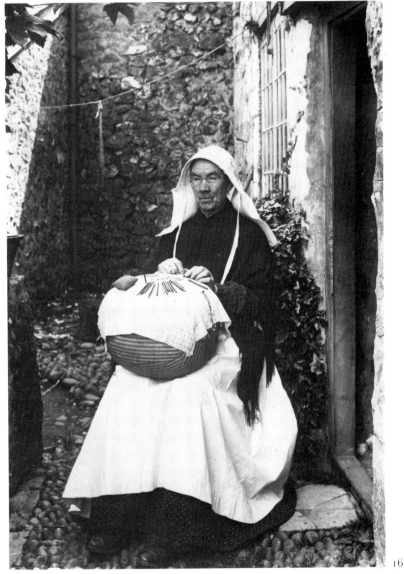

16

16

Beer, Devon. Countrywomen turned their hands to a variety of crafts to eke out their husbands' wages or provide for the family when the breadwinner was laid off because of illness or bad weather. Lace-making, an old traditional craft, had fallen into disuse but was revived around the middle of the century when lace came back into fashion and was particularly popular with Queen Victoria. Honiton was the principal English centre for hand-made lace (as opposed to the coarser, cheaper machine-made commodity) and, at its best, compared favourably with the finest produced in France and the Low Countries. Its creation was exacting, and very trying on the eyes, which is probably why this woman is bespectacled and sits out of doors. Her name was Mrs Woodgate and, according to local tradition, she worked on at least one dress for the queen.

17

Dunster, Somerset. Mrs Cecil Frances Alexander, writer of many hymns and religious verses, was staying at Dunster when she composed the children's hymn 'All things bright and beautiful', containing the typically Victorian verse (seldom sung today),

'The rich man in his castle,
The poor man at his gate,
God made them, high or lowly,
And ordered their estate'

Here we see some of the 'lowly' posed for the camera in front of the Luttrell Arms Hotel and the Yarn Market. Dunster was already something of a picturesque tourist attraction – hence the smart, liveried bell-boy – but the others in the picture were typical members of the village working community. The carter conveyed goods and people to and from local towns and villages. The delivery man with hand-cart took a variety of products door-to-door.

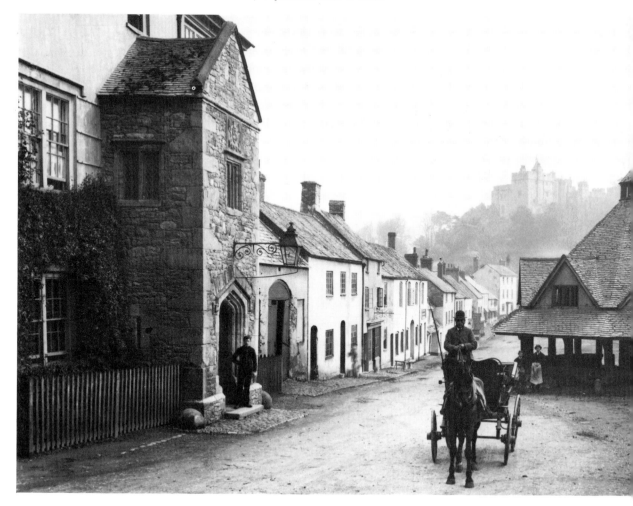

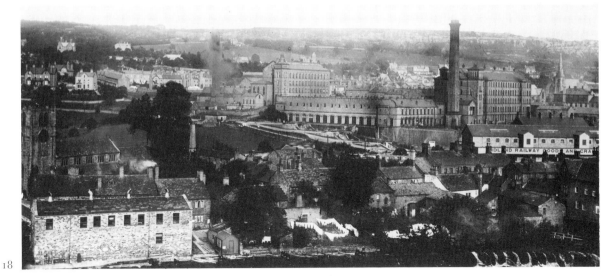

18

18

Bingley, W. Yorks. The industrial town prospect was very different. Smoke from mill chimneys smudges the landscape and stains the stonework. The railway and the Leeds and Liverpool canal slice through the centre of the town (a flight of locks can be seen in the middle of the picture). Terraced houses huddle together and washing hangs out in small back yards. Beyond the town, farms and substantial houses are dotted among the trees and fields, but even the countryside is scarred by the quarries which supplied the stone to Bingley.

17

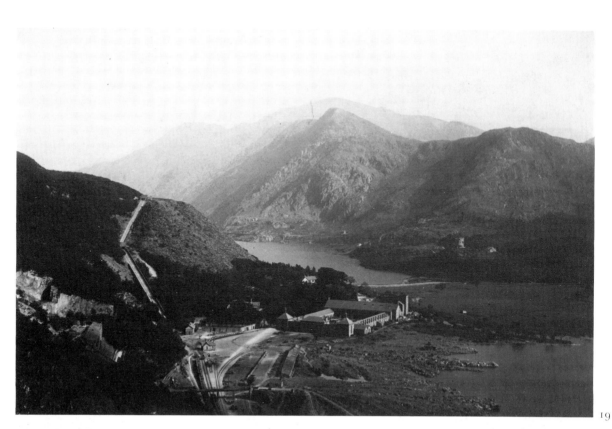

19

19

Llanberis, Gwyn. There was a great deal of small-scale quarrying and mining in Frith's Britain. The slate industry of North Wales was experiencing unprecedented expansion. Most of the slate used in the British Isles came from a few quarries in this scenically magnificent region. The building boom and the arrival of the railway (the Chester–Holyhead Railway was opened in 1850) ensured a steady demand. In 1873, 52,000,000 slates were shipped from Porthmadog, the port which served the industry. A government report in 1882 declared 'after coal and iron, slate is the most valuable mineral raised in the U.K.' [*Report of H.M. Inspector of Mines*].

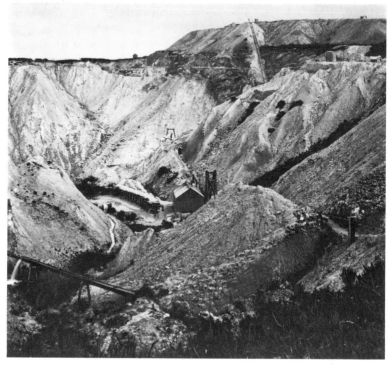

20

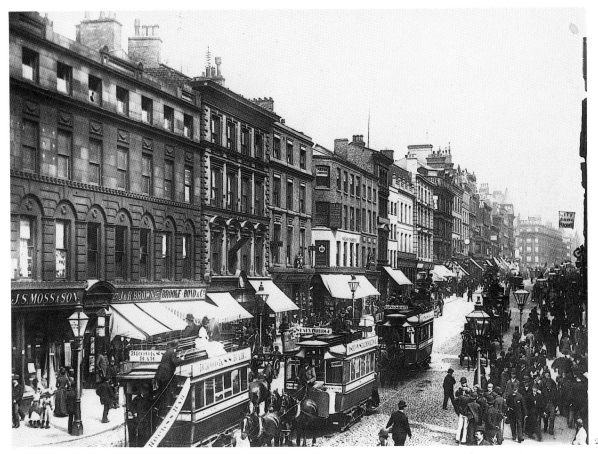

21

20

St Austell, Cornwall. The Cornish china clay industry was a nineteenth-century success story and one involving small-scale business. The *Mining Journal* of 10 November 1866 declared: 'St Austell will tell its own tale [of] new mansions that have been lately built by persons who only a few years since were standing behind the counter or working at their trades and are now independent gentlemen.' Several pits, including Carclaze, shown here, began life as tin mines, the clay being dumped as waste. When its potential for porcelain and pottery (and, later, in the making of paper and cheap cloth) was realized small mining companies developed all over the area, making modest fortunes for pit owners and bringing much-needed employment to a poor agricultural area. Shallow workings were always preferred, on cost grounds, but the pits inevitably deepened as time

passed. The clay was washed out by water and pumped to the surface to be dried. Waste material was dumped by 'trucks running on rail inclines. Output increased from 1,000,000 tons during the decade 1860–1869 to 4,000,000 tons in the last decade of the century.

21

Market Street, Manchester. Shops proliferated. Society snobs might turn up their noses at those who earned a living by 'trade' but many a Victorian millionaire started in business with a small retail outlet. Brooke Bond and Co were still operating a few grocers shops and had not yet turned into the giant international tea enterprise of later years. Francis Frith, himself, is evidence that there were opportunities for the self-made man, starting in a modest way:

'I began a wholesale business in a maritime town, in partnership with a young man of fine principles and a most amiable disposition, and we jogged on together on friendly terms, toiling at our daily drudgery with that wonderful, persistent, tick-tock mixture of hopelessness and resignation which animates a town clock ... But we soon separated amicably, and I then worked hard, and established a fine and profitable business ... it was anxious and terribly wearing work. With inadequate capital, I turned over some £200,000 a year ...'

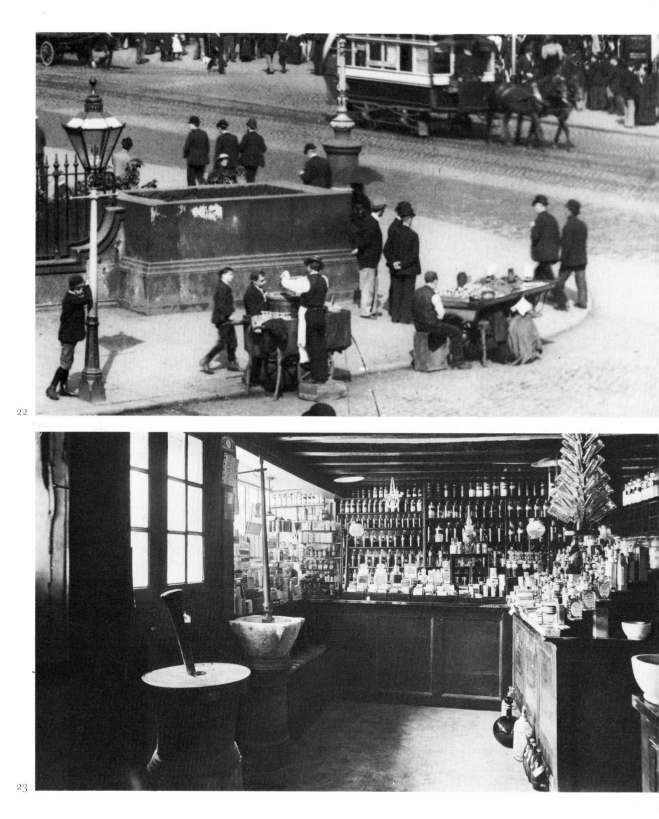

22

23

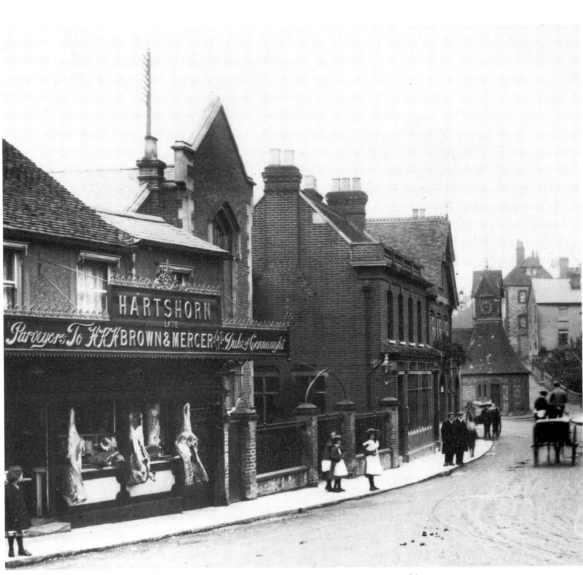

24

22

Street traders, Manchester Piccadilly. Other tradesmen began in an even smaller way (and many did not rise above it). There were few restrictions on street trading in *laissez-faire* Britain. Anyone who could offer the public a useful service could set up his cart or stall dispensing fruit, hot chestnuts, pies or cold drinks in season.

23

Knaresborough. Reputedly the oldest chemist shop in England, this shows what many shop interiors looked like a hundred years ago – solid wooden counters and shelves stacked neatly with gleaming rows of jars and bottles. It was a place where the assistant was, literally, there to offer a service. He was on a par with the domestic servant and it was his job to pander to the whims of the customers, who were, of course, always right.

24

Leatherhead, Surrey. In those class-conscious days the patronage of the gentry and nobility was eagerly sought and proudly displayed. It was more than a social cachet; it was genuinely good for business. Less exalted customers presumably reasoned that if the Duke of Connaught, Victoria's third son, ate Mr Harthorn's meat, then it must be good. It was rather like the modern gimmick of using top TV and sporting personalities to advertise your product. The Duke of Connaught's favourite residence was a dozen miles off at Bagshot.

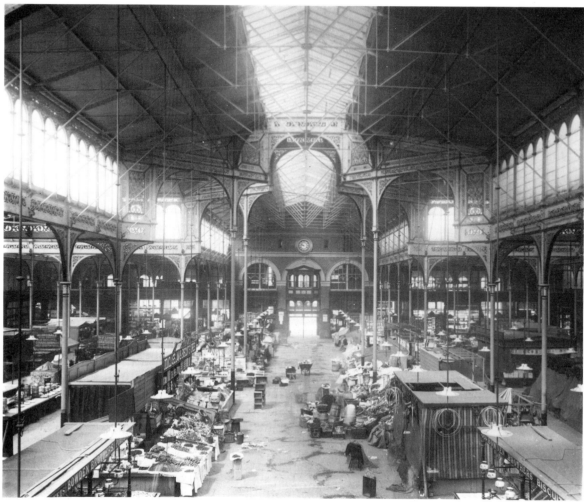

25

26

The Market Hall, Bolton, Lancs. The logical step from the street stall and the street market was the covered market. Many municipal authorities built these halls, in which space was leased to traders. Using cast iron, as Paxton had done at the Crystal Palace, enabled a large open space to be enclosed. Such buildings brought together hundreds of small traders such as 'Bowen Brothers Biscuits', 'Douglas's Jam and Biscuit Stores' and 'J. Lowe's Old Original Cough Lozenges'. There was even a canteen (lower left) where customers and stall-holders could refresh themselves with tea and cakes.

Nottingham. The growth of highly-competitive commerce led, inevitably, to the growth of advertising. The first agency in Britain opened in 1812 but it was the second half of the century that saw the dramatic expansion of this industry. The proliferation of popular newspapers and magazines gave scope for advertising but it was the transformation of town and city streets that was most dramatic. Shop windows bristled with posters, as did hoardings, end walls and public vehicles. An empty space was a lost opportunity and there were no planning regulations or Trades Descriptions Act to worry about. Thus, with no concession to modesty, Cappers' Tea could be described as 'The Finest in the World'.

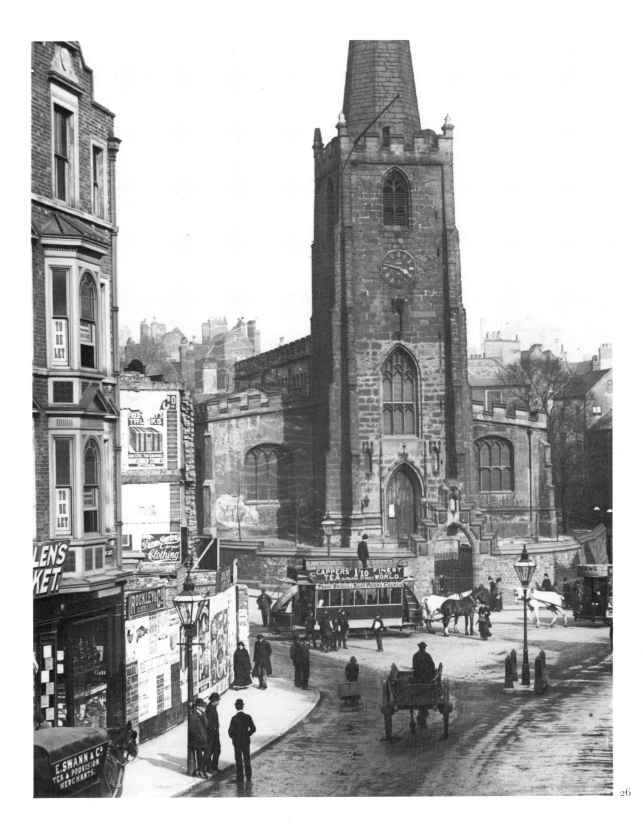

26

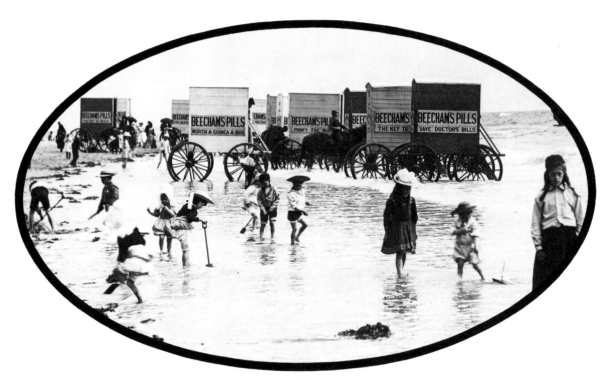

27

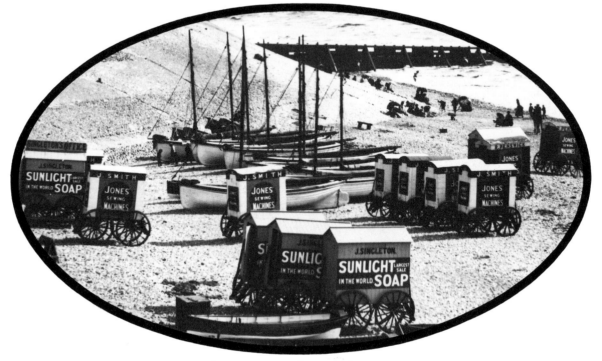

28

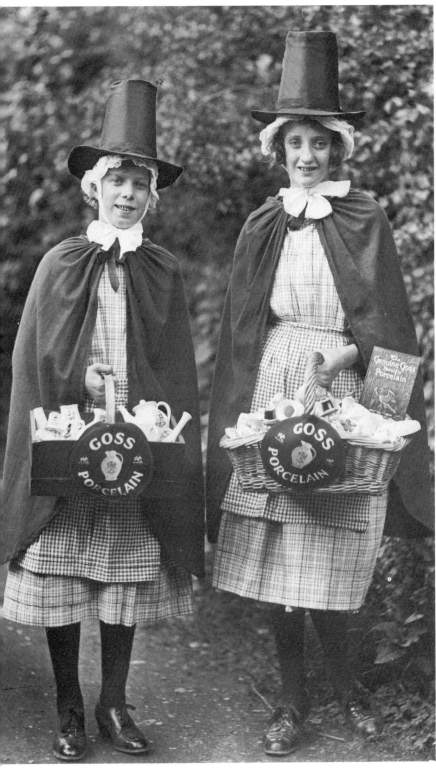

27 28
The beach, Blackpool, Lancs.
The beach, Tenby, Dyfed.
Nor was there any escape from advertising if you went on holiday. Sponsorship is no twentieth-century invention as these pictures show. Bathing-machine proprietors were paid handsomely to proclaim such wholesome products as Sunlight Soap and Beecham's Pills.

29
Welsh girls at Snowdon. One spin-off of the development of country holidays and tourism was the beginning of the souvenir industry. One pioneer in this field was the firm of Goss which specialized in porcelain novelties – thatched cottages, animals and so on. The company also had novel ways of marketing its novelties, like these Welsh salesgirls. Early pieces of Goss porcelain now fetch high prices in the saleroom. It was the sort of thing that Jerome K. Jerome prophesied: 'The "sampler" that the eldest daughter did at school will be spoken of as "tapestry of the Victorian era", and be almost priceless … and travellers from Japan will buy up all the "Presents from Ramsgate", and "Souvenirs of Margate", that may have escaped destruction, and take them back to Jedo as ancient English curios.' [*Three Men in a Boat*]

29

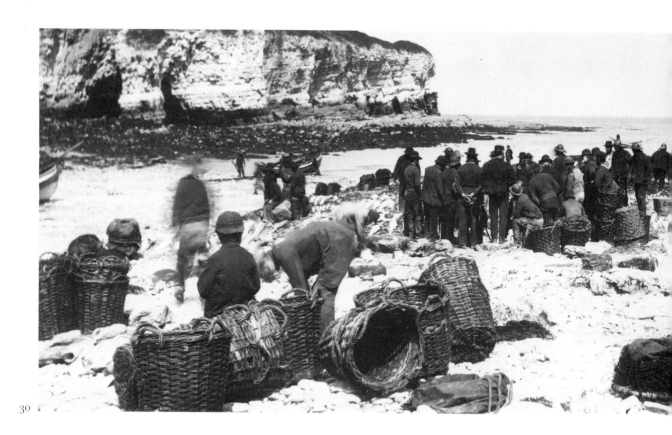

31
The Barbican, Plymouth, Devon. Other
fishing ports were busier. The simple
mechanics of bringing home the catch
and selling it on the quayside might
have been the same but at a place like
Plymouth the process involved many
more people – fish salesmen, porters,
railway agents, carters and insurance
brokers. Within hours of coming ashore
most of the fish would have been crated
up and loaded onto trains taking it to
the capital and other major markets.
Little wonder that Plymouth more
than doubled its population between
1851 and 1901 from 52,000 to 108,000.

30

The North Landing Fishmarket, Flamborough Head, Humberside. Every coastal village had its fishing fleet. Some, like the one at Flamborough, served local needs. When the wind was in the north the catch was landed on this beach. Tradesmen and wholesalers from nearby towns came down to buy, fill their baskets, load up their wagons and take the fresh fish back for sale. For the fishermen it was a hard life and not a highly remunerative one. For, though there was an increasing demand for fish, complex economic factors kept food prices down throughout most of our period.

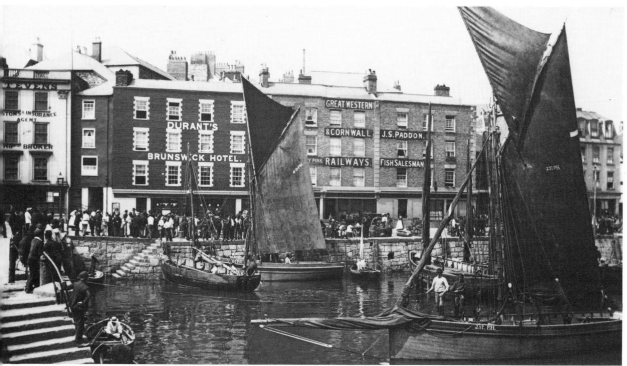

31

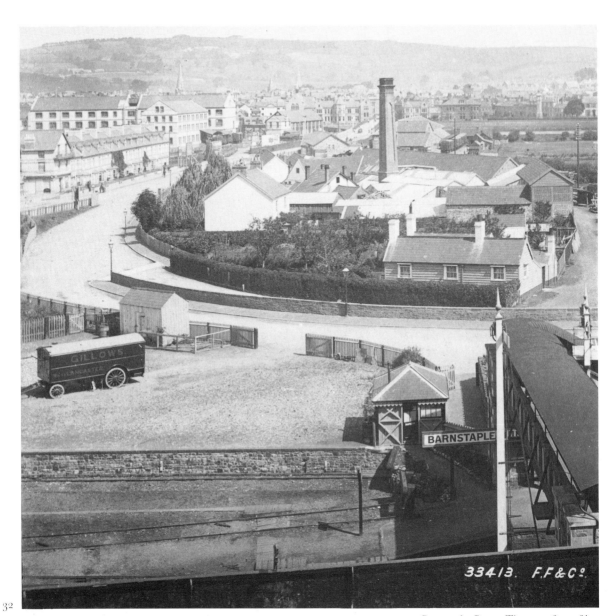

32

33413. F.F&Cᵒ.

Barnstaple, Devon. The very fact of increased mobility meant new jobs in many categories of employment, for example railway staff and long-distance road hauliers. This detail from a larger Frith photograph illustrates the point well. In the station yard at Barnstaple Junction stands a removal firm's pantechnicon van which has come by road all the way from Lancaster. Time and again one discovers intriguing details even in the most seemingly uninteresting Frith photos.

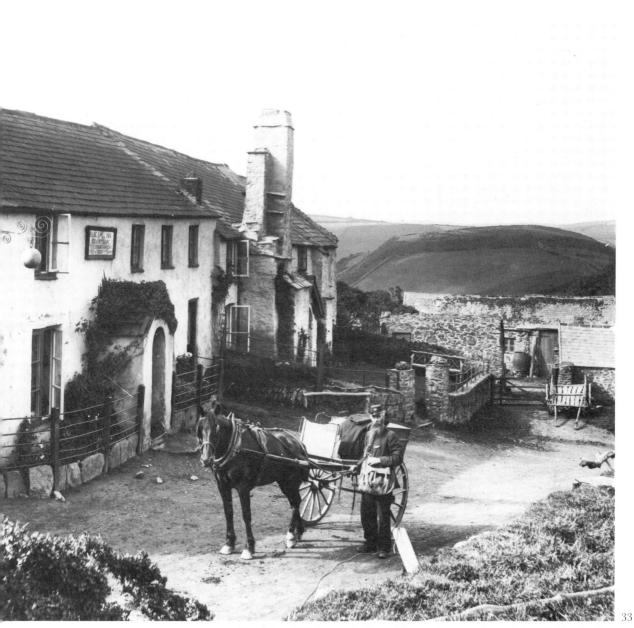

Countisbury Hill, Lynmouth, Devon. The improvement of the postal service must be regarded as one of those quiet, un-dramatic revolutions which affected almost every household. The Royal Mail began to be carried by rail in 1838 and two years later the penny post was introduced. In 1870 it became possible to send postcards to friends and relatives at half the letter rate. As the century progressed the numbers of letters and parcels handled by the Post Office increased rapidly. The effects of this on the spread of information and the growth of literacy are incalculable. It also reduced the sense of isolation of remote dwellings like the Blue Ball Inn on the quiet coast road of North Devon. The postman and his trap have prob-ably just completed the mile-and-a-half, one-in-four climb up Countisbury Hill.

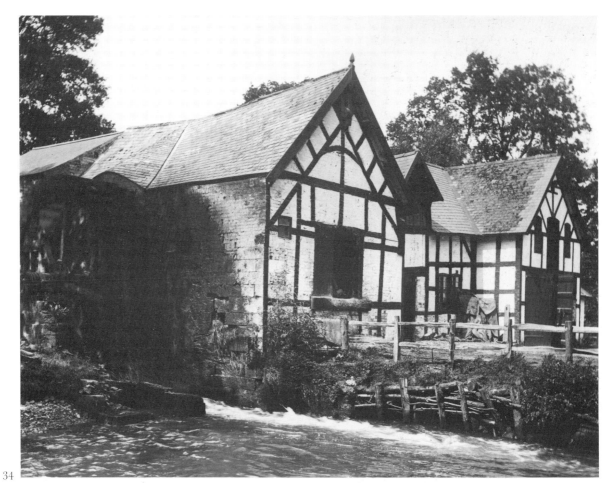

34

34

Rossett, Clwyd. Frith and his associates took many photographs of water mills. This was, doubtless, because they are picturesque. However, the fact that there were so many to photograph reminds us again of the small scale of much of British industry. There were thousands of breweries, bakeries, dairies and flour mills all serving local needs. Rossett Mill, on a tributary of the River Dee, served Wrexham, Holt and the surrounding villages. Steam power may have revolutionized textile manufacture and heavy industry but water power continued to be extensively used until the coming of electricity.

35

Mapledurham, Oxon. Another placid mill scene beautifully composed by the photographer. Still summer days such as this were ideal for the man from Friths. He could set up his tripod on the bank, catch the reflections in the mill pool, and pose his figures to add interest to the scene. The bright sunlight enabled him to reduce exposure time, always a problem when a picture included people and animals. It is interesting that the man on the cart is filling the barrel with water from the pool. We do not know whether this was intended for drinking or for other purposes (irrigation perhaps – for crops had to be watered by hand in hot weather) but we have to keep at the back of our minds those appalling outbreaks of diseases like typhus, often carried in polluted water.

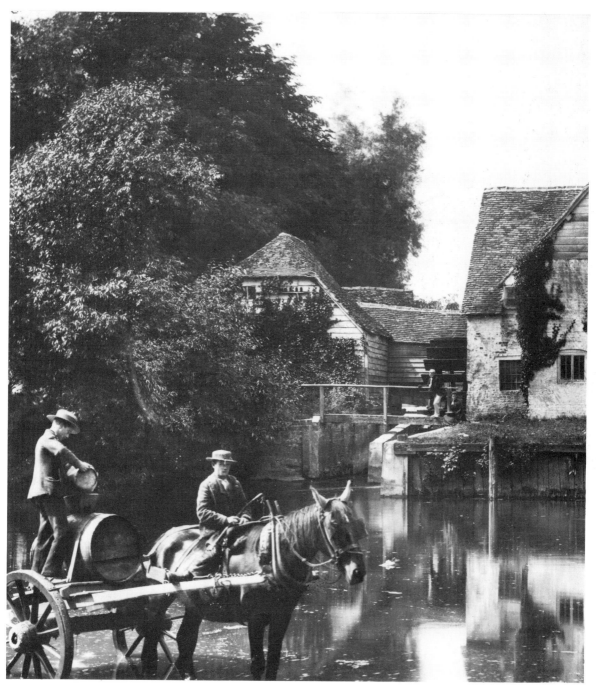

35

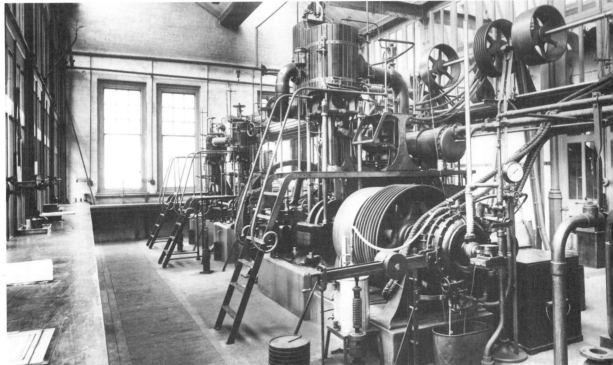

36

37

Britannia Bridge, Menai, Anglesey. Frith took many pictures of bridges because to the Victorians they had a special significance. They were the most striking and ubiquitous proofs of native engineering genius. Major building projects occupied more labour than any other single industry. The Britannia Bridge on the Chester and Holyhead Railway was opened in 1850 and was a major tourist attraction in its own right. Built by the formidable team of Stephenson and Brunel, its massive iron tubes had to be floated out into the river on special pontoons and raised into position by hydraulic presses. Each section of tube weighed almost 2000 tons and millions of cubic feet of masonry went into building the piers. Over 1500 men were employed on the project, some of whom were killed in the course of construction.

36

Owen's College, Manchester. The exhibition of electric lighting in the Crystal Palace in 1882 may be said to have marked the arrival of electricity in British life. In the same year the first power station was opened at Holborn Viaduct in London. And a few months earlier Parliament had passed an Electric Lighting Act, empowering municipal authorities to establish local supplies. Yet there were many problems to be overcome before the new power could be brought into homes, offices and factories. A means had to be found of producing alternating current. Generators had to be built and sources of power found to drive them. One of the places where the necessary experiments were carried out was at Owen's College. Founded in 1870, this was one of the first institutions devoted to the study of science and technology. It later became Manchester University.

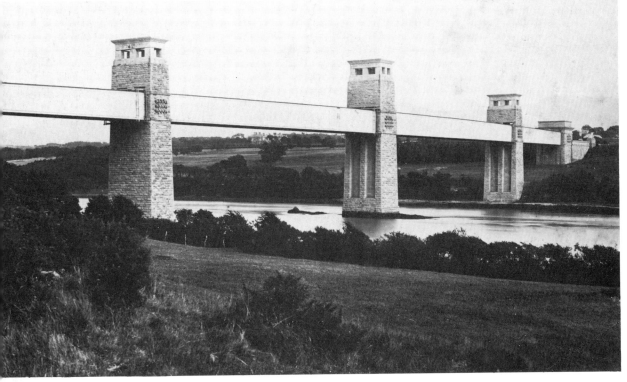

37

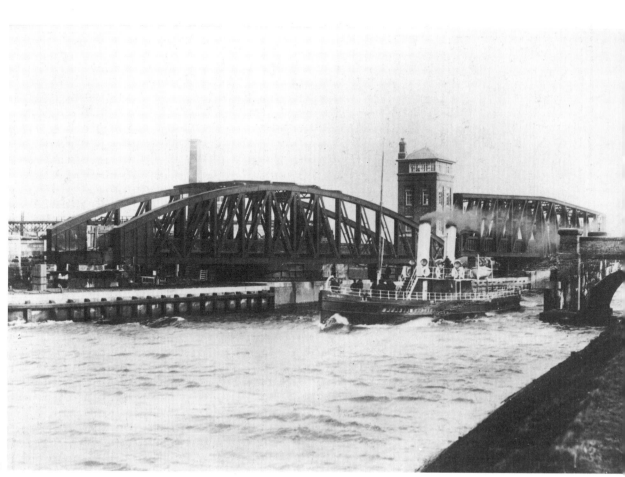

38

Barton Bridge, Manchester Ship Canal.
Commercial expansion and the engin-
eering enterprise it fostered continued
to the end of the century. In 1894 the
36½ mile-long Manchester Ship Canal
was opened to convey the produce of
Manchester's expanding textile in-
dustry to Merseyside. Thus Britain's
last major canal was built fifty years
after the railways had – supposedly –
'killed' the inland waterways. The
canal could accommodate much larger
ocean-going vessels than the audacious
little *Manx Fairy* here seen passing the
swing bridge.

2
...AND AT PLAY

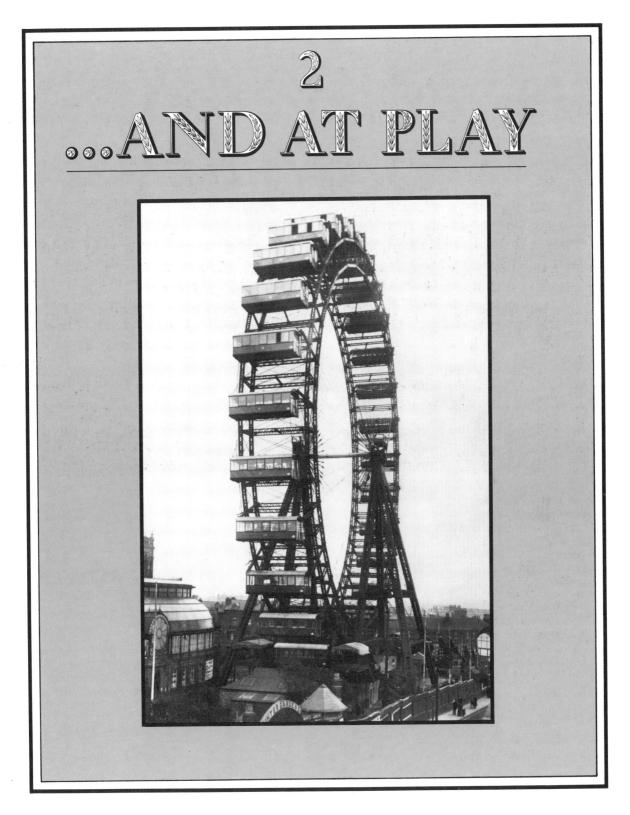

'Workmen usually labour six days in the week and each day the hours of labour are from six to six in the factories and from eight to eight in other occupations, with one hour and a half for meals, and shorter hours on Saturday.'

That report by an economist in 1867 indicates the slow progress of regulations governing hours of labour. Sunday was, by tradition, a day of rest and to this an Act of Parliament of 1850 added a half day on Saturday for textile workers. This spread to many other industries. The fight for shorter working hours was taken up by the burgeoning trade union movement and by the end of the century the nine-hour day was established throughout much of British industry. Additional holidays had also been secured by many working people. The principal bank holidays were established by Parliament in 1871 but it was largely the force of tradition that secured a major summer break for most working people. Local festivities such as Wakes Week were so ingrained that employers dared not ignore them, so that whole factories and mills closed down for one week a year.

Looking through Frith's pictures to see how people used their leisure time one is struck by the appearance of water in so many of them. It was Jerome K Jerome who in *Three Men in a Boat* left us a classic picture of Thames life in the 1880s, with its fishermen and lock-keepers and riverside inns and its wide variety of craft, from sculls and skiffs to pleasure steamers. The wealthy were the proud owners of steam launches, which were anathema to JKJ:

'It was just before the Henley week and they were going up in large numbers; some by themselves, some towing houseboats. I do hate steam launches; I suppose every rowing man does. I never see a steam launch but I feel I should like to lure it to a lonely part of the river, and there, in the silence and the solitude, strangle it.'

His own fascination with water, the author confessed, began in early childhood with 'five of us contributing threepence each and taking out a curiously constructed craft on the Regent's Park lake'. Many Victorian boys and girls obviously shared his passion. Many more looked forward with eager anticipation to the annual trip to the seaside. The railway made it possible for working class families to enjoy the coastal resorts that had once been the exclusive patronage of the well-to-do. This, of course, changed the character of these fast growing towns. In 1850, Victoria complaining of a lack of privacy, sold the Royal Pavilion at Brighton and spent her summer holidays on the Isle of Wight instead. Brighton did not miss her. Miles of public promenades were built, scores of new hotels and boarding houses opened, there were three piers and, in 1887, Britain's first electric railway was added to the attractions. In the North, Blackpool mirrored this growth from a quiet spa to a bustling holiday centre with a permanent fairground and its celebrated tower (built in 1895).

There was a growing interest in outdoor sports and athletic pursuits, as a few random dates will indicate:

1839 Henley Royal Regatta founded
1856 The University boat race became an annual London event
1863 The Football Association founded
1877 The first Wimbledon lawn tennis championships
1878 The Bicycle Touring Club (later the Cyclists' Touring Club) founded
1901 The Association of Cycle Campers formed to amalgamate several existing camping clubs.

For the less energetic the 'day outing' with picnic and bat and ball to some place of beauty or interest became popular. The mode of transport was the excursion train, the steamboat or the horse-drawn carriage. Many redundant stage-coaches enjoyed a new lease of life as char-a-bancs (a term applied to horse-drawn vehicles long before the invention of the first motor-coaches).

For the more sedate still, there was the municipal park, which is where our photo-tour begins.

On Ullswater, Cumbria. Looking at this idyllic picture one is irresistibly reminded of Kenneth Grahame's delightful Water Rat. 'There is *nothing* — absolutely nothing — half so much worth doing as simply messing about in boats.' Frith and his colleagues took thousands of photographs of beautiful stretches of countryside. We have only included a few in our selection because such views tell us little about the changing Victorian scene. Yet we do well to pause at a picture such as this to admire the high standards of artistic composition and the skilled technique of handling various textures which Frith instilled into his trainees.

39

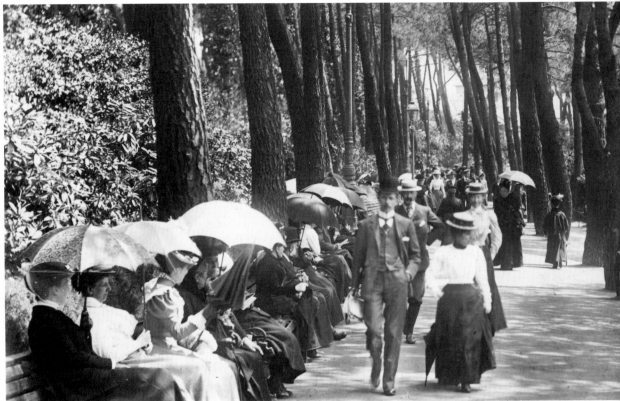

40

41

Children in Shrewsbury, Salop. One group
of society impervious to fashion was
children. This detail from a photo-
graph of the Stone Pulpit, a celebrated
local landmark, demonstrates the
growing confidence of the photogra-
pher in handling posed groups. It is
notoriously difficult to get children to
sit still and when they are sitting still
they look unnatural. Frith's man, in
this 1891 view, has induced his sub-
jects to be immobile but, yet, to look
natural. And what more natural than
boys playing on a building site, to the
detriment of their clothes. Surely,
seconds after the exposure, these lads
must have been clustered round the
photographer, prodding his equip-
ment, wanting to know how it worked
and what was underneath the black
cloth.

40
Invalids' Walk, Bournemouth, Dorset.
Such a scene might have been observed on any summer Sunday afternoon, in any park, in almost any town or city – ladies and gentlemen, shopgirls and domestic servants, factory hands and office clerks, all taking the air, but shielding their bodies from the sunshine by encasing them in clothes from neck to toe and hoisting protective parasols. The Victorians shunned direct sunlight as eagerly as we seek it: '. . . got to the Abbey by 9.30 but by that time, even, the sun was very fierce and we were glad to keep in the shade' [Frith Papers]. However, the fact that the scene is in Bournemouth adds to the significance of this Frith view.

Bournemouth was a deliberate creation of builders and landowners, speculating in the new fashion for seaside holidays. Early in the century Lord Tregonwell chose a deserted stretch of Dorset coast to build himself a summer residence. By 1851 Bournemouth was a village with a population under 700. Then the development really started: summer homes for the wealthy, miles of seaside promenade, two piers, boarding houses and parks. The railway arrived in 1870, responding to the boom and accelerating it. By 1890, when it was incorporated as a town, Bournemouth had a population of 37,000 – and it was still growing.

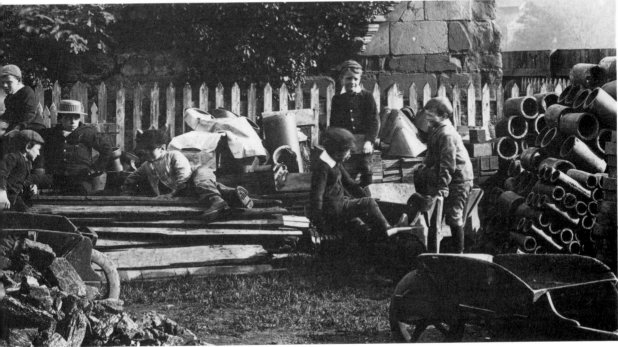

41

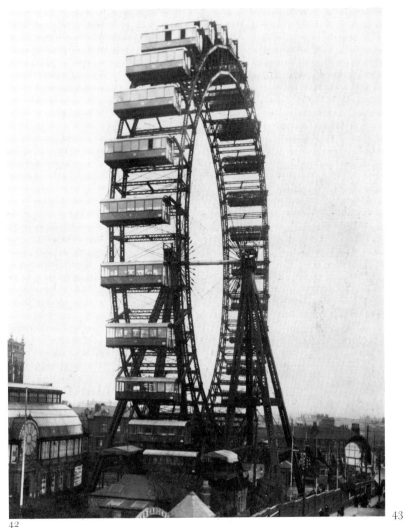

42

43

The Winter Gardens, Blackpool, Lancs.
Theatrical displays, pageants and spectacles of all kinds flourished throughout this period. Every town of any size had its live theatre and probably a music hall, too. At Blackpool the Winter Gardens was built to house attractions of all kinds throughout the year. Newsome's Circus also seems to have had a permanent site in the town. The major spectacle it was offering patrons in 1890 was an enactment of scenes from the Irish potato famine of half a century earlier. Unlikely as such a subject might sound, it perhaps attracted members of the immigrant Irish community in the north-west, who could cheer at 'The Attack on the Prison Van and the Rescue of John O'Connor'. For the doubtful it was, perhaps, reassuring to know that the Lord Mayor was attending one of the performances.

43
The Big Wheel, Blackpool, Lancs. Another major attraction at Blackpool was the Big Wheel, opened in 1896. It was one of the first large, permanent fairground structures to be seen in this country. It could accommodate up to 900 visitors at any one time and carry them 220 feet into the air for a panoramic view of the town. At 6d (2½p) a time it was not a cheap ride but people in this picture are queueing up for the experience.

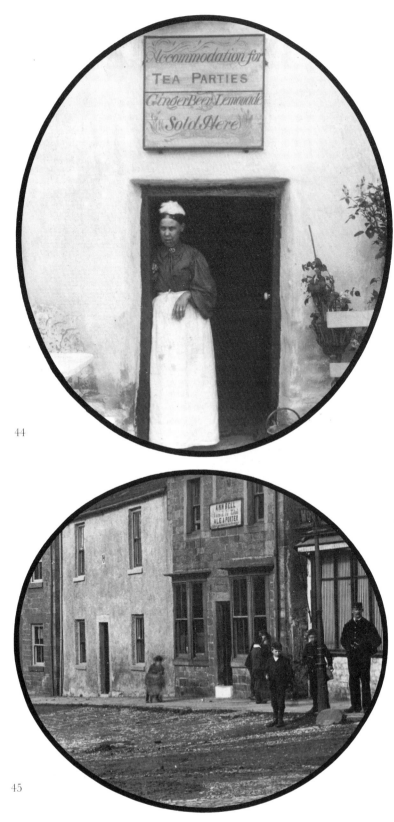

44

45

44
Eyre Cliffs Cottage, Bridport, Dorset. Everyone wanted to cash in on the growing tourist industry – and why not? Life for many country people was bleak enough. The opportunity to attract passing travellers (perhaps on day trips from Weymouth or Bournemouth) with home-made lemonade and ginger beer and 'teas' was not to be missed.

45
Public House, Galgate, Lancs. Tea and lemonade, of course, were not to everyone's taste. The common resort for working men seeking relaxation was the pub where 'Ale and Porter' were on tap. Porter was a strong, dark, cheap beer made from partially-burned malt and probably so named because it was a favourite drink with porters and other labouring men. Alcohol abuse was one of the greatest social problems throughout the period. Various governments tackled the licensing laws and the issue aroused great passions on both sides, brewers, publicans and defenders of personal liberty taking issue with religious groups and social reformers. Various organizations existed aimed at securing legal prohibition and total abstinence, the biggest of which was the Church of England Temperance Society, founded in 1862.

46
Beside the lock, Chertsey, Surrey. Another example of how Frith's photographers brought a topographical view to life with added human interest. The boys with their magnificent model yacht have paused in their play, perhaps because a vessel is about to emerge from the lock.

47
Landing place of the George Hotel, Bray, Berks. A few miles up the Thames another group of youngsters also enjoy riverain pursuits. Bray, once the home of the celebrated, coat-turning vicar, is close by Maidenhead which Jerome K Jerome dismissed as 'too snobby to be pleasant . . . the haunt of the river swell and his overdressed female companion.' Perhaps the self-assured young fisherman was the son of such parents. He certainly appears to be quite a smart young gentleman.

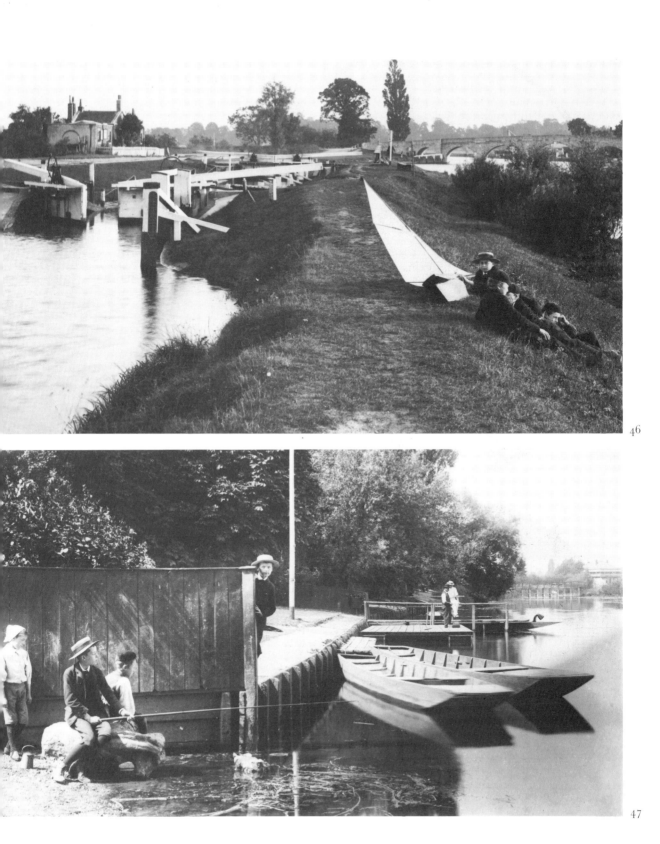

46

47

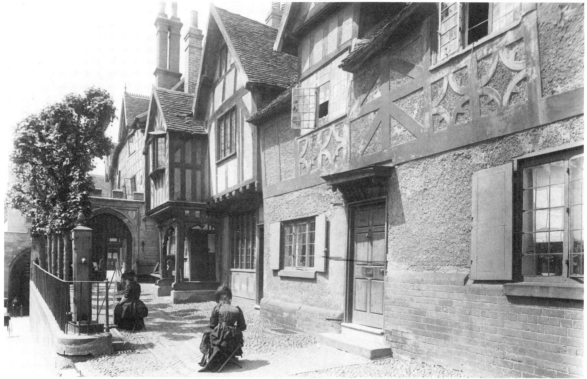

48

49

48
Lord Leycester Hospital, Warwick.
Drawing and painting were considered
suitable pursuits for young ladies and
they certainly formed an excellent
focal point for the artist with the
camera. In an age when thousands of
middle- and upper-class ladies were
denied professional outlets for their
talents and abilities many achieved
considerably high standards in a
variety of skills such as music, draw-
ing, crochet, modelling and tapestry.
Some, like Julia Cameron, even took
up photography.

49
Burnham, Bucks. Golf was an ancient
game but one which gained enor-
mously in popularity in the second
half of the nineteenth century. Several
links were built in the vicinity of new
population centres, easily reached by
members of the commercial middle
class who lacked the leisure to indulge
the traditional gentlemen's pursuits
of hunting, shooting and fishing. The
game became popular for women,
too, and the Ladies' Golf Union was
founded in 1893.

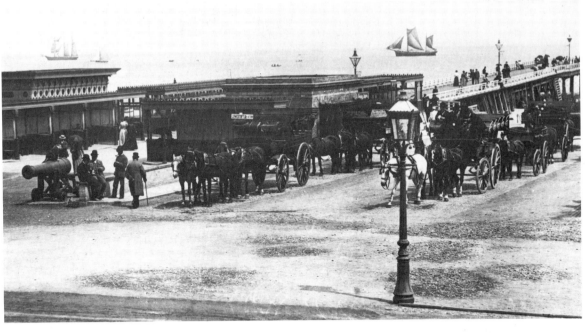

50

51

50
The Jetty, Great Yarmouth, Norfolk. A coach outing was an important part of any seaside holiday. At Great Yarmouth there were fleets of carriages – some open, some closed – ready to take sightseers to Lowestoft, Cromer and other destinations.

51
Pleasure steamer, Bowness, Cumbria. Back to Bowness for a type of outing that was even more popular – a tour of the lake by steamer. One look at the well-filled craft proves the popularity of this form of leisure activity. The invention of powered vessels meant that, for the first time, large groups of people could travel on inland waters in comfort and safety without being at the mercy of wind and current. The Lake District was an increasingly popular region with holidaymakers from the industrial sprawls of the north-west.

52
53

The Gardens, Buxton, Derbys. What a
sedate game lawn tennis was in the
1880s – long skirts and bustles, bonnets
and caps to prevent the faces of ladies
and gentlemen acquiring a coarse, un-
fashionable tan, and all players lobbing
the ball gently back and forth from
the base line. No wonder the spectators
are not exactly riveted by the games
in progress! The gentlemen's doubles
match attracts some attention from a
group of friends but the photographer
is of more interest to the two young
ladies peering coyly from beneath their
parasol. The dimensions of the court
and the height of the net had only
recently been finalized after a decade
of experiment by the All England
Croquet and Lawn Tennis Club at
Wimbledon. But that decade had seen
the game catch on rapidly all over the
country and the Lawn Tennis Associ-
ation was founded in the same year as
this photograph – 1886.

53

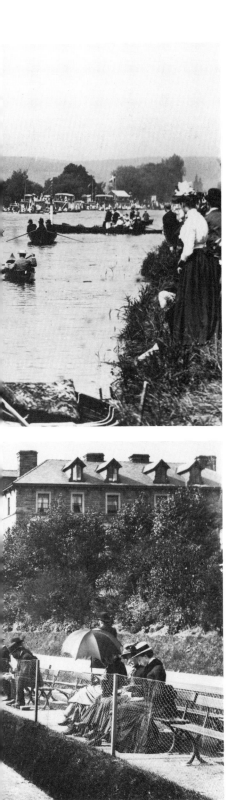

52
The Regatta, Henley-on-Thames, Oxon.
Henley Regatta was founded in 1839.
Under royal patronage from its in-
ception, it proved immensely popular,
and one of the most interesting points
to note from Frith's photographs of
the event is the crowds. Large numbers
of people turned out to watch, not
only from the banks but from a variety
of oared craft. The Thames was the
cradle of international rowing as a
sport, but clubs sprang up all over the
country and were popular among all
sections of society.

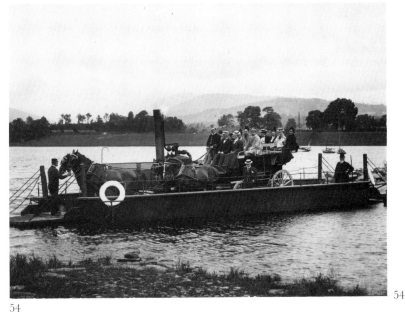

54

The Ferry, Bowness, Cumb. A coach out-
ing in the last years of the century
was, I suspect, an opportunity to com-
bine a day in the country with an
indulgence in nostalgia. Few if any
of the people in this picture could
remember the days when the stage
coach regularly plied the highways
and the post horn heralded its ap-
proach. The sleek bays, the brightly-
painted equipage and the smart,
liveried coachmen gave them a taste
of the world of their parents and grand-
parents. It gave the photographer a
marvellous opportunity to capture a
rare combination of steam-powered
and horse-powered transport. So far
from languishing as a craft, coach-
building flourished throughout most
of the period. Pleasure-coaches were
built for many local operators and
hotels, and four-in-hand clubs were
founded for people who wanted to
take driving up as a sport. This ferry
crossed the middle of Lake Winder-
mere and was a vital time-saver for
holidaymakers headed for Hawkshead,
Coniston Water and the more distant
coast.

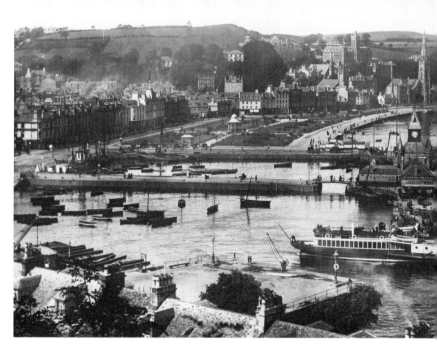

Speedwell Cavern, Castleton, Derbys. The growth of tourism of all kinds – cycling, walking and camping holidays, day excursions, etc – led to the exploitation of all manner of potential attractions. Castleton, in the Peak District, is set among hills labyrinthed with caves and old mine workings. It was in the 1880s that someone had the idea of attracting visitors to these fascinating underground chambers and charging for the privilege of being escorted into 'The Grand Speedwell Cavern' and dropping pebbles in 'The Bottomless Pit'. Note, again, the excellent composition of the picture with the group of sheep forming the focal point from which the lines of walls and scarps carry the eye out to the edges.

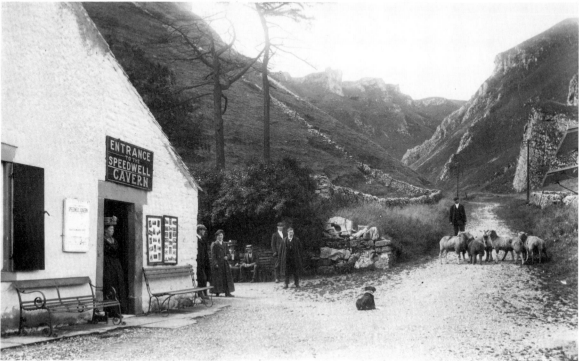

56

55
Rothesay, Strathclyde.

'In search o' lodgings we did slide
Tae find a place where we could
 bide.
There were eighty-twa o' us inside
A lodging hoose in Rothesay-O.
We all lay doon tae tak our ease,
When somebody happened for tae
 sneeze
And wakened half a million fleas,
The day we went to Rothesay-O.'

As the old song suggests, Rothesay, on the Isle of Bute, was a favourite resort for Glaswegians, and steamers plied up and down the Clyde to take families for day outings or longer visits. Frith's photographer has caught well the bustling activity of the port. The picture shows the largely nineteenth-century growth of the town. In the summer season steamers plied on various tours to the kyles of Bute, Arran and Inverary.

55

57
Bourne End, Berks. Here are the steam launches to which Jerome K Jerome took such exception, moored opposite the premises of Shaw and Sons who proudly proclaim themselves as builders of the contraptions. Both privately owned and hire craft plied Britain's inland waterways. And quite a noise and a stink they must have made, with their long funnels pouring smoke across the calm surface of the river where other pleasure seekers preferred the slower, quieter progress afforded by row-boat or punt.

57

58

59

60

Totnes, Devon. Another magnificent picture showing the Englishman's love of water. This time the centre of attraction is the *Totnes Castle*, a paddle-driven pleasure steamer plying between Totnes and Dartmouth. Passengers have arrived and are being met by horse-drawn transport. Other revellers crowd into smaller boats. Notice especially the man in the canoe by the slipway. This energetic sport was another development of the period, and was organized by the Royal Canoe Club, founded in 1866.

St Catherine's Ferry, Guildford, Surrey. An increasing number of private pleasure-craft owners spent holidays on the river in steam launches such as this, or in houseboats which were towed to their moorings much as modern caravans are towed by motor cars. Like caravans they varied in the luxury of their appointments. The best were sumptuously fitted out and comprised suites of reception rooms as well as sleeping and kitchen quarters.

Bognor Regis, Sussex. In fact, the 'Regis' was not added until 1929, when King George V recuperated there from an illness. The resort was made fashionable at the very end of the eighteenth century but, like Brighton, its character changed over the ensuing decades. Yet even in the 1880s and 1890s it was still one of the more genteel resorts. Bathing machines were still very much in use, enabling ladies and gentlemen to change privately into their exceedingly modest bathing dresses and then enter the water without exposing themselves to other beach users. However, one of them seems to be being used as a beach hut, drawn up to the top of the shingle while its hirers desport themselves around it. The number of actual bathers was few and not many people learned to swim. Paddling was as close as most children got to a real 'dip'.

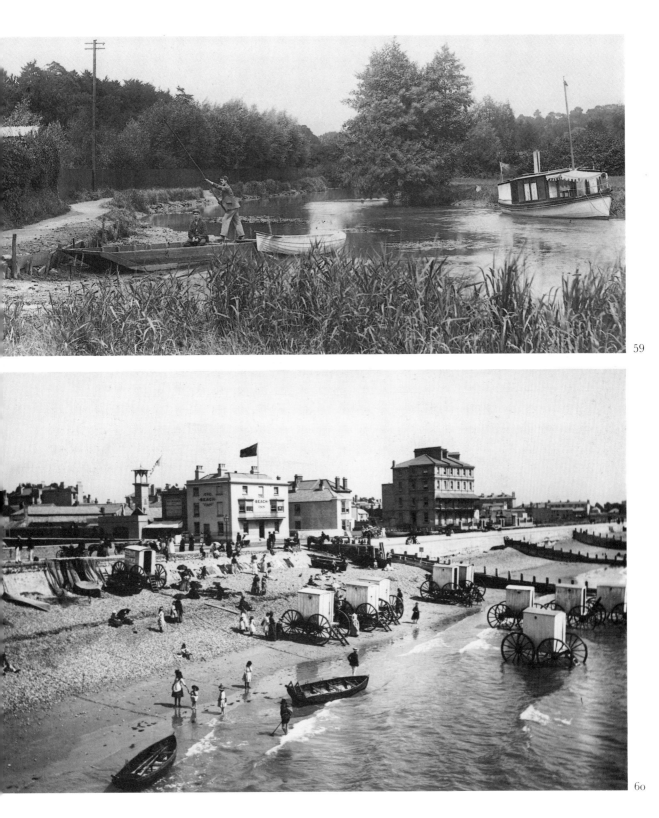

59

60

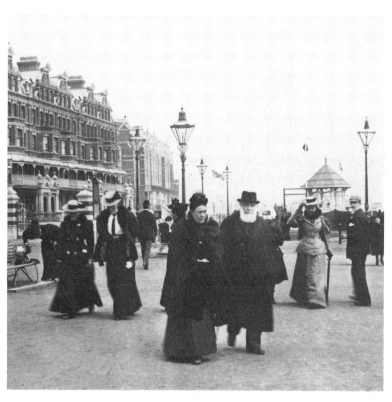

61

61
The Marina, Bexhill-on-Sea, E. Sussex. Promenading was a more important part of a seaside holiday, especially for older citizens. The 'ozone' was thought to have health-giving properties whereas sunlight was positively harmful. Bexhill was a late starter in the seaside resort stakes. The sea front development – half a mile from the original hilltop town – took place in the 1880s.

62
North Bay, Scarborough, N. Yorks. The connection between health and holiday was a vital one in the development of the seaside resort. Scarborough, the largest such centre on the north Yorkshire coast, grew into a spa because of its mineral springs. Later developers also stressed the efficacious effects of sea bathing. To these natural attractions the nineteenth century added promenades, ballrooms, cliff tramways and gardens.

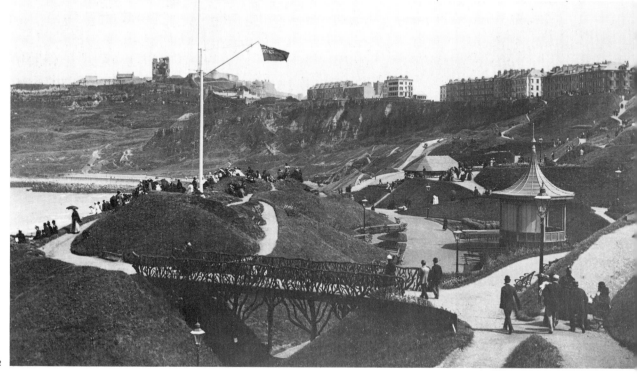

62

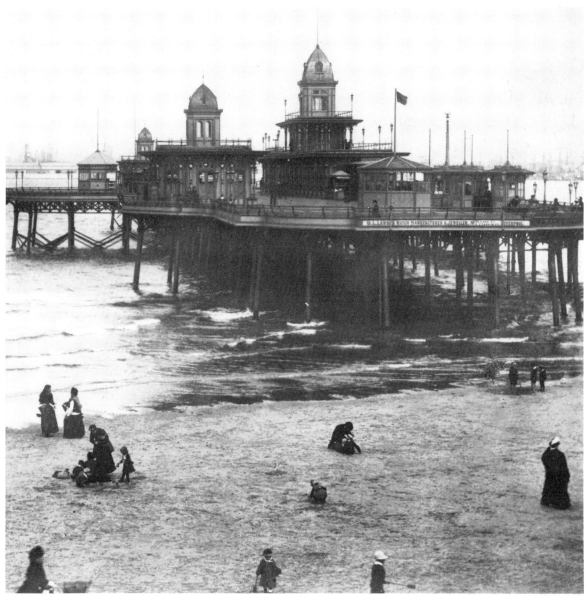

63

The Pier, New Brighton, Merseyside. The pier was a distinctively British invention. The first of these 'overgrown jetties' was built at Brighton in 1823. Thereafter, no self-respecting resort could afford to be without one. But New Brighton was in a special category: it was a deliberately created resort for the hundreds of thousands of people who lived and worked on Merseyside. During the period Liverpool's population grew from 376,000 to 704,000, while Birkenhead mushroomed from a village to a sprawling mass of boilerworks and shipyards. The local civic leaders were sufficiently aware of the needs of the industrial masses to encourage the development of a resort at the northernmost tip of the Wirral peninsula. Building speculators were not slow to respond and New Brighton, consciously designed to rival the Sussex resort, was built in the 1870s and 1880s. North Wales miners resorted to New Brighton sometimes for unofficial holidays. This became something of a problem as the *Carnarvon and Denbigh Herald* reported: '. . . as many as 150, we are told, have frequently announced their intention of going away for an excursion for a day. . . . We have heard it stated that as many as 2,300 days have been lost to the proprietor in one month' (12 January 1878).

St Ives, Cornwall. What a very well-behaved bunch of children! Perhaps they were members of a Sunday-school outing, all in their best clothes, posing for the photographer. The linking of St Ives to the main railway network in the 1880s probably came just in time to save the town from serious decline. The disappearance of pilchards from adjacent waters was a blow to the fishing industry while, at the same time, tin mining, the other principal activity, was waning because of the exhaustion of the shallower seams. But holidaymakers took the picturesque harbour and winding streets to their hearts and St Ives began its transformation into a tourist and artistic centre.

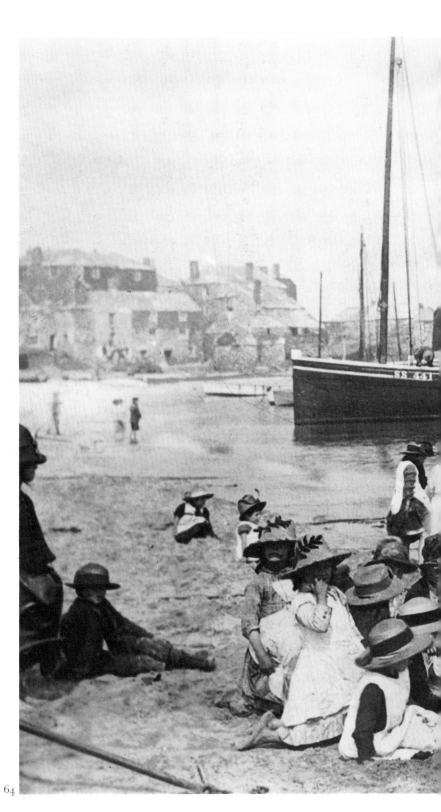

64

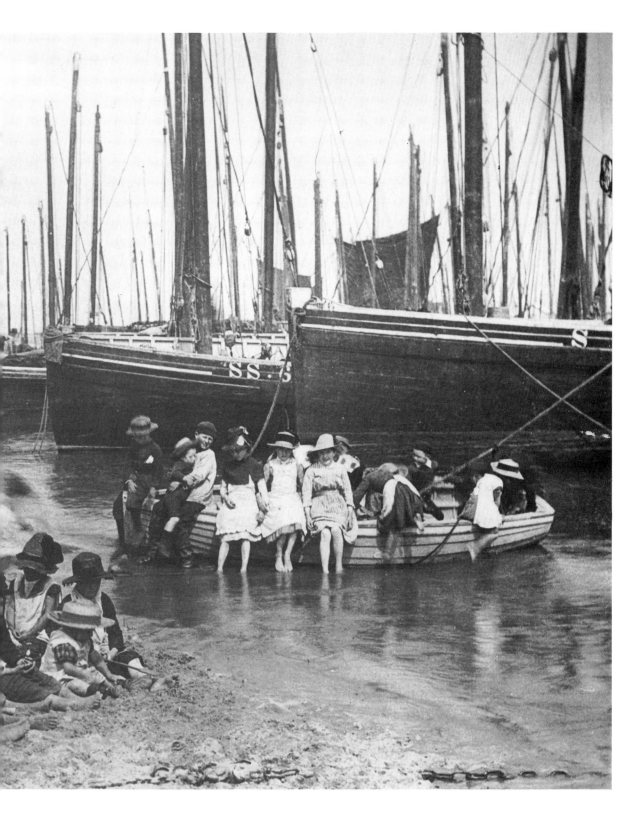

65

Rice Bridge, near Reigate, Surrey. Perhaps this contented group enjoying the tranquillity of the River Mole are members of Frith's own family. Certainly the photograph was taken not far from his home and business headquarters. Angling increased enormously in popularity throughout this period and clubs were formed all over the country. It was a relatively inexpensive sport and provided an escape from the noise and smoke of industrial towns to the peace of the countryside. Techniques and equipment improved: the development of silk lines, reels and bamboo rods (as opposed to those made of native woods) can all be ascribed to the period 1870–1900.

3
TOWN AND COUNTRY

The half century 1850–1900 saw more new building in Britain than any comparable period before and, probably, since. Factories, railway stations, urban dwellings, schools, colleges, hospitals, suburban housing, municipal buildings, churches, chapels and country mansions for the *nouveaux riches* – every conceivable kind of construction project was undertaken, and the face of the land changed drastically. Of course, virtually all this development occurred in the towns, as a few random statistics suggest.

Urban population

	1851	1901
London	2,362,000	4,536,000
Manchester	303,000	645,000
Nottingham	57,000	240,000
Edinburgh	160,000	317,000
Southampton	35,000	105,000

Towns grew inevitably to accommodate the population but the era of haphazard growth, jerry-building and the proliferation of slums was coming to an end. A new civic pride was emerging, personified in Joseph Chamberlain, mayor of Birmingham, 1873–6. During his time as mayor and councillor, slums were cleared and parks laid out, a library and art gallery were built, gas and water supplies were extended and brought under municipal control. Private benefaction went hand-in-hand with public planning: fountains, horse troughs and statues graced the streets.

It was far different in the country. Paradoxically, the railways which brought new life to some areas made others more remote than they had ever been. As the new communications systems sapped life from the roads and inland waterways, hamlets, villages and small towns that had relied on the passing trade found themselves isolated.

'The Crooked Billet Hotel and Posting-house on the Bushmead road had been severed from society by the Crumpletin Railway. It … fell from a first-class way-side house at which eight coaches changed horses twice a day into a very seedy, unfrequented place' [R. S. Surtees, *Ask Mamma*]. So wrote Surtees in 1858 and, although

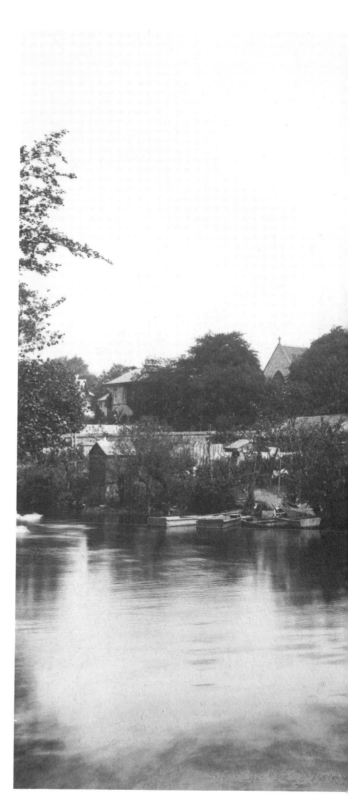

Ringwood, *Hants*. Francis Frith and Co played an important part in the creation of the English rural myth. A basically urbanized population looked to its bucolic past with nostalgia and the photographer provided idyllic views to support that nostalgia. In such scenes as this are encapsulated all that the late Victorians and their successors came to think of as the 'typical' English village – the neat rows of white-painted cottages, the thatcher engaged in his centuries-old craft, swans on the river, the church looking down on the little community and everywhere timelessness and peace. Before long town dwellers would start returning to the country and actually begin creating such idyllic scenes, until much of southern and midland Britain became studded with 'chocolate box' villages which bore no relationship to the working communities of the past.

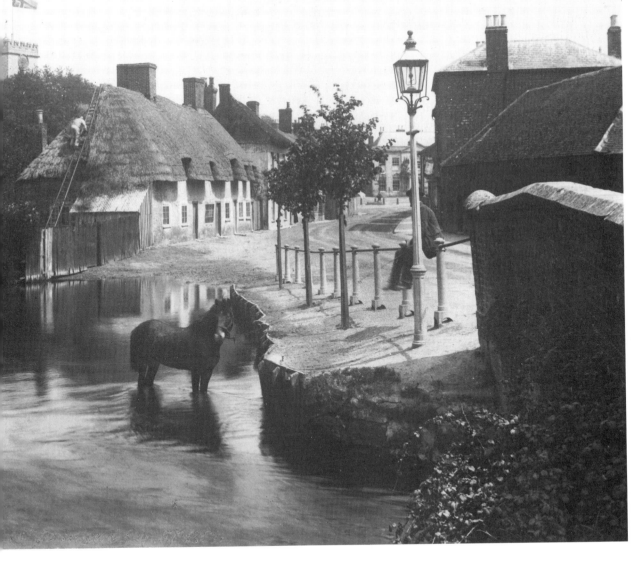

66

his Crooked Billet was an imaginary hostelry, there is no doubt that it represented a very real phenomenon. This was just one contributory factor to hardship experienced by many in the rural areas, where poverty and extremes of wealth were more marked than in the towns. Agricultural labourers were the worst paid section of the working class. Landlords worked their estates with fewer men, thereby increasing profitability at the cost of the rural community. Agriculture was badly hit by cheap food imports from the late 1870s onwards and the drift from the land accelerated. The total number of farm workers dropped from around 1,000,000 in 1875 to 690,000 by the end of the century. The 'great house' families lorded it over local society and the more prosperous tenant farmers formed a rural middle class. Many of the peasants lived in old, insanitary, rat-infested dwellings, worse than any city slums, a fact we do well to remember when we admire the neat, thatched, tarted-up cottages that modern owners have made of those dwellings.

The smaller towns and larger villages had few amenities. Street lighting (gas) was fairly wide-spread by the end of the period, though often inadequate, with long, dark stretches between the few small pools of light. Town streets were paved or cobbled but such luxuries had, by no means, reached the smaller communities. The decline in traffic and the disappearance of the old turnpike trusts caused many cross-country roads to deteriorate. Even some major highways became overgrown. Piped water and drainage were rare outside the cities. Drinking water came from wells, pumps and ponds. Polluted water and insanitary conditions were largely responsible for the frequent epidemics of typhus, cholera, typhoid and other enteric diseases.

Public health was a major concern but governments were reluctant to set up effective local authorities with powers to control housing, sewers and water supplies, and it was not until 1875 that an Act came into force which enabled an effective start to be made on tackling the problem. But long before that private and public measures had been taken about the cure, if not the prevention, of disease. Many hospitals were built, in both town and country, often by voluntary subscription. Treatment was, in most cases, financially-aided and, in some cases, free.

One casualty of the drift to the towns was church life. Though there was considerable Christian work among the urban population (notably by the Salvation Army and Church Army) old patterns of worship were broken and moral problems, such as alcoholism, were on the increase. Frith and his associates took thousands of pictures of picturesque parish churches but one scans the photographs in vain for evidence of vigorous religious activity.

Mary Ann Frith gives us a delightful glimpse of the slow pace of country life in her journal. She is describing a visit to a remote Friends' meeting house in the Lake District: 'We drove to Newlow and put up the horse there, and walked for nearly 2 miles up hill. The old Friend who has the care of the Meeting House and farms 32 acres of land belonging to Friends, was at work in his garden. He asked us the time, for in that out-of-the-way place they are not very correct time-keepers'.

Dorchester, Dorset. The reality of life in the countryside was different from the neat picturesqueness of popular myth. The thatch is mossy and patched, the pool stagnant, the environs of the house littered with carts, tools, makeshift hencoops and untidily-stacked firewood. This is the home, probably rented, of a family trying to scratch a living from the land during a period of unprecedented agricultural decline. Falling prices depressed employment and reduced the area under cultivation. In 1871 8,250,000 acres were under the plough. Thirty years later this had fallen to 5,750,000 acres. Some of the unploughed land simply returned to a state of nature, some was given over to stock farming – which required less labour.

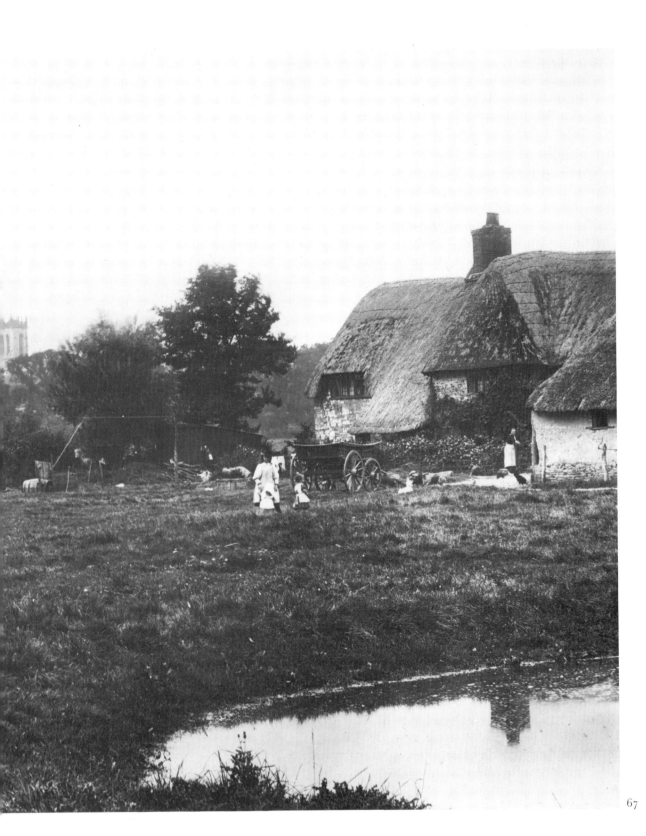

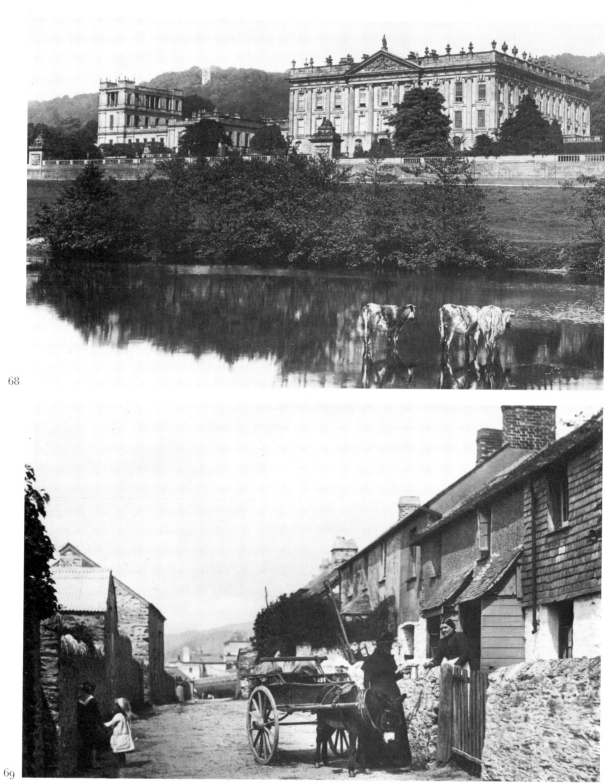

68

69

68

Chatsworth House, Derbys. In rural Britain class distinction was obvious to the most casual observer, for it fashioned the landscape. The sixth Duke of Devonshire re-sited Edensor village so that he could not see it from his mansion at Chatsworth, still undergoing expansion and alteration. Thousands of Derbyshire acres were laid to parkland and gardens. While agricultural labourers were among the poorest in the country and their dwellings often little better than hovels, most of the landed nobility and gentry lived in a splendour we now find difficult to imagine.

In 1872 Emma Rothschild wrote about her fine home in Berkshire: 'Tring Park looks beautiful; the grass and the trees are luxuriantly green and the air is perfumed with the smell of hay and the lime trees ... Excepting a walk to the P.O. I've not left the Park precincts which are more entertaining than anything beyond' [c.f. M. Rothschild, *Dear Lord Rothschild*, p.6].

Frith's first photographic forays were to take pictures of such houses.

69

Downderry Street, St Germans, Cornwall. 'It is not ... the growth of towns or decay of agriculture, nor any of the causes usually given for the dullness, the greyness of village life. The chief cause is ... the caste feeling which is becoming increasingly rigid in the rural world ...' [W. H. Hudson, *Afoot in England*].

That gloomy analysis of country life, written in 1903, undoubtedly only tells part of the story, but there was a certain drabness about life in village and hamlet every bit as real as that pervading the tenements of industrial cities, and the constant presence of wealthy landowners in their fine houses must have intensified the depression.

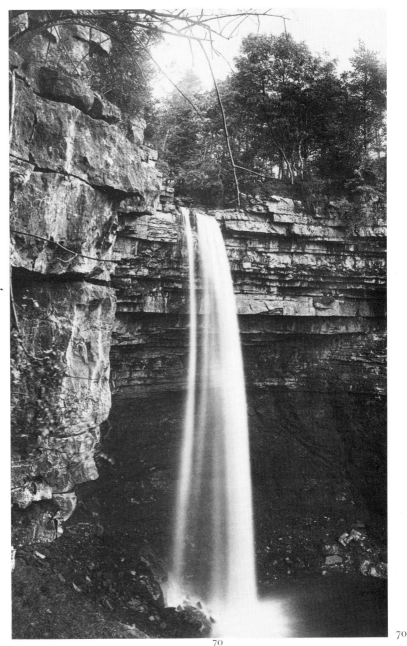

70

Hardrow Foss, N. Yorks. Waterfalls were among the natural phenomena favoured by Frith and his team. They presented quite a challenge to the early photographers who did not have shutter speeds of fractions of a second available to them. This explains why the rapidly moving water appears as a white blur.

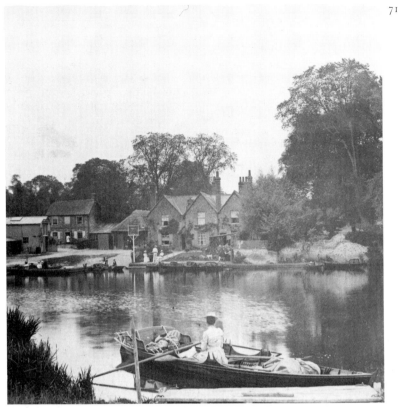

71

The Beetle and Wedge, South Stoke, Oxon.
The Beetle (the word here referring to the heavy implement used for driving home a wedge) and Wedge operated its own ferry across the Thames at Moulsford, there being no bridge between Goring and Wallingford. It was a popular fisherman's haunt. Near this spot Jerome K Jerome and his companions 'fished' an altogether different object out of the river – the body of a young woman. She had had an illegitimate child and been thrown out by her disgraced family. 'For a while she kept both herself and the child on the twelve shillings a week that twelve hours' drudgery a day procured her, paying six shillings of it out for the child, and keeping her own body and soul together on the remainder ... She had made one last appeal to friends, but, against the chill wall of their respectability, the voice of the erring outcast felt unheeded ...' [*Three Men in a Boat*]. It was, indeed, an age in which success was applauded and failure, all too often, condemned.

The Castle, Sherborne, Dorset. Ruins had always exercised a fascination, and Francis Frith photographed several. In this picture of the old castle at Sherborne, given by Elizabeth I to Sir Walter Raleigh who used some of its stone in the construction of a new house, he used figures, probably his own wife and one of his children, to enhance the composition and to convey an impression of scale.

Mary Ann Frith described a visit to some other ruins, Furness Abbey, Lancs: 'Frank made a lot of good pictures, and enjoyed having his family about him. We took the Etna and boiled our eggs and made tea. Oh! how thirsty everyone gets these hot days'

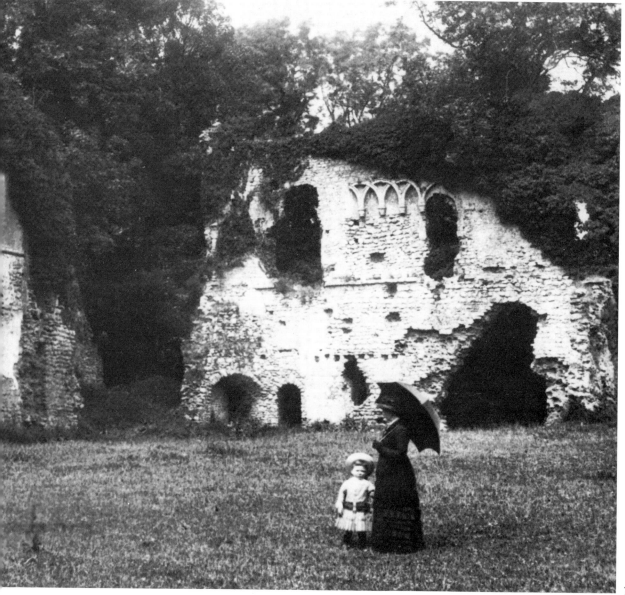

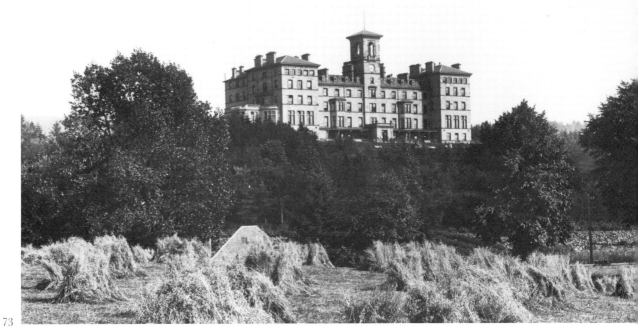

73

74
Arundel, W. Sussex. Almost like a painter producing a composite picture, the photographer has brought together many elements of the rural scene – the old castle, the not-quite-so-old windmill, the cattle peacefully browsing and, in the foreground, taking our eye into the picture, the neatly-thatched hay stack. In the days before mechanization it was less costly in terms of time and manpower to stack the hay in the field where it was cut and close to where it would be needed. The stack then had to be thatched to keep the rain out (moisture in the heart of the stack might generate sufficient heat to start a fire) and fenced to keep animals away.

73

The Hydro, Dunblane, Central Region.
Queen Victoria's love of Scotland
created a fashion and many English
ladies and gentlemen travelled north
for their holidays. Dunblane, a pic-
turesque and ancient town north of
Stirling, gained from this and from
the arrival of the railway. An enor-
mous hydropathic hotel was built for
well-to-do guests to take the waters
and undergo a variety of aquatic cures
for a variety of complaints. Dunblane
was also the centre of an important
agricultural region. Nothing was more
typical of the ageless rural scene than
the stubbly field dotted with stooks of
golden corn. Frith's photographer,
seeking a view which would make a
statement about Dunblane, cleverly
brought together the old and the new.
Francis first visited Scotland as a young
man and 'made undying acquaintance
with Loch Lomond and Glencoe,
with Melrose and Elgin, Dunkeld and
Stirling, Dunblane and Kelso ...
what a land of spirit-stirring and en-
riching scenes ...'

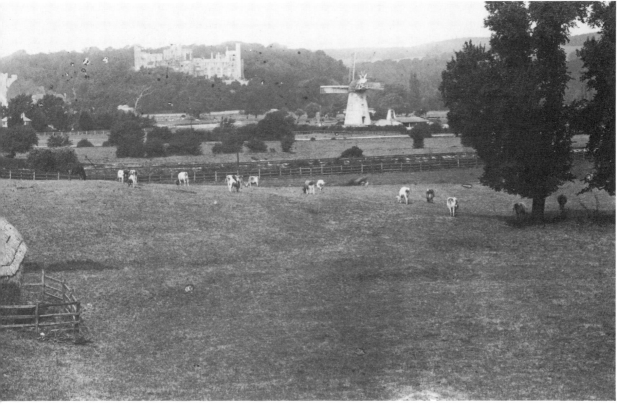

74

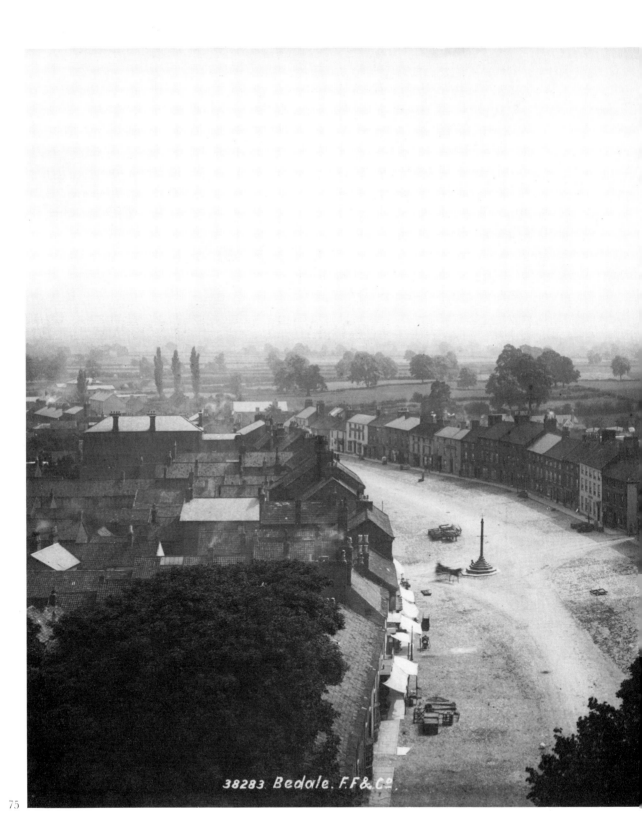

38283 Bedale. F.F& C?

75

Bedale, N. Yorks. This photograph, taken from the church tower, demonstrates the remarkable accuracy of detail which could be achieved by the calotype process. Indeed, although photography has made enormous advances in the last hundred years no method is as capable of accurate magnification as the glass-plate method. This view shows at one sweep the whole village – the streets of tiled houses running down to the unmetalled, unlit high street with the village cross at its centre. By enlargement we are able to see the cross in detail. A pony and trap pass by. Trestles have been laid out, perhaps for a street market. The pub opposite has stacked barrels outside ready for collection by the brewer's dray.

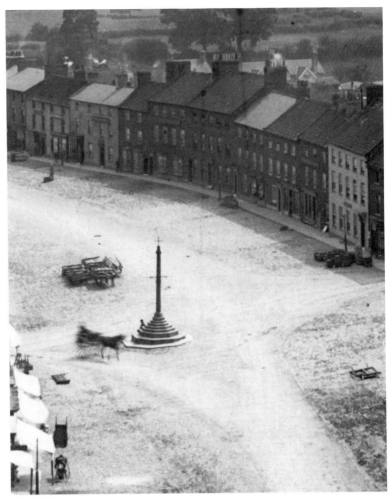

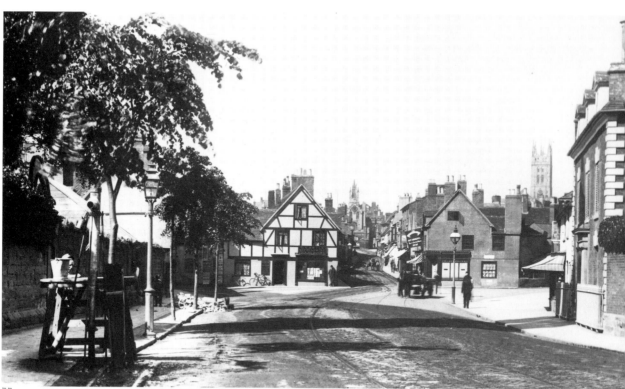

76
77

The Cottage Hospital, Totnes, Devon.
Public health was an increasing con-
cern throughout the second half of
the nineteenth century. After various
bureaucratic experiments, the country
was, in 1872, divided into districts
each governed by a locally-elected
authority responsible for sanitation,
housing standards, food distribution
and medical care. This led directly in
many of the larger towns to the build-
ing of much-needed hospitals. But
public action by no means took over
the entire field of social welfare. Pri-
vate charity was a major contributor,
particularly in rural areas. Cottage
hospitals, like the one at Totnes
(1881), were set up and maintained
largely by private subscription. Local
doctors attended, often charging re-
duced fees. Administration and fund-
raising were frequently in the hands of
some 'Lady Bountiful' from the 'big
house'. It is easy to scoff at such pat-
ronising attitudes but Christian char-
ity was preached as a duty and was
taken seriously by many of the upper
classes.

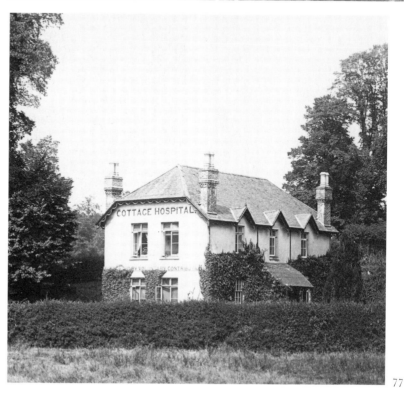

77

76

Warwick. By contrast a country town like Warwick had some 'mod cons' but by no means all. The streets were paved. There was adequate gas-lighting. But the good townsfolk still had to fetch their water from pumps. Note that even a comparatively small town like Warwick had tracks laid for horse-drawn trams. The town is well geared for visitors with establishments such as 'The Castle Refreshment and Dining Rooms' offering 'hot dinners', tea and coffee. Two cyclists have obviously stopped to avail themselves of this hospitality.

78

Burwash, E. Sussex. Life was very similar in this attractive Sussex town but here the photographer has set up his camera for a close-up view of a little corner of Burwash and its inhabitants. The passers-by have all stopped to pose except for the woman busy looking over the buckets, spades and galvanized iron baths of the hardware shop. The housewives have paused in their gossipping; the children have stopped bowling their hoops; all attention is focused on the man with the camera. Note the many layers of clothing worn even by the children. The open windows indicate that it is a warm day but coats, hats and layers of petticoats are the order of the day. It was to Burwash that Rudyard Kipling, that advocate of Victorian values, came to live in 1902.

78

79

Convalescent home, Lowestoft, Norfolk.
Recovery from illness or surgery was a
slow process. Unaided by drugs, the
body had to recover its own equilib-
rium. Thus the convalescent home
was usually situated in a coastal town
where the inmates could take advant-
age of 'sea air'. The pampered relax-
ation of such homes could only be
afforded by the moderately well-to-
do.

The Friths shared the prevailing
belief in the efficacy of sea air. One of
their children was delicate and in
Mary Ann's diary for 3 January 1874
we read, 'We came to this charming
place (Heathside, near Poole, Dorset)
on 1st August last year on Mabel's
account and are staying here through
the winter.'

79

80

Bath, Avon. This is a remarkable pan-
oramic view and shows that the Vic-
torian camera could depict clearly and
without a refocusing of the lens dist-
ant and close objects. Bath was one of
the few cities which experienced com-
paratively little change throughout
the period. Long-established as a spa
town and having a population of
54,000 at the middle of the century it
continued its sedate way until the end
of the Victorian era when its popu-
lace had decreased slightly to around
50,000. Its great heyday as a fashion-
able resort was past but it still en-
joyed a clientèle of regular visitors,
come to take the waters, and its essen-
tial *raison d'être* had not changed.
Undoubtedly, some of its residents had
been attracted to nearby, booming
Bristol whose population almost
trebled in the same period.

80

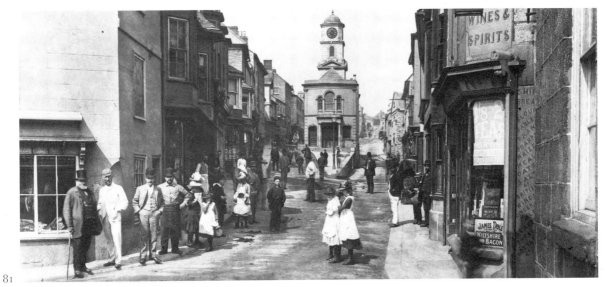

81

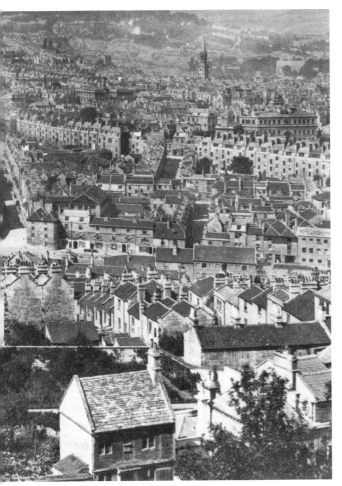

81

Penryn, Cornwall. Frith and Co photographed many street scenes in small towns the length and breadth of the country. We have chosen just a couple which show a cross-section of people and the surroundings in which they lived. The town was built of granite, the local stone, the quarrying, dressing and exporting of which was also the basis of the town's economy.

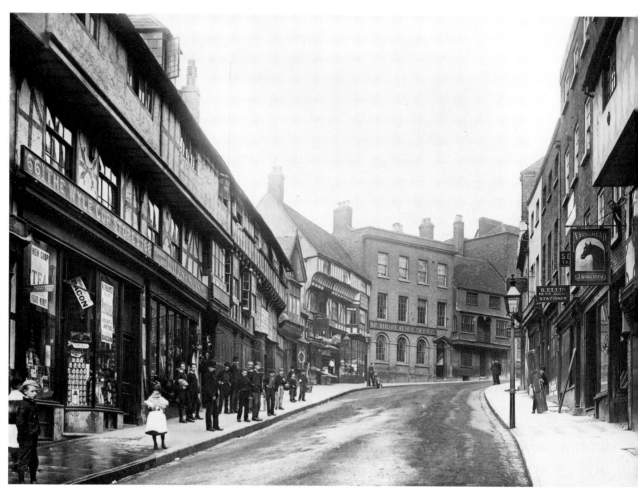

82

82

Shrewsbury, Salop. There were fewer
people about when this photograph
was taken. It seems to have been near
closing time for the boy on the right is
putting up the shutters of Mr Ellis's
shop and no one is entering or leaving
the well-stocked grocer's. The half-
timbered Nag's Head has not opened
its doors yet but the ominous portals
of the Inland Revenue Office gape
ever wide. Most people actually had
to go and pay their taxes in person.
The street is well-swept and ade-
quately lit.

83

*The Church of St Mary and St Nicholas,
Wilton, Wilts.* Frith and Co photo-
graphed hundreds of churches. Relig-
ious life flourished, at least among the
wealthier classes and those aspiring to
their ranks, and one proof of this is the
considerable refurbishing and 'im-
proving' of parish churches. Many
new churches were built, most of
them in the prevailing Gothic style,
the Victorians apparently believing
that any modern church had to be
made to look like a medieval one.
However, when the Earl of Pembroke
provided Wilton with a new church
he indulged the architects, Thomas
Wyatt and David Brandon, who had
a fancy to build in an Italianate style,
making free use of mosaic and other
'foreign' materials.

84

St Peter's, Kirkley, Lowestoft, Suffolk.
This church interior displays one of
the most vigorous developments in
English nineteenth-century religious
life. The Oxford Movement of the
1820s and '30s initiated a high-church
revival within Anglicanism. This
manifested itself most obviously in
ornate ritual and church decoration.

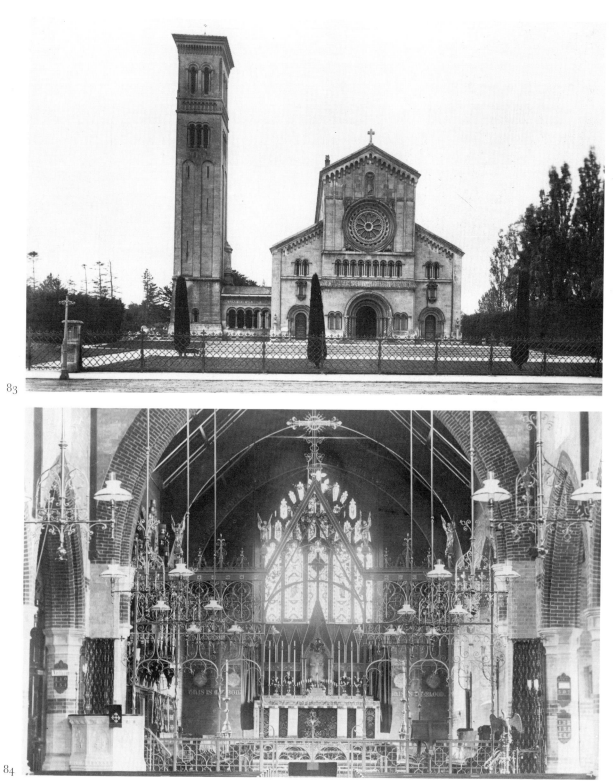

83

84

85

The Church of St Michael, Madeley, Salop. There are many points of interest in this picture. St Michael's, Madeley was built by a famous engineer, Thomas Telford, a man normally associated with bridges, roads, canals and the railway 'mania'. Its octagonal design broke completely with tradition and was a signal of a new age. Its crowded and seemingly rather unkempt churchyard boasted a number of unusual cast-iron Victorian tombs. Even in death Midland industrialists proclaimed their faith in the new technology. A more prosaic use was found for metal in the grave covers designed to prevent people removing flowers or otherwise disturbing the hallowed repose of the occupants.

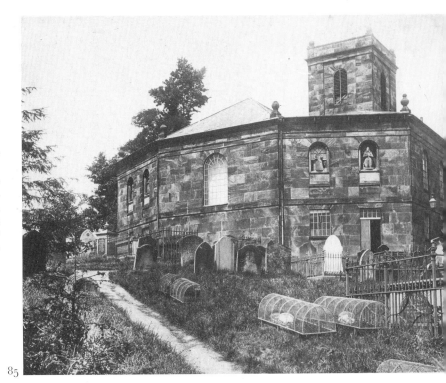

85

86

Friends' meeting house, Swathmoor. Francis Frith, the dedicated Quaker, took no photographs himself of Friends' meeting houses, or, if he did, none have survived. But this late photograph from the collection does illustrate the spartan simplicity of nineteenth-century Quaker worship. Simplicity was a hallmark of the Friends. Although many prospered through trade, they could not indulge in ostentation or undue luxury without violating their faith. Moral rectitude, like charity, was instilled into Frith from an early age. In his unpublished memoirs he recalls, 'When I was about six years old, having of course heard the text, that whosoever says to his brother "Thou Fool" is in danger of something very terrible, and having, in a hasty moment, made use of those words to my sister, I soon became so ashamed and so terrified … that I passed through a real and deep crisis of feeling, obtaining no rest from a severe mental conflict until I received an assurance of divine forgiveness.'

86

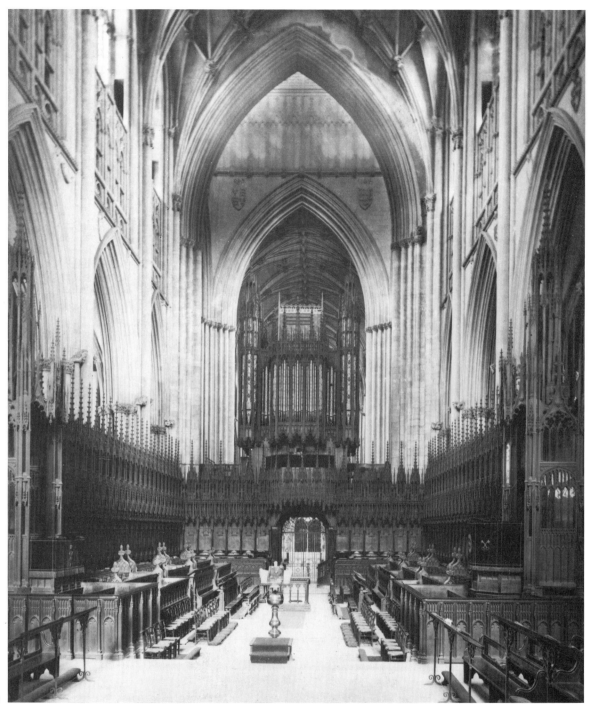

87

The Choir, York Minster. This picture is included as another reminder of the technical achievement of Frith and the men he trained. To acquire such a detailed interior photograph using only natural light involved going to the cathedral when there were no visitors wandering about, waiting for maximum sunlight, preferably uninterrupted by passing clouds, and taking an exposure of anything up to four minutes.

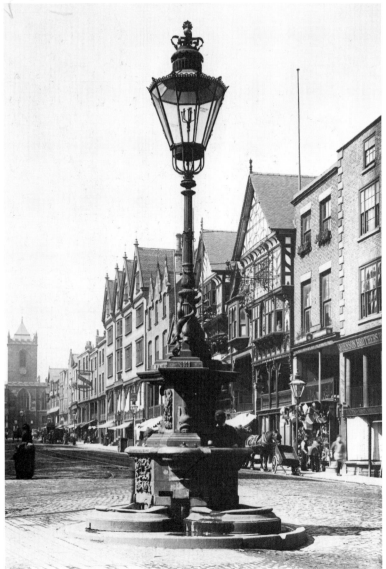

88

89

High Street, Chelmsford, Essex. Everyone seems to have turned out here to pose for the man from Frith's. They have partly obscured the elaborate market cross and lamp, erected by some prominent citizen. What an enterprising man Mr Barnard must have been, operating from the same premises a temperance hotel, a decorator's business and a workshop for cabinet-making and upholstery.

90

The Town Hall, Birmingham. The new cities had to have municipal buildings reflecting their importance and Birmingham's Town Hall, in its classical monumentality, was typical of a style which reflected the new civic pride. But the building is interesting for other reasons. It was designed by Joseph Hansom (1803–82), a prolific architect who built many churches, municipal buildings and private houses. Yet his name is perpetuated in the hansom cab, that most typical of all Victorian conveyances, which he designed. Alas, poor Hansom possessed more inventive genius than business acumen. He went bankrupt building Birmingham Town Hall and he only made £300 out of his hansom cab patent. Fortunately, he recovered from these early reverses to become one of the most prolific and sought-after Victorian architects. A placard on the side of the building announces a meeting to be held by General William Booth, the founder of the Salvation Army. This movement, begun among the poor of London's East End, was founded in 1878 and grew rapidly. By 1890 Booth was much in demand as a public speaker and Oxford University awarded him an honorary doctorate.

88

Bridge Street, Chester. Civic pride inspired both town corporations and private individuals to adorn their streets with decorative and useful amenities. This street lamp-cum-drinking fountain-cum-horse trough was erected in Chester in 1859. Note the quality of the photograph which enables even the legend 'Brays Patent' on the lamp glass to be clearly discerned. Also clearly visible are the wires and rings used by the gaslighter, who would engage a hook on the end of a pole in the rings and, by pulling, open a valve to release the gas, which he would then light by means of a taper, also attached to the pole.

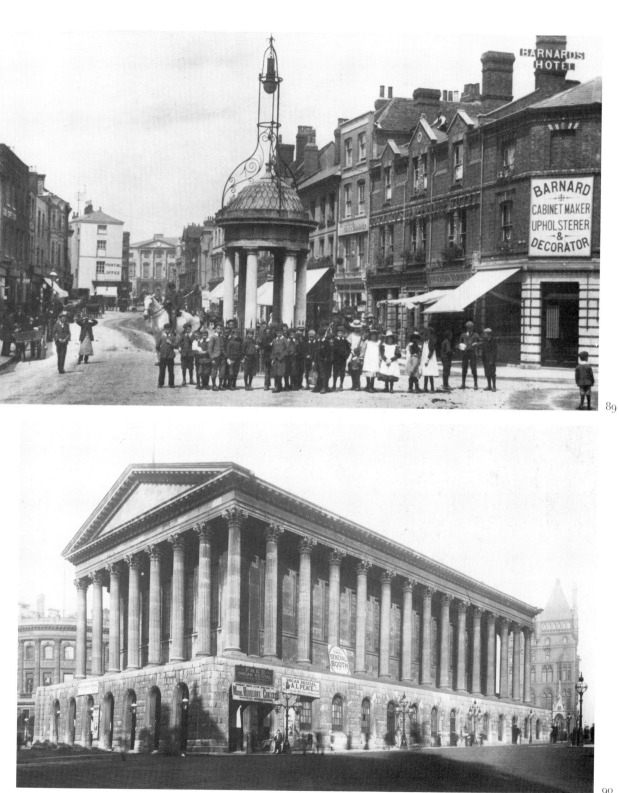

89

90

Public gardens, Harrogate, N. Yorks.
Warned by the cramped and over-
crowded industrial cities in which ap-
palling slums gave way to monotonous
rows of terraced houses and then to
grey suburbs, town planners of the
latter part of the nineteenth century
tried to avoid the mistakes of their
predecessors. The housebuilding con-
tinued, much of it very unimaginative,
but increasing provision was made for
parks and public gardens. In Harro-
gate an area of over 200 acres was
preserved by Act of Parliament for the
recreation of the citizens but that was
only part of the 540 acres laid out with
grass, trees and herbaceous borders.
Harrogate was the North of England's
most prestigious spa town, increasing
in size and popularity throughout the
period. As such it was particularly
sensitive about its appearance. Yet
civic pride and a desire to provide for
the recreation of town-dwellers also
motivated other municipal authorities
to give more thought to urban devel-
opment.

The Market Place, Abingdon, Oxon. Never
was there such a time for erecting
statues. This one, commemorating
Victoria's golden jubilee in 1887, was
donated by Edwin Trendell and made
the centrepiece of Abingdon's market
place, already ringed by several fine
buildings of various periods. Patriotism
was an immensely strong emotion in
nineteenth-century Britain. It seemed
the most natural thing in the world to
raise permanent memorials to national
and local notables. Note, again all the
signboards covering the walls beyond.

91

92

93

94

The Suspension Bridge, Clifton, Avon. This photograph has so much to commend it as a fine topographical picture. It has excellent composition. It shows off well the gracefulness of the bridge. And the closer you look, the more detail you see. The bridge was, probably, the most daring of all I.K. Brunel's designs although it was not completed until 1864, long after the engineer's death. Its single span 'flies' 245 feet above the gorge. From the jetty on the right ferries across the river could be caught as well as transport to the centre of the city.

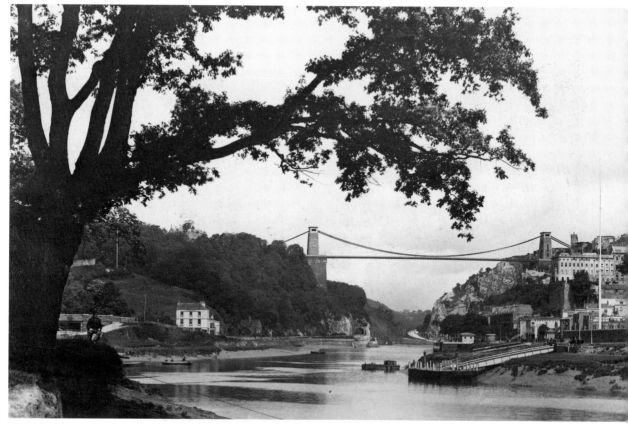

94

93

The Infirmary, Bolton, Greater Manchester.
We mentioned earlier the growing concern for public health and the assumption of greater responsibility by local authorities. Here, in Bolton, the very heart of the cotton industry, a large, modern hospital was built in the 1870s, its decorative tower joining the mill chimneys which dotted the skyline. It is not an attractive building and the photographer did not choose this view for its aesthetic appeal. Yet the town was proud of it and that said something about the quality of life in the industrial North.

95

The Houses of Parliament, London. And so, after a quick tour of Britain's villages, towns and cities we come to London, the nation's heart. Two architectural events dominated the second half of the nineteenth-century. In 1867 the new parliament house was opened. After the disastrous fire of 1834 designs had been requested for a new legislative building. The only stipulation was that its style should be 'Gothic or Elizabethan'. The self-confident Victorians seemed strangely lacking in their ability to devise new architectural styles. Charles Barry and his brilliant pupil, Augustus Pugin, were successful, though neither lived to see the work completed. It was Pugin who spoke for much of the architectural fraternity when he said, 'I strive to revive, not invent'. Over Westminster Bridge passed a constant procession of horse-drawn traffic – hansom cabs and buses, large carts, their loads held in place by nets, and small carts carrying just a few sacks. The presence of a high-piled hay wagon on the bridge reminds us that there were thousands of stables in the city.

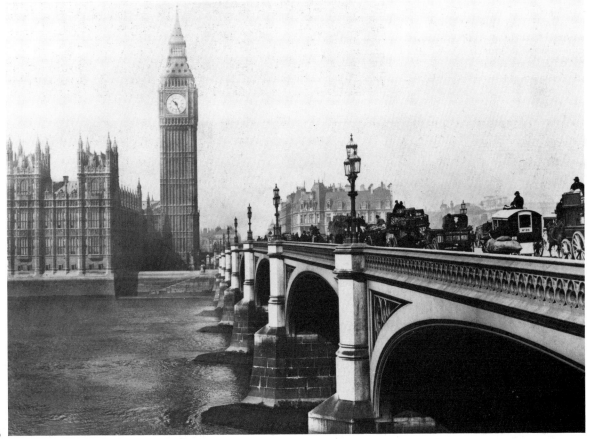

95

[99]

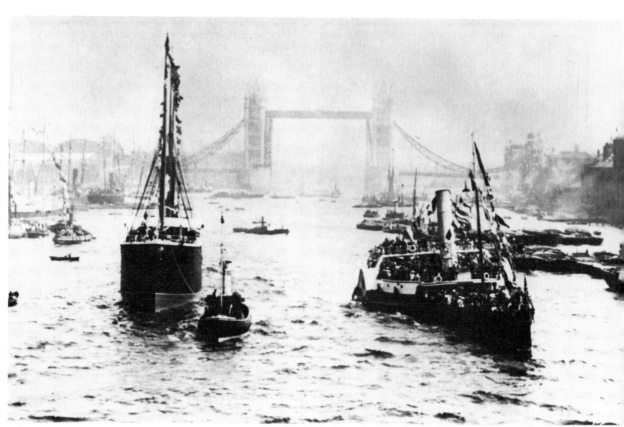

96

The opening of Tower Bridge, London.
The other major event was the open-
ing of Tower Bridge in 1894. Once
again the Gothic style was mandatory
(although the proximity of the Tower
of London was, on this occasion, a
special consideration). The new bridge
was made necessary by the growth of
London's dockland in response to rap-
idly increasing foreign trade. This, in
turn, led to the expansion of London's
sprawling East End, which quickly
swamped the fields that once lay be-
tween the City wall and the docks
further down river. On its opening day
the massive drawbridges, operated by
a hydraulic system, powered by steam,
opened officially for the first time to
welcome into the Pool of London a
flotilla of steam and sailing vessels
dressed overall.

4
OUT
AND ABOUT

Many more British men and women were travelling around these islands than ever before. It is true that there were still villagers who lived and died without scarcely ever going out of earshot of their own parish church bells but, as we have already seen, the steadily spreading railway network carried a large volume of passenger traffic. People travelled from the country to the towns in search of jobs, from the towns to the country in search of their roots – and for a variety of other reasons. But how did they get about and how did travellers fare a hundred years ago?

In the heady days of the railway 'mania' advocates of the new transport confidently asserted that it would replace all other forms of conveying goods and passengers. The second half of the century proved that that boast was far too simple. The railway certainly outdid the canals for speed of conveying coal and other heavy bulk goods. But speed was not always the prime consideration. Canal transport was, in many instances, cheaper. Birmingham and other Midland towns, for example, continued to make use of the inland waterways. Although canal transport definitely declined, its collapse was not as rapid and catastrophic as has sometimes been suggested. Trunk roads, by contrast, did go through a very slack period. Yet the railways, which so severely wounded long-distance road transport, created, in its place, a tributary system of country roads feeding the new lines and linking them with the remoter areas.

Those who journeyed any distance by road were likely to find conditions very varied indeed. Many sections of highway had been owned and maintained by turnpike trusts but these had never been popular and Parliament refused to extend licences when they came up for renewal. The legislators tried to make parishes shoulder the responsibility but this did not work satisfactorily. Not until roads were placed under the authority of district councils by the Public Health Act of 1875 was any systematic care established.

The vehicles that plied the highways and the muddy lanes were enormously varied. Wagons, carts and carriages were built by individual craftsmen. There was little in the way of standardized designs. The basic passenger conveyance was the

fly, a term used to cover every type of covered, one-horse carriage, usually with accommodation for two passengers. When Superintendent Thompson of the Silverbridge constabulary arrived to arrest the Rev'd Josiah Crawley in Trollope's *Last Chronicle of Barset* Mrs Crawley's insistence on accompanying her husband presented problems:

'There was room in the fly for only two, or if for three, still he knew his place better

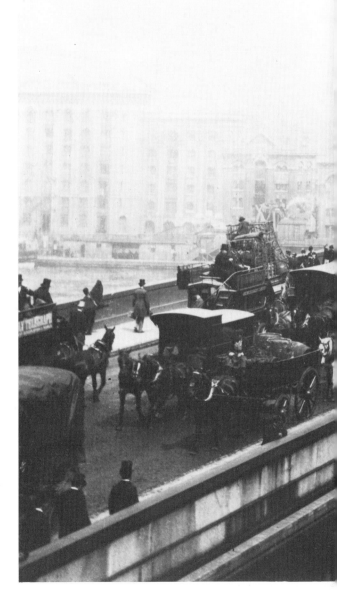

than to thrust himself inside together with his prisoner and his prisoner's wife. He had been specially asked by Mr Walker to be very civil. Only one could sit on the box with the driver, and if the request was conceded the poor policeman must walk back. The walk, however, would not kill the policeman. . . . Thompson instructed his myrmidon to follow through the mud on foot. Slowly they made their way through the lanes, and it was nearly twelve when they were driven into the yard of the "George and Vulture" at Silverbridge.'

And the 'myrmidon', we may be sure, did not take much longer than the fly to reach his destination.

Probably the next most common vehicle on the roads of town or village was the carrier's cart, an open four-wheeled conveyance which collected

London Bridge. Traffic jams did not come in with the motor car. What a cavalcade of carts, wagons, carriages, buses and cabs is seen here. Close examination reveals two horse buses, two brewers' drays, various tradesmen's covered carts, a very untidily stacked straw or hay wagon, a coal cart, a wagon precariously piled with what look like bamboo cages and, in the middle of the bridge, two or three carts piled high with hampers, sacks and miscellaneous items. Think how much training and skill are hinted at in just this one picture: all these horses have been schooled to their allotted tasks and their drivers must be adept at steering them safely through the congested streets.

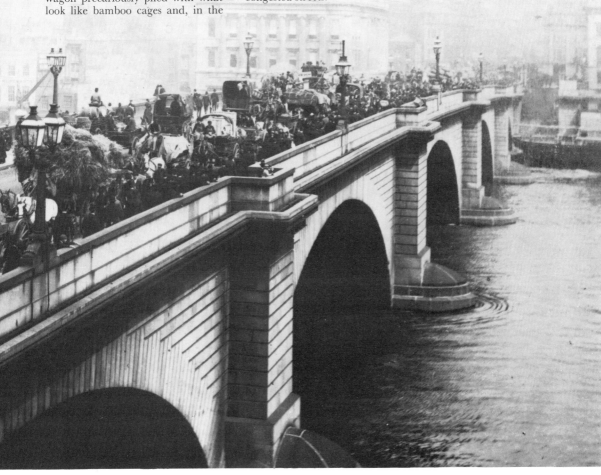

97

and delivered parcels, sacks, newspapers, live-stock and anything else the local community needed collected or delivered. Then there was the dog cart, so called because it was originally designed to carry members of shooting parties and their dogs. This solid and safe two-wheeled vehicle was the most popular form of personal transport, particularly with ladies. Beyond these carriages there was a variety of 'sporty' vehicles, such as gigs and curricles as well as the luxurious broughams, landaus, phaetons, victorias and barouches of the wealthy.

There were three types of vehicle used for carrying larger numbers of people: the omnibus, the charabanc and the pleasure coach. By 1850 the omnibus, for city use, had been developed into a two-horse carriage, capable of accommodating 28 people at up to eight mph. The charabanc had the disadvantages of being open to the elements and carrying half as many people as the omnibus. The pleasure coach we have already met. It was similar in construction to the old stage coach and many stage coaches, in fact, ended their days serving hotels and organizers of pleasure outings. This was, without doubt, the golden age of horse-drawn transport.

All these different vehicles lumbering about the streets made for congestion and occasional accidents. It was in order to bring a greater degree of orderliness to town and city streets that the Tramway Act of 1870 empowered local authorities to lay down rails for horse trams. Many municipalities hastened to instal tramways, but the horse tram was a short-lived phenomenon. By the end of the century it was being replaced by the electric tram.

The revolution brought about by the internal combustion engine belonged to the Edwardian era. Motor cars were still great rarities in the closing years of the nineteenth century. The same was not true of bicycles. The high bicycle or penny-farthing appeared in 1870 but it was difficult to ride and was essentially a sportsman's vehicle. Various kinds of tricycle existed for more genteel ladies and gentlemen. The new sport rapidly gained in popularity. Interest in travel had already been fostered by the railways and greater mobility of population. Now people had

a cheap way of travelling. In 1878 the Bicycle Touring Club was founded. In 1885 the 'Rover Safety Bicycle' – the prototype of the modern machine was invented – and cycling became a craze.

The Esplanade, Redcar, Cleveland
(a) The lightweight wicker carriage was one type used for trips along the prom and was pulled by a pony or some other small animal.
(b) The 'Royal Salvo' tricycle was invented by James Starley with ladies specifically in mind. After two were ordered by Queen Victoria in 1881 the machines became extremely popular. The large wheels gave stability and also an efficient conversion of lady-like energy into forward motion.
(c) Enterprising entrepreneurs at Redcar, a seaside resort for the workers of Teesside and the industrial north-east, provided a variety of machines for hire along the esplanade. Even the backs of the benches carry advertising.

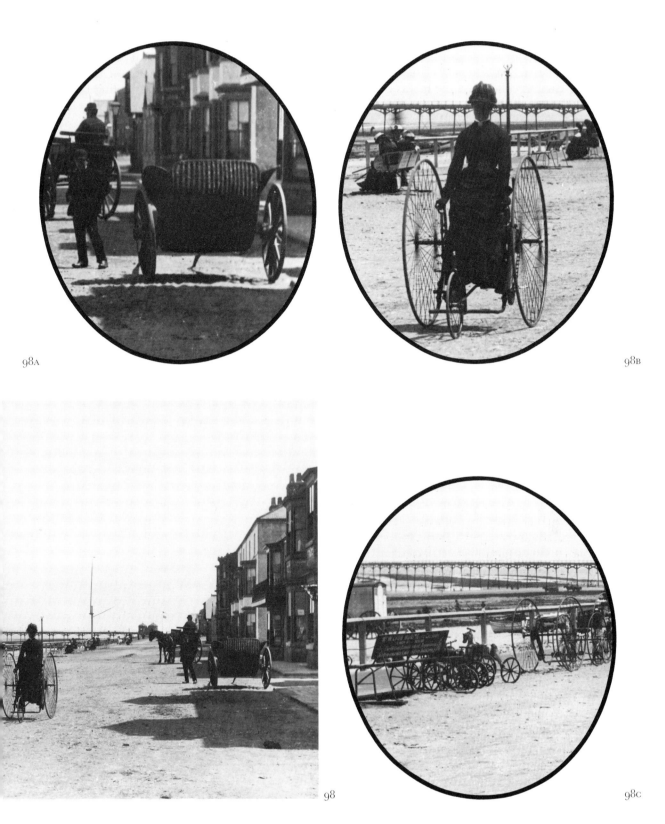

98A

98B

98

98C

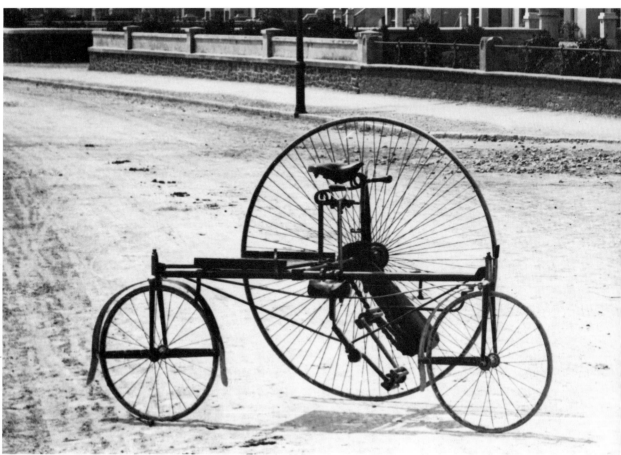

99

99

The Esplanade, Paignton, Devon. This rare machine was known as a country tricycle and made its first appearance about 1875, when interest in the new sport was really accelerating. The first cycle race had been run in Paris in 1868 and had been won by an Englishman. In 1873 four penny-farthing riders completed a journey from London to John o'Groats. Such vehicles as the one in this picture might have had a longer life had it not been for the rapid development of easily manageable two-wheeled bicycles in the 1880s. By the end of the century cycle manufacture, centred on Coventry and Nottingham, had become a major industry.

100

The Lion Hotel, Bala, Gwyn. Touring holidays became so popular that hotels vied with each other for the custom of hikers and cyclists. The Lion Hotel at Bala, in the heart of the North Wales mountains, was one of the first to win the approval of the Cyclists Touring Club, for the original shield motif shown here was changed in 1886 to the winged wheel which the club has used ever since. The four-wheeled carriage was doubtless used for collecting hotel guests from the nearest railway station, at Ruabon on the Shrewsbury and Chester line. Bala was one of the Welsh towns which profited from its comparative proximity to the industrial Midlands and north-west. It attracted the more energetic holidaymakers from the smoky cities. Originally a woollen cloth town, it developed in the nineteenth century as a sporting and cultural centre. Eisteddfods were frequently held there and the first British sheepdog trials were staged there in 1873.

101

The Slipway, Cleethorpes, Humberside. No visit to the seaside was complete without a spin on the prom in an open carriage. At Cleethorpes a trip along the three-mile-long Kingsway promenade and back would fill in a very pleasant hour. Reclining on the supple leather, her parasol held proudly aloft, a shop girl could feel 'quite a lady', and her consort something of a 'toff' (a word derived from 'tuft', the golden cap tassle worn by aristocratic undergraduates at Oxford and Cambridge). The fine sandy beaches of the Humber estuary attracted holidaymakers from Yorkshire and the Midlands.

102

New Street, Birmingham. Several types of transport can be seen in this Birmingham street.

(a) The development of the horse bus from the stage coach can be clearly seen from this picture. The vehicle, here, interestingly pulled by three horses instead of four, looks like a carriage with an extra deck and an outside staircase fitted. Despite appearances, these horse buses were very stable.

(b) A smart gentleman's two-horse town carriage with liveried coachmen follows a wagon piled high with sacks and a covered farm wagon.

(c) The two-wheeled safety bicycle was appearing increasingly on British streets towards the end of the century.

(d) Handcarts were a very common sight.

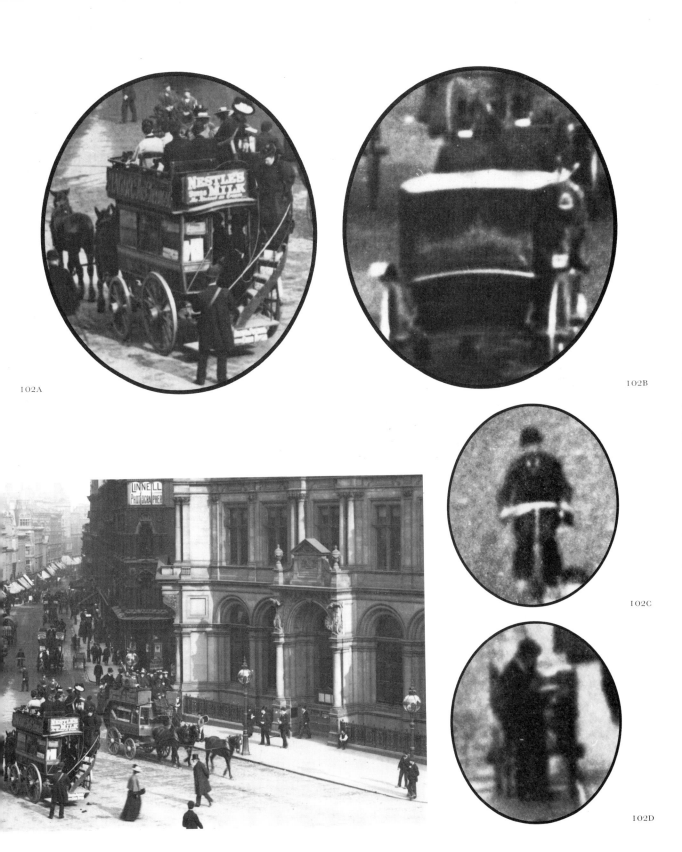

102A

102B

102C

102D

103

Manchester, Piccadilly Had Joseph Aloysius Hansom ever received a fair return for the invention of his 'Patent Safety Cab' he would have become a wealthy man indeed. Instead, he sold the rights for £10,000 to a development company which promptly went bankrupt and Hansom received nothing. To save his invention, he helped put the firm back on its feet, for which he was recompensed to the tune of £300. The enormous popularity of these vehicles resulted from their sturdiness, safety and manoeuvrability. The wheels were large and the frame was set close to the ground. From his lofty rear perch the driver could communicate with his fare via a hatch in the roof and he could also operate the door. By the end of the century the hansom's days were numbered. The arrival of electric trams already meant fewer horses on the streets of Manchester.

103

104

The West Pier, Brighton, E. Sussex. The common name for a variety of four-wheeled closed carriages was 'hackney'. The word derived from the hackney or hack horse providing the motive power. By an interesting process of derivation the term 'hack' came to refer to anyone available for hire and thus, in a pejorative sense, to writers and prostitutes.

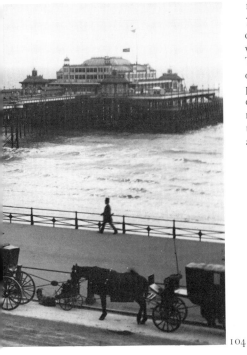

104

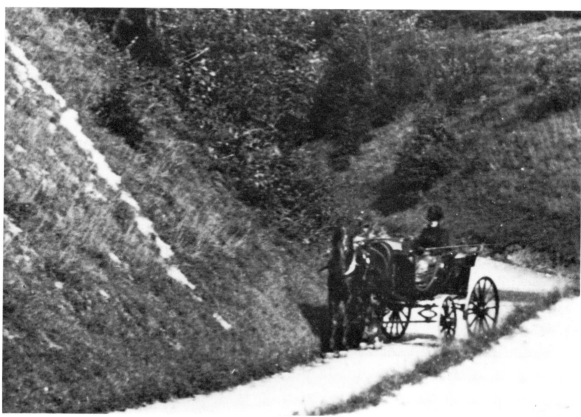

105

105

Near Reigate, Surrey. The phaeton was a fast, lightweight, one-horse carriage designed to be driven by the owners. These elegant vehicles were the 'sports cars' of their day. It was while driving a 'souped-up' phaeton that the aged Swithin Forsyte was challenged by a costermonger in his cart.

'He laid his whip-lash across the mare's flank. The two chariots, however, by some unfortunate fatality, continued abreast. Swithin's yellow, puffy face grew red; he raised his whip to lash the costermonger, but was saved from so far forgetting his dignity by a special intervention of Providence. A carriage driving out through a gate forced phaeton and donkey-cart into proximity; the wheels grated, the lighter vehicle skidded, and was overturned. Swithin did not look round. On no account would he have pulled up to help the ruffian. Serve him right if he had broken his neck!' [J. Galsworthy, *The Man of Property*]

106

The Exhibition, Manchester. This was the horse tram at the height of its development. Passengers paid more to sit inside. Those who preferred fresh air ascended the external staircase and sat 'outside'. Restricting these large vehicles to running on metal tracks created more room on wide city streets for other traffic but they were slow and tended to form queues which, in fact, added to congestion. Their rapid disappearance in the closing years of the century was not entirely due to electrically-powered (and later petrol-powered) vehicles. The tram on the right is setting down passengers at the royal entrance to the Manchester Exhibition (1889). The 1851 Crystal Palace event established something of a fashion in industrial exhibitions. Several were staged in major European cities by nations and regions anxious to show their wares in highly-competitive world markets.

107

The canal, Exeter, Devon. Five miles of canal connected Exeter with the head of the tidal estuary at Topsham, thus enabling sea-going vessels to be brought into the heart of the city. Here we see a sailing barge being towed along this stretch of water. Barges and coastal craft played an enormously important part in the commercial life of the country, conveying goods from port to port, port to railhead, town to town, or from one road connection to another.

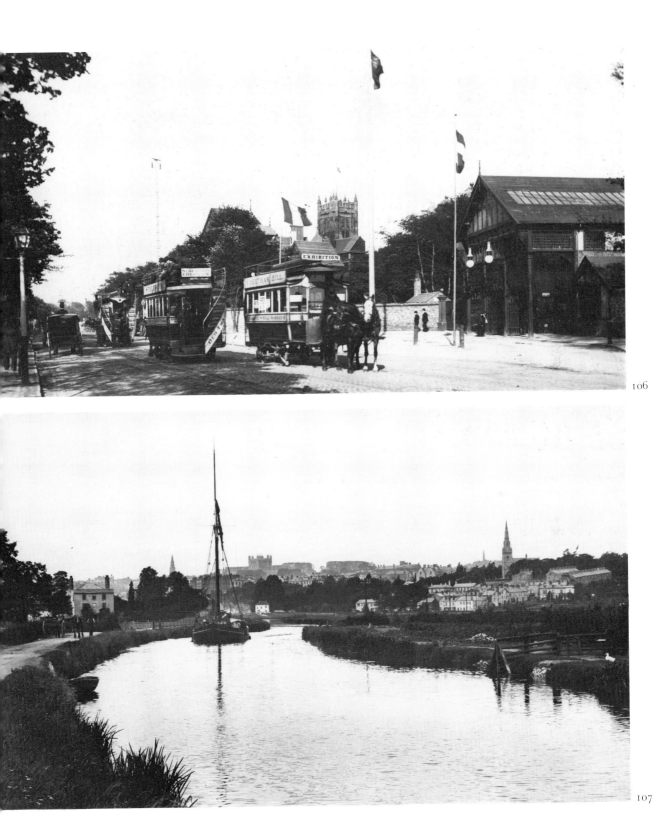

106

107

109
Felixstowe, Suffolk. A dog cart was not driven by dogs but dogs certainly were harnessed to some light vehicles. So were other animals, especially for children's carts. Here we see a particularly elegant donkey carriage, reminiscent of the larger hooded carriage known as the victoria, because it was popular with the queen. Using goats was certainly a novelty.

108
Eccleston Ferry, Chester, Cheshire. Fords and ferries were frequently encountered. Shallow streams and rivers presented no problems to carts and carriages – which was one advantage of the horse over the internal combustion engine. Where fording was not practicable, as on the Dee just south of Chester, ferries were used. Most were privately owned and on a busy route a ferryman could make a good income. This ferry worked on a simple winch system.

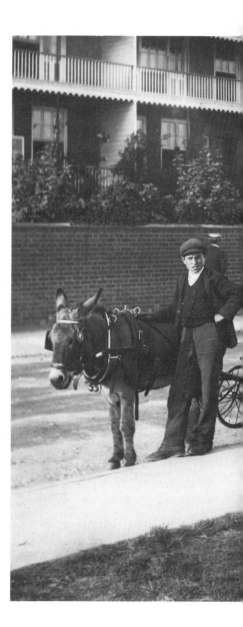

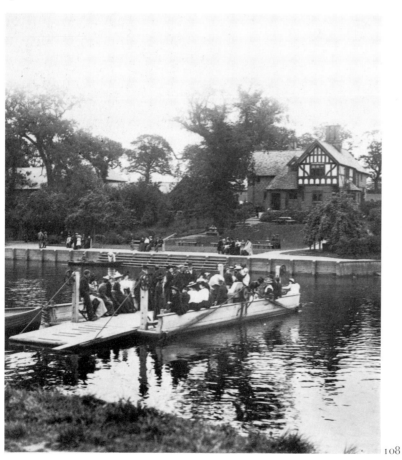

108

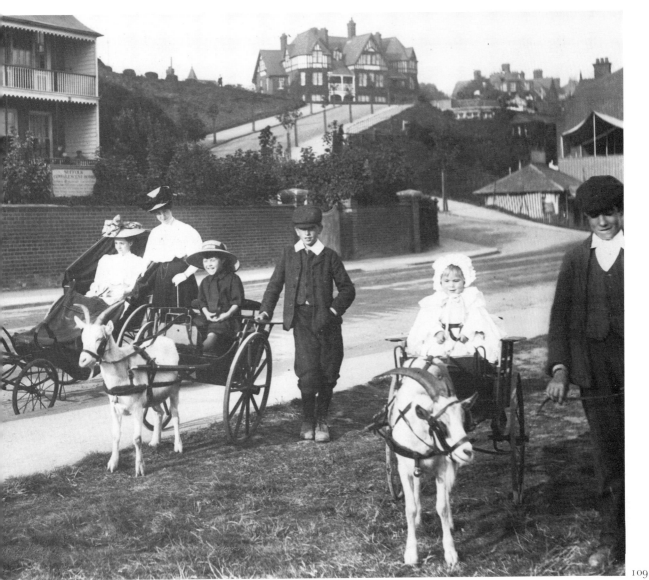

109

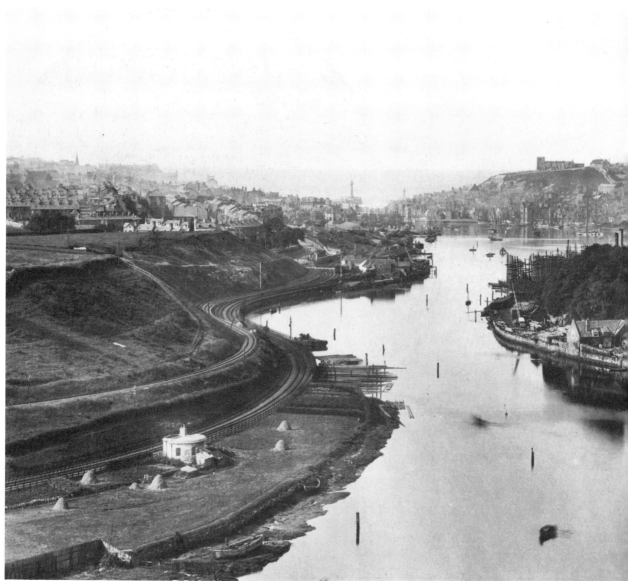

Whitby, N. Yorks. Few pictures demonstrate more clearly how railways changed the face of Britain. Whitby was a fishing port and a shipbuilding centre in the great days of 'the wooden walls of England'. Its houses clustered round the bottom of East Cliff (A) surmounted by the old abbey ruins. The old harbour and the packed waterfront can clearly be seen. Whitby flirted with the railway at first. The Whitby and Pickering Railway Co's line was not linked to the national network and by the middle of the century its owners had abandoned locomotives in favour of horses. The track was brought into Whitby on the other side of the Esk estuary from the old town (B). But it was inevitable that the little railway would be linked with the Great North of England line at York. This meant more tracks and sidings, a bigger station, and developers eager to create a resort which would bring thousands of visitors to Whitby every year. Thus developed the modern centre of Whitby with its residential areas, hotels, boarding houses, promenades, pavilions, etc., a process clearly well under way by the 1870s.

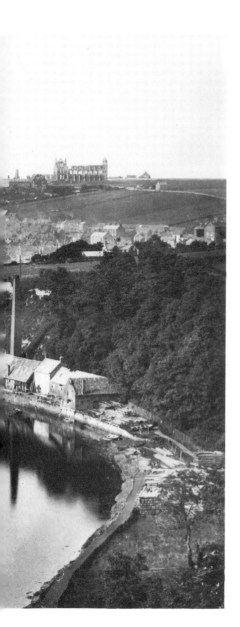

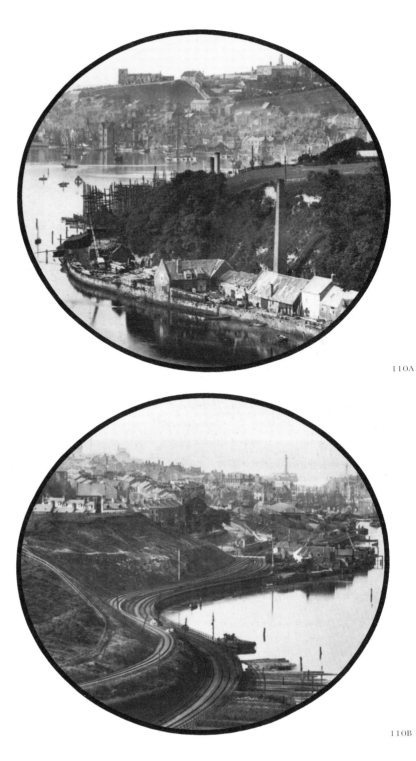

110A

110B

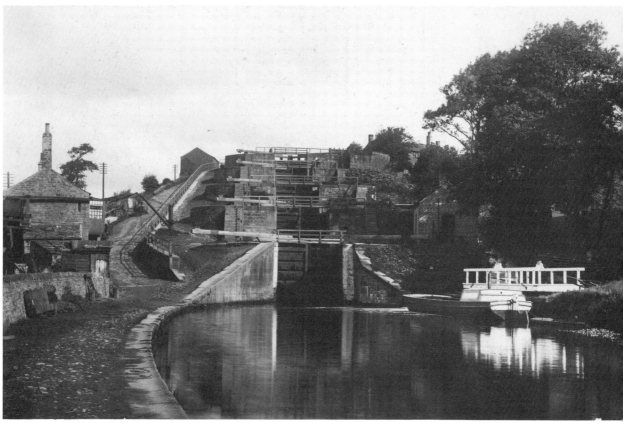

111

111

Five-rise locks, Bingley, W. Yorks. The Leeds and Liverpool Canal was a monumental feat of engineering carrying a waterway right across the Pennines and involving several multiple flights of locks. This valuable transport link between the major textile centres and the ports was an early target of the railways and by 1841 lines followed almost exactly the same course as the canal. But the canal did not die. Even though most of the long-distance freight now went by rail a great deal of local trade continued to go by water.

112

The Forth Bridge. The railways marched on, improved methods of steel production providing engineers with the material to solve ever greater problems. Success was not inevitable, as the Tay Bridge disaster of 1879 proved, when the structure collapsed during a storm with the loss of eighty lives. When the Forth Bridge came to be built in 1882 extensive wind tests were carried out. Special workshops were built at Queensferry to fabricate the steel members. The bridge, completed in 1890, symbolized more than British engineering achievement: it was the forging of a major link between England and Scotland, two countries which had remained very distinct despite political union. Queen Victoria had begun to break down the barrier. Now thousands of her subjects crossed the border every year by rail.

113

The railway, Barmouth, Gwyn. 'Progress is not an accident, but a necessity. . . . It is part of nature.' [Herbert Spencer, *Social Statics.*] The Victorians worshipped progress and the ever-spreading railway system was the most dramatic evidence of this invincible god. Rails and steam locomotives came to the quiet Barmouth estuary in the 1870s. They brought development, change, prosperity: tourists to visit the mountains and stay in the hotels; quick transport to convey the region's produce to markets all over Britain. Yet there were some thinkers and writers who questioned the beneficence of the aggressive deity: 'So long as all the increased wealth which modern progress brings goes but to build up great fortunes, to increase luxury and make sharper the contrast between the House of Have and the House of Want, progress is not real and cannot be permanent.' [H. George, *Progress and Poverty*]

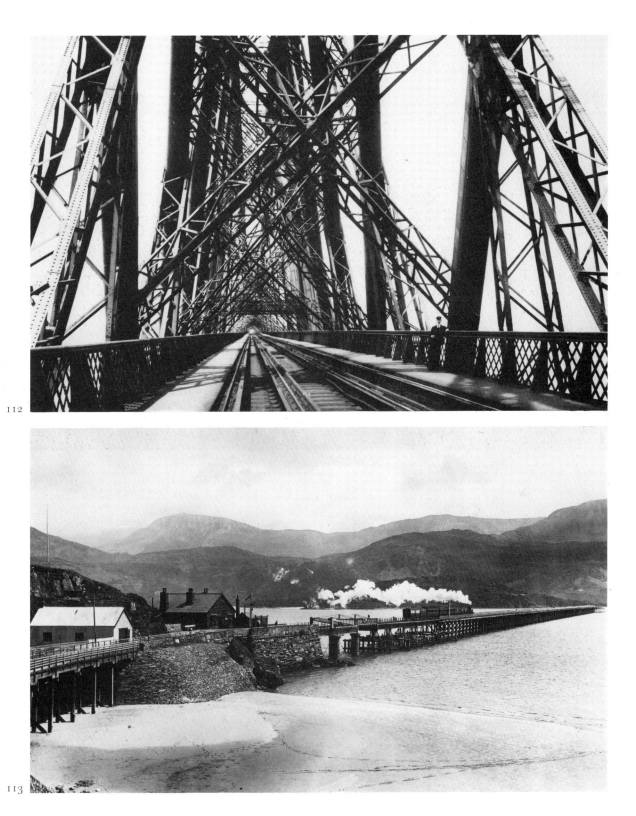

112

113

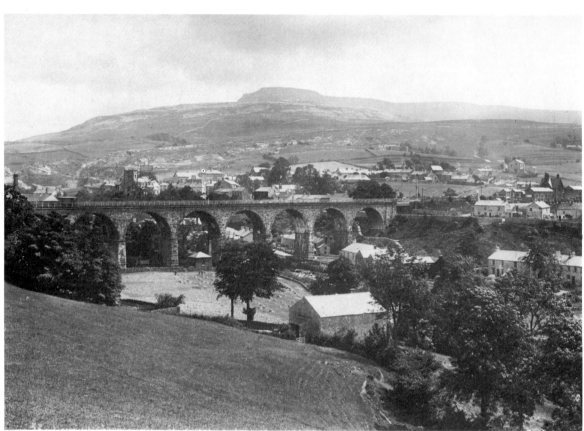

114

114

Ingleton and Ingleborough, N. Yorks. Even the silent, majestic fells were not immune to the advance of the railway. A branch line strode across the River Doe on a viaduct and steam whistles echoed across the valley.

115

Snowdon, Gwyn. By the end of the century even the wildest, remotest parts of Britain were succumbing to the domination of the railway. This rack-and-pinion railway to the Wyddfa summit of Snowdon was photographed in the year of its opening, 1897. Doubtless the proprietors were as anxious to have this latest tourist attraction photographed as Frith and Co were to add it to their collection. The mountains of North Wales had attracted an increasing number of visitors but only the more energetic had climbed to *Y Wyddfa*, 'the view place'. Now the whole family could reach the summit and admire the scenery in comfort.

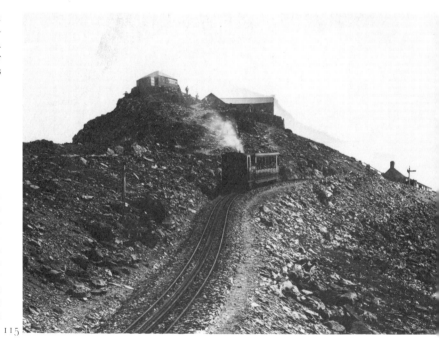

115

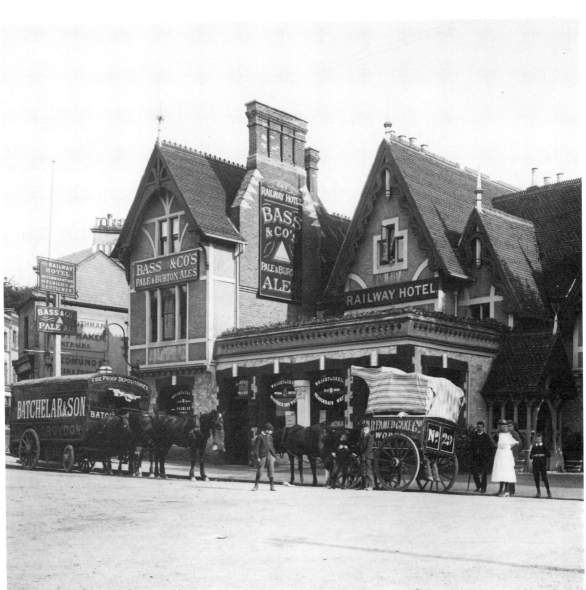

116

Railway Hotel, Lower Caterham, Surrey.
The railways gave rise to a spate of hotel building and refurbishing as breweries and private landlords cashed in on the needs of the travelling public. Caterham was on a branch line but it was a popular spot with 'weekenders', come from the capital to enjoy the Surrey countryside. From here connections were available, via Croydon, not only with the London–Brighton line, but also with the South Eastern Railway and trains to Dover. Another proof of the greater mobility of the population is Batchelar and Son's removals cart. It was known as a 'pantechnicon' van ('van' being short for caravan), the word being coined around the middle of the century to describe a furniture warehouse or depository. It is rather ironical that the railways, which were responsible for millions of people moving house, were unable to offer the door-to-door removal service those people needed, and thus gave a boost to rival road transport.

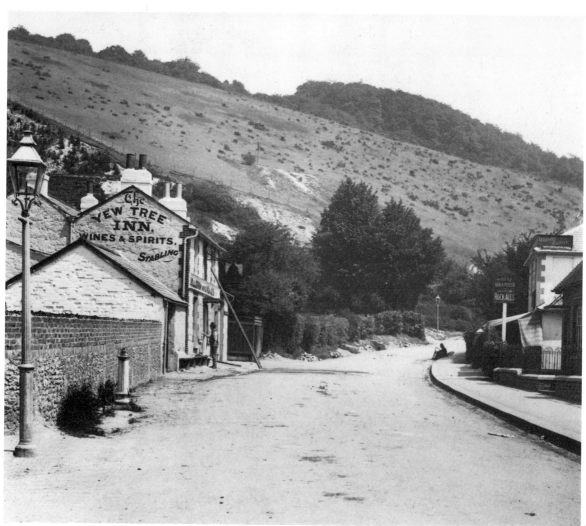

117

Reigate, Surrey. Away from the railway line English life continued its quiet, un-hurried way. Francis Frith's adopted home town, Reigate, was little more than a village and the little Yew Tree Inn offered wayfarers, not fast con-nections to distant places, but 'stabling'. Here Francis and Mary Ann in later life spent the summer months, keeping an eye on the business, taking photo-graphs, painting, attending Quaker meetings and visiting relatives. Some entries from Mary Ann's diary for 1895:

May 16th	Our Swiss maid Posa Agustein arrived.
June 3rd	Frank has gone to a little Mission Hall to take the chair at a meeting.
June 5th	I drive down to Reigate station and went to Clapham Junction and thence by bus to Alice's (the Frith's eldest daughter).
June 26th	Susie went back (to St Bartholomew's Hospital, where she was a nurse). She took a lot of good things. 2 cakes, strawberries, cream, cucumbers, etc.
August 8th	Wrote a letter to Alice and sent it by the carrier.
September 7th	A thunderstorm in the night put about a foot into our tanks.
October 7th	Crossed by Dover and Ostend, got as far as Namur.

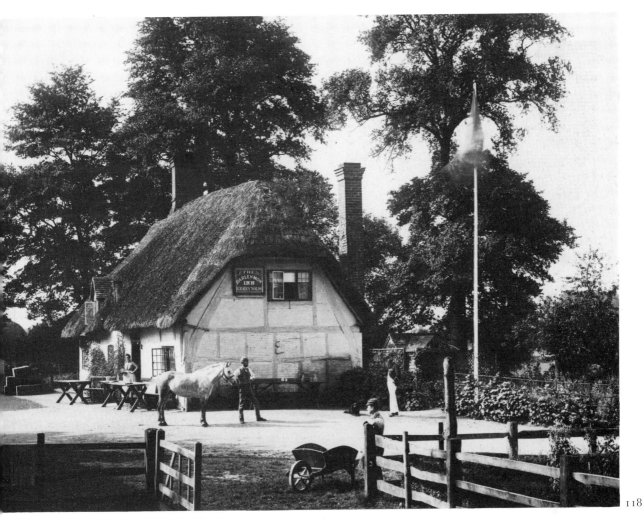

The Barley Mow Inn, Clifton Hampden, Oxon. Jerome K. Jerome found the Barley Mow, 'the quaintest, most old-world inn up the river. . . . Its low-pitched gables and thatched roof and latticed windows give it quite a story-book appearance, while inside it is even still more once-upon-a-timeyfied. It would not be a good place for the heroine of a modern novel to stay at. The heroine of a modern novel is always "divinely tall", and she is ever "drawing herself up to her full height". At the "Barley Mow" she would bump her head against the ceiling each time she did this.' And all that underscores what we have said about late Victorians having a nostalgic longing for their ancient, rural heritage. What displayed itself at one level in the architectural Gothic revival showed itself at another in the love of 'quaint' old inns and deep-rutted lanes. The owners of the Barley Mow undoubtedly deliberately catered for this taste by eschewing change. Yet there were genuinely changeless aspects in the life of the inn. The ostler, for example, was still an important member of the staff.

[123]

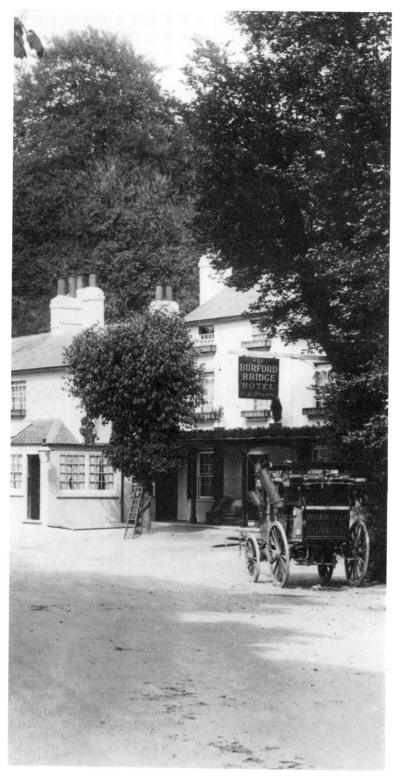

119

The Bridge Hotel, Burford, Oxon. For a last look at inns and hotels we travel to the quiet old Cotswold town of Burford. The sprawling hostelry, once a stage for the mail coach, survived the decline of road transport. Its proprietors kept one of the old carriages, though not a local one. The 'Rocket' had once plied between Boxhill and London. It was probably only kept for outings. The hotel would have had other conveyances for fetching and carrying guests. Fairly modest travellers like Francis and Mary Ann, even when unencumbered by photographic gear, did not travel light. Mary's diary entry for 11 May 1895 reads, 'A landau and pair for us and a brake and pair for the luggage to the station.' A brake was a wagon with inward-facing seats, suitable for passengers or goods.

120

McLeod's Temperance Hotel, Edinburgh. McLeod's Temperance Hotel in Edinburgh's High Street was, by contrast, a definite break with the past. Drunkenness was a major social concern and, as we have seen, various temperance groups sought by control of licensing hours or even abolition to bring the problem under control. The conflict between the brewers and their customers on the one hand and the abolitionists on the other was perhaps more acute in Scotland where Calvinism had strong roots. McLeod's hotel actually stood next door to the one-time home of John Knox the sixteenth-century Protestant champion. His hostelry provided a haven for those who wished to avoid the temptation of strong drink and for those who could not bear to be near alcohol and its devotees. Note the laundry hanging out of a next-door window.

Bath. And here is the original Bath chair. These traditional conveyances for carrying invalids to and from the pump-room and the baths had, by the end of the century, become a tourist attraction in their own right, and were hired, not only by the infirm, but also for sight-seeing tours of the city.

121

Shakespeare's Birthplace, Stratford-on-Avon, Warwicks. Another indication of what travellers went to see and why is the story of the restoration of Shakespeare's birthplace. The half-timbered house in Henley Street (top) was bought by public subscription in 1847 and a trust was set up to return it to its former glory. The work was completed by 1861, a few years before the second photograph was taken (bottom). From that time onwards Stratford became more than ever before a centre of pilgrimage.

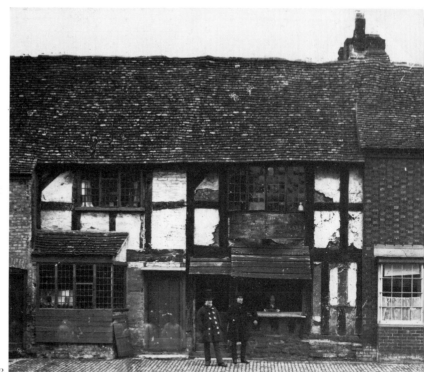

122

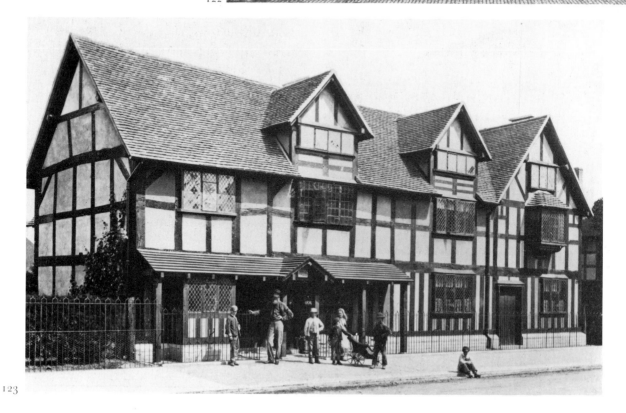

123

5
DOWN TO THE SEA IN SHIPS

Francis Frith may well have met seamen who served under Nelson in the great age of fighting sail. In the year of his death, steel, turbine-powered torpedo boats capable of speeds exceeding thirty knots were being supplied to the British navy. The nineteenth century was a period of successive revolutions in shipbuilding. By 1845 sail had already begun to give way to steam and in that year the *Great Britain* was built, the first large iron ship. It was fifteen years before the Royal Navy was prepared to start building ironclads. But no sooner had the Admiralty made this concession to modernity than the development of exploding shells, turret guns, torpedoes and even submarines compelled it to think more radically about ship design. Even then it was not until the 1880s that their lordships could bring themselves to abandon the idea that masts and sails were indispensable for ships of war. In the commercial world sailing ships were still holding their own and the second half of the nineteenth century gave the world of sail its crowning glory – the clipper. Its competitiveness was based largely on its ability to carry more cargo than steamships which had to devote much of the below-decks space to engines and fuel. The invention of the triple expansion and turbine engines in the 1880s and 1890s ended the story of the commercial sailing ship.

Expressed statistically the facts are as follows: in 1853 steamships accounted for only 250,000 tons out of a total mercantile marine of over 4,000,000 tons. Forty years later the total tonnage was 8,700,000, of which 5,700,000 was steam-powered.

That is the background against which we must see the following pictures. It is a background of immense change. The seafaring community was having to accept a Pandora's box of new ideas. Some responded with excitement. Others with fear. The opportunities were there for those who would grasp them. Britain's merchant navy was still the finest in the world and the nation's dominance in the construction of iron and steel ships was quickly established. As foreign trade expanded more and more of it was carried in British ships. That meant principally the major companies, but if the main shipping lanes were busy so, too, were

all the ancillary routes. That meant work for the tramp vessels, the coastal traders and a host of irregulars. Among these smaller craft sail continued to dominate throughout the period. But the writing was on the wall. Steam trawlers and cargo vessels were faster, less limited by wind and weather and could be worked with smaller crews.

Other changes were also in process. The men on whom much of the country's mercantile prosperity depended – the sailors and dockers – were among the most poorly paid and shabbily treated. All that began to change in 1889. The dockers went on strike for sixpence an hour and an end to contract labour. What shocked the employers was not only the determination of the men but the large measure of public support their cause attracted. The dockers obtained almost all their

demands and this was a shot in the arm for trade unionism generally. Seamen rushed to join their newly-formed union and within a couple of years shipbuilding employees were also organized.

All this, of course, is below the surface in Frith pictures. The bustling quaysides, the majestic sailing ships, the picturesque wherries and barges, the yachts and the sleek passenger liners – all tell a story of self-confidence and prosperity, a story of an island nation at the peak of its power based on maritime ascendancy. It is when we look at the faces of the men 'who go down to the sea in ships and occupy their business in great waters' that we glimpse something of that other story.

Francis Frith, experienced traveller that he was, was a keen observer of ships and shipmen. He knew what life at sea was like.

'My first voyage from Liverpool to Alexandria was a perilous one, in a rolling, wall-sided, nearly new screw-ship, seven times the length of her beam. We had a tremendous gale of wind nearly the whole way, but fair, doing an average with sail and steam of fifteen knots on the flat, and half as much again if you reckon the ups and downs of the tremendous billows. Many a time half the ship's length was covered with a flood of water which she scooped up with her nose in the trough of the wave and tossed backward when she rose, as by a miracle, quivering in every nerve.'

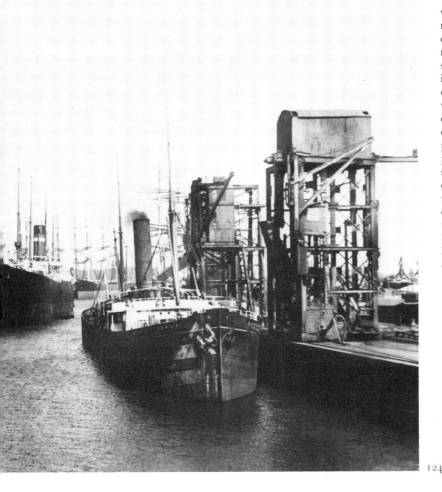

The docks, Barry, S. Glam. Barry docks was a deliberate creation of the late nineteenth century and epitomizes the changes overtaking the maritime community. The enormous demand for steam coal, to fuel ships as well as industry, encouraged South Wales colliery owners to build a new deep-water port rivalling Cardiff. The first dock began business in 1889, the year of the great dock strike, and was soon packed with colliers of all kinds. Our picture shows wood and iron sailing ships, a steam collier and a long-distance steam trader. The new docks were fully mechanized and could operate with a smaller work force than more traditional rivals. Business boomed and soon the port was handling a wide variety of cargo. A second dock was opened in 1898.

124

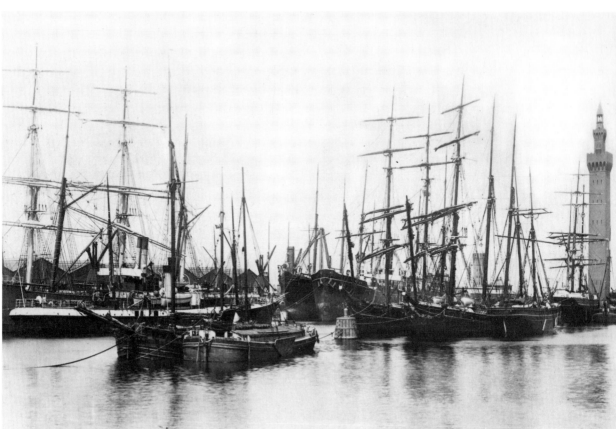

125

125

The docks, Grimsby, Humberside. Grimsby docks were expanding for different reasons. The ancient, traditional fishing industry relied on its proximity to the rich fishing grounds of the North Sea but went into decline in the eighteenth century when the harbour began to silt up. Increased demand and improved travel facilities encouraged a major dock rebuilding around the middle of the nineteenth century. The remarkable water tower, providing a hydraulic pressure head for the lock gates machinery, was completed in 1852. It was inspired by the architecture of the Palazzo Publico in Siena. The single-masted fishing smacks (foreground) began operating out of the new dock in 1856. The use of larger sailing vessels and, in the 1880s, steam trawlers extended the range of fishing activities to the White Sea and the waters off Greenland. Frith's photographer found a variety of long-haul and inshore fishing ships in the port. The steam vessel on the left may be a whaler.

126

The harbour, Gorleston, Norfolk. This magnificent picture of the Gorleston fleet setting out on a summer's morning seems so graceful and picturesque. These two-masted trawlers were the finest small fishing vessels ever built and were destined to be the last stage in a centuries-old shipbuilding tradition. Life aboard these craft in the turbulent North Sea was, of course, anything but romantic. The ships were away for weeks at a stretch. Adverse weather conditions frequently obliged them to shelter or unload their catch in other ports. The wives of the crewmen never knew when – or even if – they would see their husbands again. The picture also demonstrates that many small ports maintained a viable fishing industry in this period.

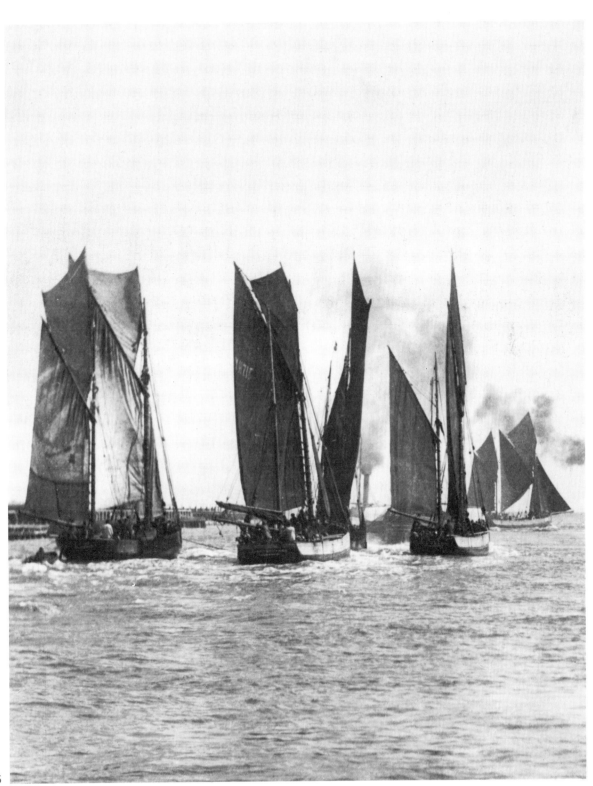

126

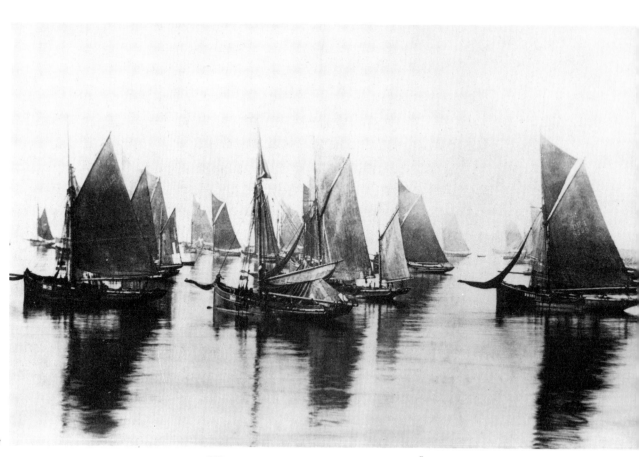

127

127

The harbour, Brixham, Devon. This is another beautiful and highly atmospheric picture. It shows the Brixham fleet of trawlers and smacks waiting for a breeze. The larger vessels, identified by the registration letters DH (for Dartmouth) operated all round the British Isles. Indeed, many fishermen migrated to the larger and faster-growing North Sea ports. At Brixham geographical conditions were not favourable to the large-scale expansion which would have enabled the port to share fully in the commercial boom. However, by the end of the century tourism was beginning to make a substantial contribution to the local economy. The smaller vessels worked the inshore fisheries, oyster beds and lobster grounds.

128

The harbour, Mevagissey, Cornwall. Local lads rest against an upturned tender while a sailor looks on. Most of these young men were probably already working with their fathers on the fishing ships. Mevagissey was one of many Cornish ports from which fleets of small boats operated using drift nets and lines.

129

The harbour, Mevagissey, Cornwall. This fine view shows the variety of craft which might assemble in even a small Cornish port. Smacks are drawn up to the rocks. A Fowey trawler floats free and hangs her sails out to dry. A schooner leans at her moorings on the departing tide. Within the harbour many vessels crowd together. Still more litter the deep water anchorage.

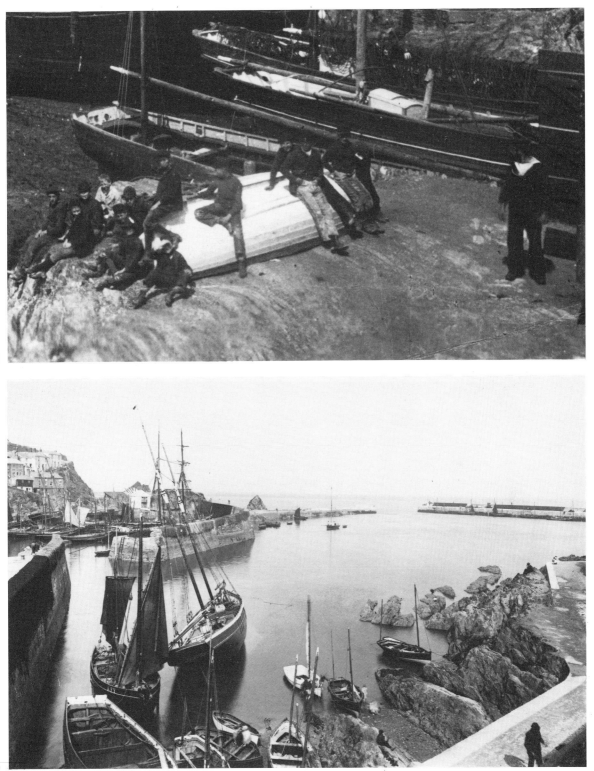

128

129

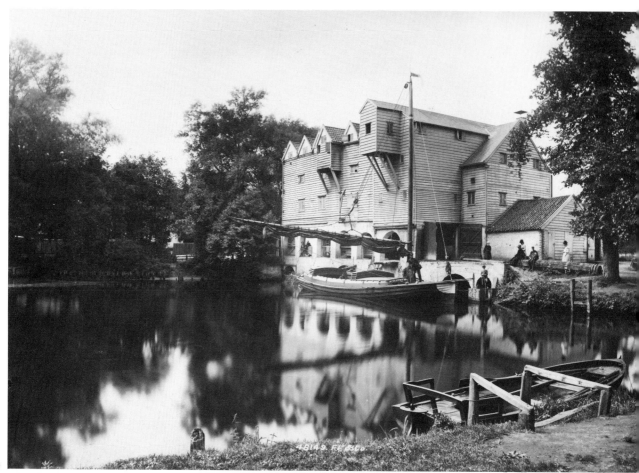

130

130
The Broads, Norfolk. What the sailing barge was to the Thames the wherry was to the Norfolk Broads. Water traffic was far the most practicable on that large stretch of inland waterway. Once again Frith's man has composed a fine picture out of an everyday economic activity. The simple, elegant craft has its sail furled and its boom swung outboard to facilitate cargo handling. The hatch covers have been removed and work – perhaps taking on sacks of flour from the mill – is about to commence.

131
Harbour entrance, Lowestoft. New building at Lowestoft was undertaken with tourism as well as conventional commerce in mind. The town, whose population increased fivefold in the half-century after 1831, owed its growth to the boom in the fishing industry and the holiday trade. Piers, promenades and all the paraphernalia of seaside resorts were constructed as were slipways for boat construction and improved berthing facilities. The harbour walls were equipped with pavilions so that observers, like the lady with the little carriage and parasol, could watch the comings and goings in comfort. In our picture two trawlers prepare to sail while pleasure-bent watermen sail and row around the harbour.

132
On the Thames, Surbiton, Surrey. Two sprit-sail Thames barges at one of the many landing stages on the Thames. These vessels loaded in the Port of London from coasters and ocean-going vessels with a variety of goods (one of these seems to be unloading coal) which they conveyed far up river and around the estuary. There was plenty of work for these barges to do and thousands of them were employed, making a valuable contribution to the economy as well as a graceful addition to the landscape.

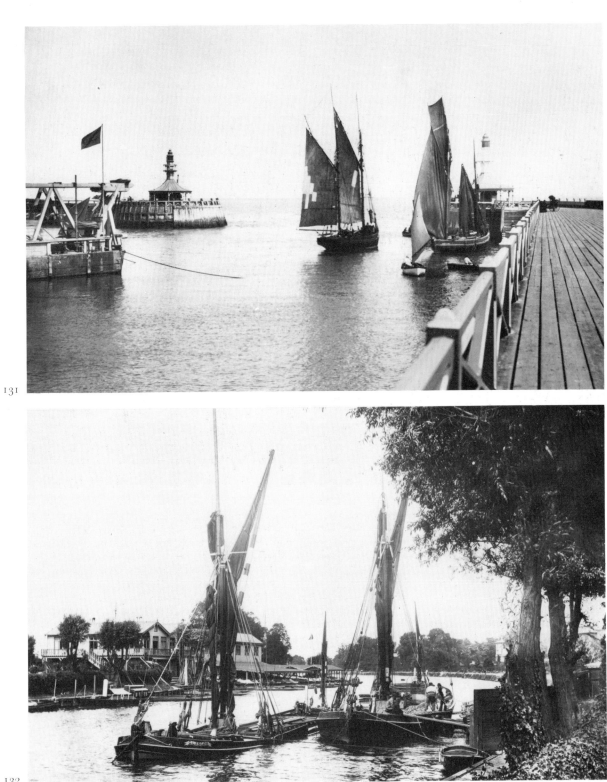

131

132

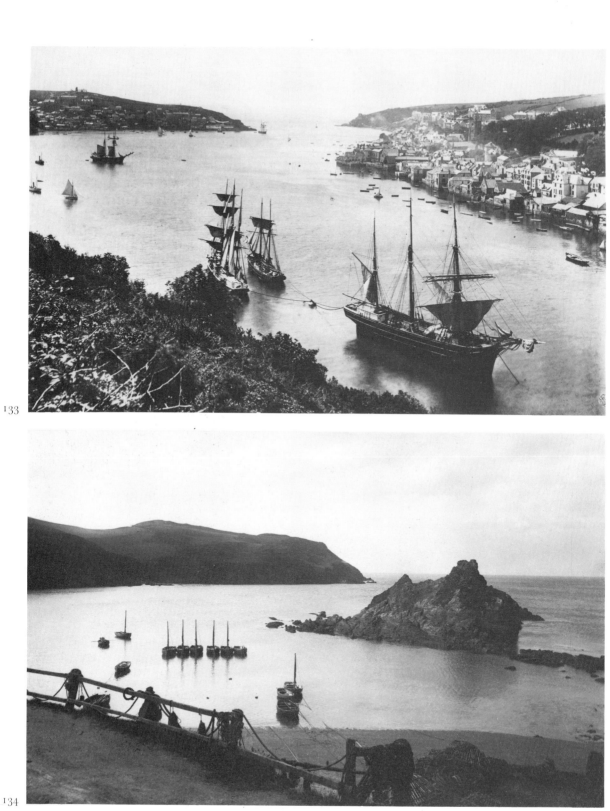

133

134

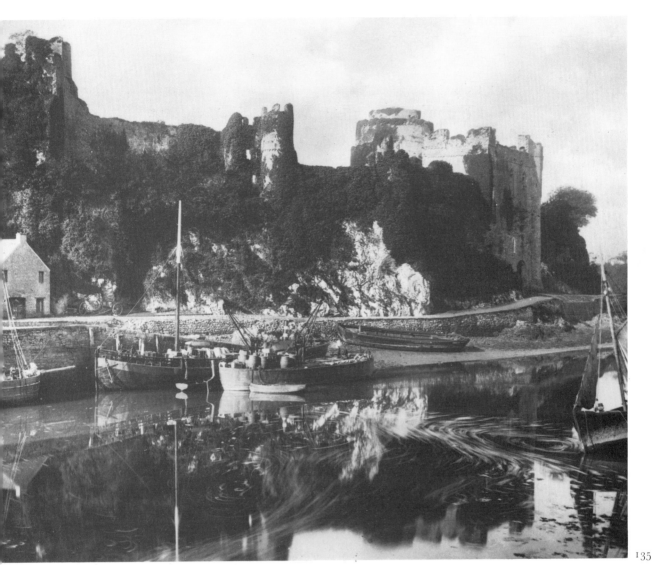

133
Fowey, Cornwall. Fowey was an important china clay port. Ships carried the raw material to other British docks and to centres all over Europe. The three nearest vessels have come, probably, from Norway to load with china clay. The two other large craft (one anchored near the distant headland) are schooners. Sailing yachts can also be seen taking advantage of the light breeze. Fowey – and Polruan, across the estuary – were very busy little ports engaged in general trade with the Mediterranean and North America in the days of sailing ships.

134
Hope, Devon. The tiny village of Hope lies at the eastern end of the wide expanse of Bigbury Bay. Like many other coastal communities it was a place where time stood still. At the end of the nineteenth century the men still eked a living from the sea as their fathers and grandfathers had done from time immemorial. Time was when smuggling and wrecking had added to their incomes but those days were past and life revolved around the trade 'tools' seen in this picture: the little sailing boats, the nets and the lobster pots.

135
The Castle, Pembroke, Dyfed. This picture has principally been included for the delightful patterns created by reflections and ripples, thanks to the time exposure. It also shows the variety of commercial and pleasure craft coming right into this quiet little town at the head of one of the arms of Milford Haven.

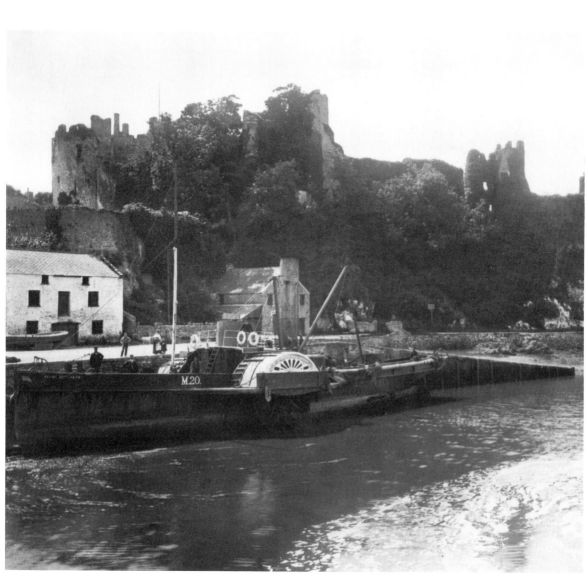

136

136

Pembroke, Dyfed. Paddle power had a very short lease of life when applied to ocean-going vessels. It had been superseded by screw propulsion by the 1860s. Paddle machinery took up more space, and wheels were less efficient than propellers in heavy seas. However, for coastal and esturial passenger-carrying vessels these drawbacks were more than countered by the advantages of shallow draught, less vibration and greater comfort. The Flying Scotsman carried passengers around the heavily-indented coast of south-west Wales.

137 138

The steamships Adriatic *and* Majestic. Even in the 1880s and 1890s the great screw-propelled passenger liners had not broken totally from reliance on sail. They carried considerable canvas and used it to increase speed or save fuel. But the obstinate retention of sail owed more to psychological than technical arguments. Captains and crew understood sail and mistrusted engines. The common argument of the conservatives was 'What would happen if the engines broke down in mid-ocean?'

137

138

[141]

139

38803. BOWNESS; YACHTS ON WINDERMERE, F.F.& Co.
38803. F.F&Cº.

140

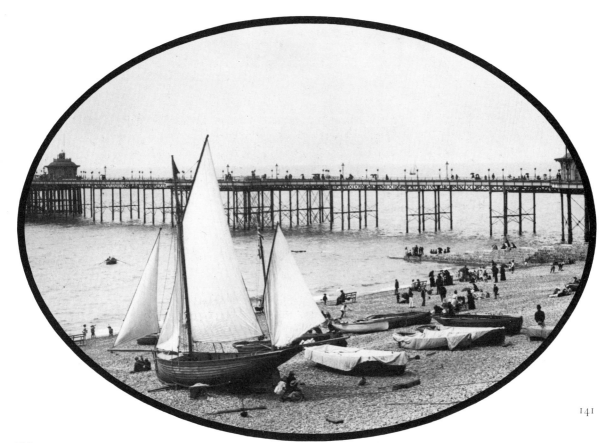

141

139

Lake Windermere, Cumberland. Francis and Mary Ann must have seen this view frequently, for they loved the Lake District and made several journeys there. These small sailing boats, crowded with sail, belonged to members of the Royal Windermere Yacht Club who raced on the lake. Many clubs were founded during this period.

140

The Clyde. Here the photographer's eye was attracted by the variety of pleasure craft. The *fin de siècle* was the great age of steam yachting. Wealthy owners vied with each other to buy bigger and better vessels, man them with professional crews and display them in various British and continental ports. Some yacht owners were, of course, more genuinely interested in the sea than others. Earl Brassey, for example, circumnavigated the globe in his yacht *Sunbeam* in 1876–7. He went on to become civil lord of the Admiralty and to write a monumental history of the British navy. By the end of the century few steam yachts were equipped to carry sail but they still sported tall masts which did, at least, enable the owner to appear really nautical by flying signal flags. The picture shows a variety of sailing vessels, from the graceful yawls (one on the right, another, partially obscured, on the left), similar in sail layout to the contemporary trawlers, to the fast-looking yacht in the middle distance carrying a large spinnaker (a triangular racing foresail which first appeared on a yacht called *Sphinx* in 1866).

141

Brighton, E. Sussex. The conjunction of commercial fishing and seaside holidays very early gave rise to a supplementary source of income for small-time fishermen. Fishing boats and rowing boats were used to give visitors trips 'round the bay'. It was not long before pleasure trips became a regular business. It is difficult to know whether either of the bigger craft seen here drying their sails are genuine fishing boats or whether, like the rowing boats, they served the tourist trade exclusively.

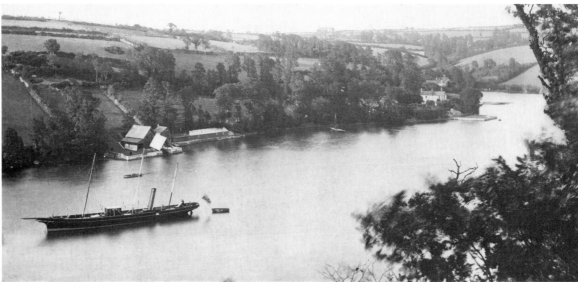

142

142

Golant, Cornwall. This sleek little steam yacht with the raked masts making its way down the Fowey from the direction of Lostwithiel must have been the pride and joy of her owner (the man standing by the aft companionway?). Many dwellers along this lovely stretch of river owned pleasure craft. In the foreground we can see a landing stage and gangplank. A larger stage belongs to the house by the bend in the river. On the opposite bank there is a large boathouse and slipway and a small sailing craft is moored a little way along the bank.

143

Off Llandudno, Gwyn. The SS *Tudor* plied the North Wales coast from Liverpool to Anglesey, taking holidaymakers, most of whom came from the industrial north-west for trips along the coast.

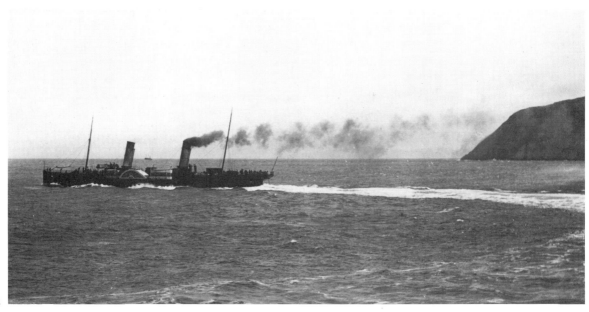

143

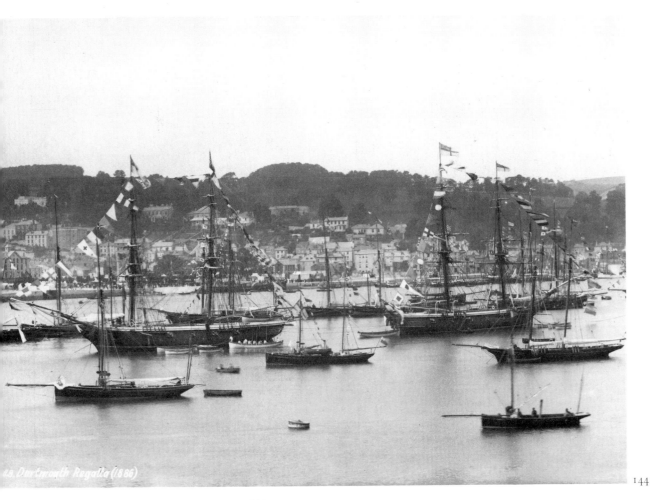

144

Dartmouth, Devon. This gay scene is the annual regatta and shows us a variety of smart, expensive vessels. The large vessels dressed overall belonged to the Royal Navy and were used as training ships. A boatload of young trainees can be seen just going aboard. We can see a couple of steam yachts and very elegant sailing yachts with their sails neatly furled. The August regatta was (and still is) a major event in the yachtsman's calendar, and it was the popularity of sailing which really 'made' Dartmouth. According to a contemporary book on etiquette, yachting had become so fashionable that some ladies were seen aboard ships in 'lace, jewellery and dress millinery', something considered shockingly unsuitable:

'A year or two ago no lady would dream of wearing any other than the regulation yachting gowns – blue serge or white principally – and yachting hats. Almost invariably "sailors" were worn, but now it is hard to distinguish the ladies of a yachting party from any other . . . the change is for the worse decidedly, taking off much of the smart, trim look from both yacht and yachtswoman.' [*Etiquette for Women: A Book of Modern Modes and Manners* by 'One of the Aristocracy']

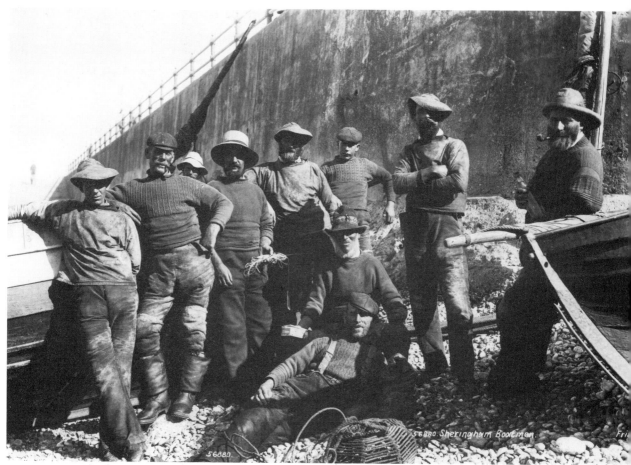

145

145

Sheringham, Norfolk. Three generations of Norfolk fishermen pose for the Frith and Co photographer. These men made their living principally from the lobsters and crabs. They wear several layers of clothes, most important of which are the thick jumpers, known locally as 'ganseys', the supple leather sea boots and the sou'westers and jerkins of oilskin. It is likely that all or most of them are closely related – but in any case they are bound together by the close bonds of shared toil and danger.

146

The harbour, Tenby, Dyfed. These fishermen at Tenby may be local men or seamen from Devon who often spent the summer months working out of the ports on the other side of the Bristol Channel. Note that the clothing, though still heavy duty, is in many respects different from that worn by the men of Sheringham. The jerseys are of a different style and some bear the name of the men's ship. Bowler hats and seamen's caps are the traditional headgear.

146

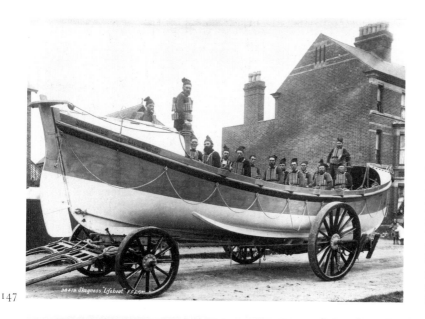

147

147

Skegness, Lincs. Fishermen did not confine their sea-going activities to pursuing the shoals; they were the backbone of the lifeboat service. The Royal National Lifeboat Institution was established in 1854. It co-ordinated and continued the work of earlier voluntary organizations. This self-righting boat operated at Skegness from 1880 to 1906 during which time her crew saved thirteen lives. It took some while to get her launched. The men had to be raised by siren or bell, hurry into their clothes and primitive life-jackets, go to the boat shed, hitch four horses to the wagon and drive them down to the beach and across the surf-line to the water. There would be many improvements to the equipment and techniques of life-saving but there could be no improvement to the bravery of the crews.

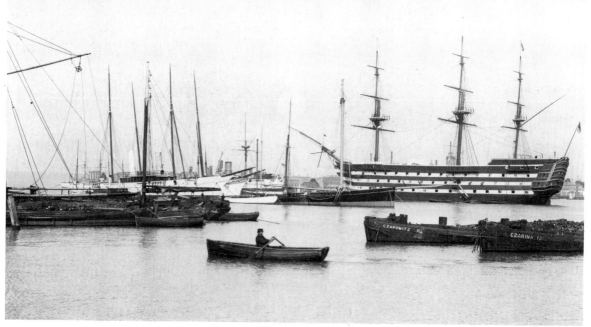

148

148

The harbour, Portsmouth, Hants. A picture which spans a century. In front of one of the great first-rates of Nelson's navy, the *St Vincent* (used as a boys' training ship from 1862 to 1906) sit two grubby lighters, laden with coal, the lifeblood of both naval and mercantile vessels. The elegant steam yachts berthed nearby are almost as long as the old warships. Beyond lie the multi-funnelled passenger liners. Wooden ships, sailing ships, iron ships, steamships – they are all here, captured in a moment of time by the camera.

6
FLYING THE FLAG

In 1876 Queen Victoria was proclaimed Empress of India. Between 1885 and 1895 Britain competed with Germany, France and King Leopold of Belgium in the 'Scramble for Africa'. As the century closed she was locked in a struggle with the Boers for control of South Africa. By 1900 the British Empire had become the largest political unit the world had ever seen. It comprised 13,000,000 square miles and 370,000,000 people. In the interests of commerce and, ostensibly, in the interests of the natives, this empire had to be defended against external aggression and internal unrest. The burden of protecting such far-flung dominions fell upon the army and the navy. But there was also concern nearer to home. The Franco-Prussian War of 1870–1 aroused fears of possible invasion from the continent, fears which were graphically outlined in a popular pamphlet called *The Battle of Dorking*, in which a senior serving officer made the public aware of what *could* happen. Britain still prided herself that she had the finest army and navy in the world, well able to discharge their responsibilities internationally. Popular attitudes were summed up in the words of a music-hall song;

'We don't want to fight but, by Jingo, if we do
'We've got the ships, we've got the men, we've got the money, too.'

But was it true? Britain's military reputation had taken quite a knock in the fiasco of the Crimean War. Service ranks corresponded closely to social classes. Commissions were usually bought and promotion depended on wealth and status rather than ability. Pay and conditions for private soldiers were poor. Enlistment was for twelve years, much of it spent abroad in debilitating climes. Discipline was hard and punishments, which included flogging, were severe. Little wonder that, by 1870, both services were undermanned. A report prepared for the Admiralty in 1881 pointed out that any sudden emergency would find the navy woefully unprepared.

'… during the great Naval War of 1790– 1815 we had in Commission in different parts of the world over 100 Sail of the Line, 140 Frigates, and over 350 smaller vessels,

with a vote of 140,000 men. During the Crimean War, 1854–56, our Fleet was chiefly composed of recently-constructed ships fitted with steam power, and for service in the Baltic and Mediterranean we had in Commission 28 Sail of the Line, 32 Frigates, 36 Corvettes and some 70 smaller vessels. The vote for men was then 70,000 largely

The Albert Memorial, London. On the steps of the extraordinary monument to Victoria's grief for her 'dear Albert' some of the crowds gathered to celebrate the queen's Diamond Jubilee, and the photographer captures a remarkable scene. The bright sunlight permits a short exposure and, although no photograph of the period can be called a 'snap', one has the impression that the picture was taken on a sudden impulse. Was he in the process of gathering the Guards' bandsmen together for a posed group? The bugler on the left seems to be striking an attitude and a couple of his colleagues are very aware of the camera but everyone else has been caught unawares. Yet the photographer's skill has made of this impromptu scene a beautifully composed picture (you can trace a parabola from the cane on the right, through the holder's left shoulder and the line of eight busbies in the left-hand half of the photograph and this curve is offset by the vertical lines of the figures and the horizontals of the steps). It was the Guards' bands that, above all, stirred the loyalty and patriotism of Victoria's subjects.

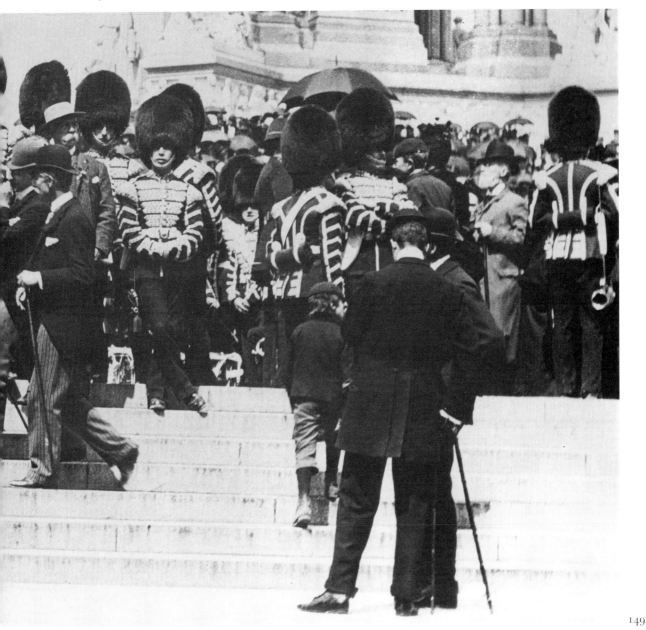

149

obtained by a bounty of £10 per man. The whole of these ships, owing to decay, have gradually disappeared from the efficient List of Ships of the Navy, and a new armour Fleet has been created at an enormous cost contrasted with the ships constructed in former years; hence, it has not been, nor will it be, practicable to keep up a fleet at all approaching to its former strength, unless much larger sums of money are expended.

'On the 1st July, 1881, the following was the strength of our Navy:-

	Large Class Ironclads	Frigates	Corvettes	Sloops	G.V.	D.Vess	Harbour Defence
In Commission	24	1	24	16	23	4	3
Repairing	16	2	13	4	20	0	4
Building	6	0	8	6	0	0	0
Total Strength	46	3	45	26	43	4	7

The army had fared somewhat better. In 1870–1 Parliament dramatically increased the amount of money available, enabling 40,000 men to be added to the list. More importantly, the Secretary of War, Edward Cardwell, instituted widespread reforms: flogging was abolished, the period of enlistment was reduced, the buying of commissions was done away with and the entire administration was overhauled. Things were improving but there was still an enormous contrast between the reality of life in barracks and the stirring sight of the Queen's scarlet-coated soldiers on parade.

> 'Oh it's Tommy this, an' Tommy that, an'
> Tommy go away';
> But it's, 'Thank you, Mister Atkins,' when
> the band begins to play ...
> It's Tommy this an' Tommy that, an'
> 'Chuck him out, the brute!'
> But it's 'Saviour of 'is country, when the
> guns begin to shoot'
> [Rudyard Kipling, *Tommy*]

Francis Frith, as a good Quaker, was a dedicated pacifist. He even delivered speeches applying his principles to political issues:

'on Sunday 31st he was again at Lancaster and addressed a large assembly in the after-noon at the Palatine Rooms on the Peace Question, of course from a religious point of view, about 400 were present ...'

However, this did not prevent him and his assistants taking an interest in soldiers and sailors and their conditions of service. Most of the views, informally posed groups and pictures of men in training were taken for Tommy Atkins and Jack Tar to send home to parents, wives and sweethearts. One can't help feeling that they must have aroused in the recipient feelings of pride tinged with apprehension.

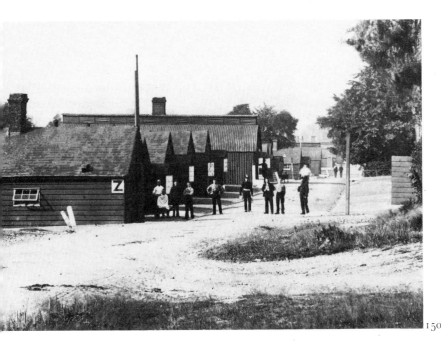

'Z' Lines, Aldershot Camp, Hants. Here we see a group of off-duty soldiers, some in uniform, some in 'Shirt-sleeve order'. One is having his hair cut by a friend. Others pose hurriedly for the photographer. The iron-wheeled cart on the right with a pulley erected over it appears to be stacked with sheets of wood or corrugated iron for repairing buildings about the camp. The summer manoeuvres at Aldershot were particularly important. In 1871 several MPs were invited to watch these exercises and the army was able to demonstrate the inadequacy of its existing manpower and equipment. This led to the creation of improved training facilities and increased recruitment.

150

151

'O' Lines, Aldershot Camp, Hants. Before 1860 there were no large, permanent, army training camps – only regimental barracks. The reasons for this were partly financial but they also reflected a genuine political distaste for the idea of a peacetime standing army. Wellington countered this by 'hiding' military units in a variety of foreign stations. For the soldiers this meant overcrowded and inadequate conditions. In 1862 Parliament was reluctantly induced to vote £7000 to provide reading rooms and gymnasia and, in 1864, a further £5000 was found for other recreational facilities. These sums were paltry even by Victorian standards. The opening of Aldershot hutted camp in 1868 was the first serious step to providing better permanent conditions for soldiers. The huts were fairly primitive but they were interspersed with trees and little gardens and leisure facilities were provided. The camps employed many civilian staff and the bowler-hatted figure may be one such (he could equally well be an off-duty officer). One of the running scandals of the day was racketeering by civilian contractors – particularly caterers.

151

152

153

153

The barracks, Chatham, Kent. Older, regimental headquarters, were, of course, more substantial. The Royal Marines and Royal Engineers were both stationed at Chatham. Here we see a troop of marines being put through rifle drill. One of the reforms instituted by Cardwell was the long-overdue provision of breech-loading rifles. Conservatism and penny-pinching had to be overcome but in 1872 the Martini-Henry rifle began to be supplied. The Royal Marines' principal bases, as might be expected, were at Chatham, still the main naval dockyard, Portsmouth and Plymouth.

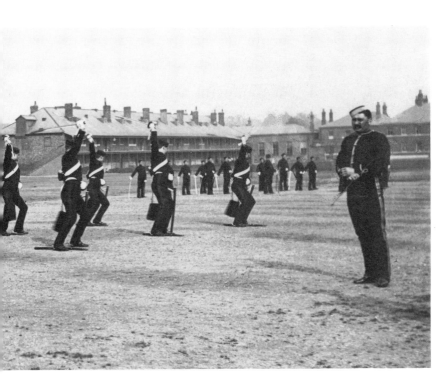

The cavalry barracks, York. The cavalry regiments were still the élite of the British army, so much so that even Cardwell, the Secretary for War, dared not challenge their organization. The soldiers shown in this 1886 photograph are practising (in suitably open order!) sabre drill, a form of attack already rendered obsolete by the rapid development of artillery. The last full-scale cavalry charge in military history had been that of von Bredow's dragoons at Gravelotte in the Franco-Prussian War, sixteen years before. Mounted troops continued to have a limited combat usefulness under certain conditions – as scouts and riflemen – but the traditional, dashing, gorgeously-dressed cavalryman had become an expensive impracticality since the charge of the Light Brigade. Note how the men lived with their horses. The living quarters were above the stables. Piles of straw and dung can be seen after the morning's mucking-out.

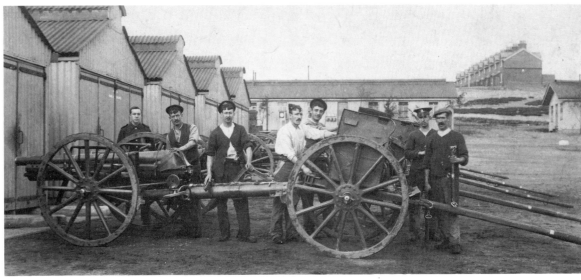

154

154

Deepcut camp, Wilts. At last, after four decades of reform involving struggles with conservatism, and painful re-thinking of the techniques of modern warfare, a new army emerged. These men of the Royal Artillery wear the much more practical khaki, introduced during the Boer War. They live in brick-built quarters. They man the comparatively new, light, breech-loading field guns. Cardwell had seen the importance of artillery and increased the muster by 5,000 men but technical advance was hampered by senior officers who insisted on using muzzle-loading cannon for two decades while other European armies went over entirely to breech-loaders. As we can see, there was a great deal of hard work entailed in keeping the new weapons clean and fully serviceable.

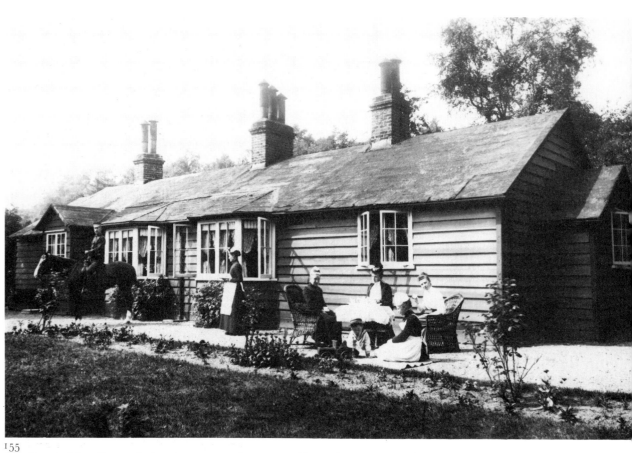

155

156

155
The General Officer Commanding's residence, Aldershot camp. Life in a training camp was not very comfortable, even for senior officers and their families. The CO's house was, essentially, the same type of hut in which the other ranks were billeted. It had certain concessions to gentility – bay windows, properly-constructed fireplaces in the principal rooms, and a laid-out garden, but how the GOC's wife must have hankered for a smart residence at regimental HQ. Nevertheless, she appears to be making the best of a bad job and keeping up appearances. While her husband poses nobly on his charger and her sailor-suited son plays under the watchful eye of nanny, she entertains friends to tea with all the calm self-assurance she would muster in her drawing-room.

156
Wesley Hall, Bulford Camp, Wilts. As in civilian life so in army life public and private benefaction went hand in hand. Military authorities were still slow in providing for the leisure needs of soldiers so churches and charitable organizations made their contribution. At Bulford the Methodist church provided a complex comprising church, hall and recreation rooms.

157

The military hospital, Bulford Camp, Wilts. Once the movement to establish permanent training camps had started in the 1870s it continued for several decades. The army's association with Salisbury Plain began in the closing years of the century and Bulford Camp was one of the first to be established. Improved medical facilities were among the important reforms of the period. Florence Nightingale's dedication to the welfare of the British soldier continued after the Crimean War. She instigated enquiries into conditions and personally supervised plans for military hospitals. In 1863 the first army medical school was opened at Netley, Hants. In the same year the first treatise on the treatment of gunshot wounds appeared. When the new camps came to be set up hospitals and medical facilities were provided as a matter of course.

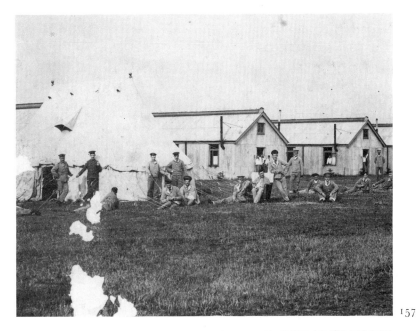

157

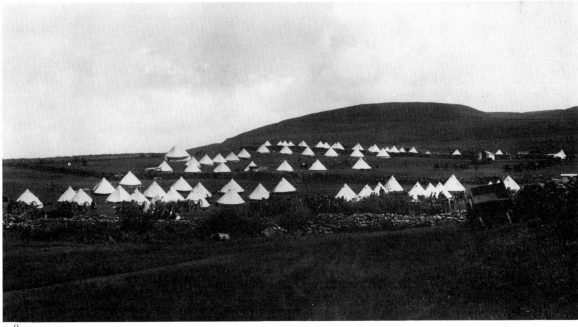

158

158

The army camp, Trawsfynydd, Gwyn. The provision of training facilities for the artillery posed a special problem. It was the custom in the 1860s and 1870s for the army to rent areas of moorland for summer manoeuvres but this did not make for good public relations, as a report in the *Shrewsbury Chronicle* suggests:

'Visitors were disconcerted by the whizzing of cannon balls over their heads when walking on the hills, the balls falling in the village of Minton nearly two miles off, to the great danger of that peaceful locality. The greatest damage was the destruction of a barn … The women ran screaming from the houses carrying their children with them.'

Such complaints led to the marking out of permanent ranges whither the R.A. came every year with their horses, gun-carriages and conical tents.

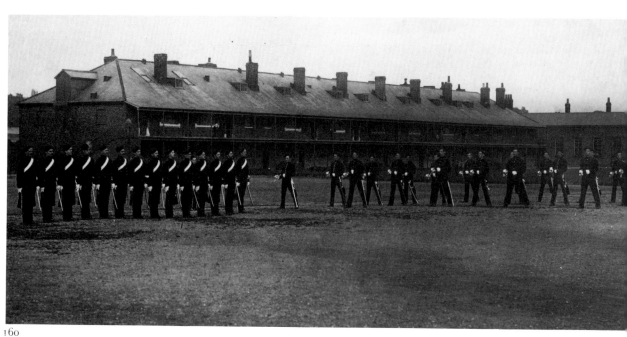

159

160

The harbour, Portsmouth, Hants. Many of the superbly built wooden ships of the Napoleonic era survived throughout the second half of the nineteenth century. Unfortunately, many of the attitudes of that era also survived in the minds of the men in charge at the Admiralty. The *St Vincent* was completed in 1815 and saw periodic service for half a century, her last important naval rôle being as a transport ship during the Crimean War. In 1862 she became a training ship based at Portsmouth.

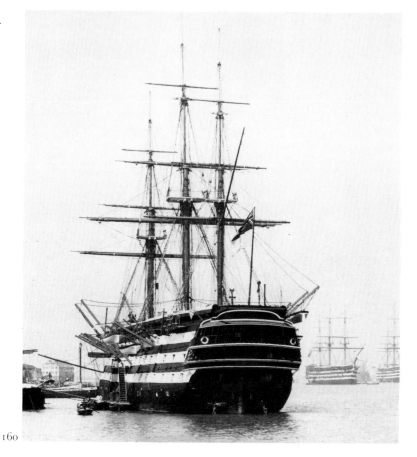

160

159

The cavalry barracks, York. The transition, albeit slow, to new tactics can be seen in this picture. The Third Hussars, drilling here, carry rifles. Yet at the end of the century, when British soldiers faced the Boers on the South African veldt, they were completely outclassed by the bands of mounted riflemen. British commanders had to rethink the use of horse-troops, most of whom became, in effect, mounted infantry, using their chargers for maximum mobility but actually fighting on foot.

161

The harbour, Devonport, Devon. It is, perhaps, understandable that the navy was reluctant to destroy and replace these magnificent ships. The beauty which attracted Frith's photographers was matched by a romantic attachment to vessels which had proved their worth most dramatically in the struggle against Napoleon. But it was obvious that the Nelsonian style of warfare – a duel between ships pouring broadsides into each other – was a thing of the past. New guns were being built with a greater range of penetrating power. The ships of the new era thus had to have armour plating and weapons mounted, not below decks where the recoil would have been devastating, but in gun turrets. However, the old vessels, like HMS *Lion* and HMS *Implacable* were good places for training the young and instilling into them a sense of naval tradition.

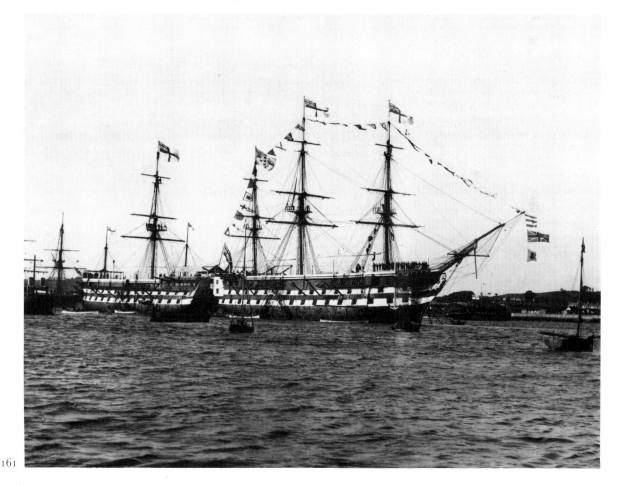

161

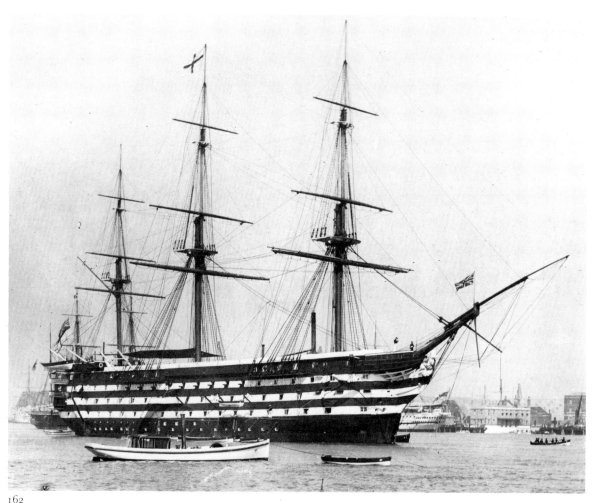

162

162

The harbour, Portsmouth. HMS *Duke of Wellington* was launched in 1852 and she was one of the navy's first screw-propelled steamships, but it is easy to see that little concession to the new technology had been made in terms of the ship's overall design. The reluctance to abandon old ideas of naval warfare can be seen in this Admiralty report of 1840:
'It is, however, in propelling vessels of war that the value of Mr Smith's invention will probably be experienced … A ship fitted with the Screw Propeller may be used either as a sailing or a steaming vessel, or as both, if required; for we ascertained by experiment that the engine can be connected or disconnected with ease, and in any weather, in two or three minutes. In

carrying a press of sail, the inclination of the ship does not diminish the propelling power of the Screw, nor lessen the ship's way, as with the ordinary paddle-wheel. The getting rid of paddle-boxes also leaves the broadside battery altogether clear of obstruction, and in boarding an enemy's vessel would allow of the ships lying close alongside of each other.'
[National Maritime Museum]

163

The harbour, Portsmouth. The little harbour transport, *Frances*, threads her way through the anchored vessels delivering sailors to their ships, some apparently accompanied by ladies, allowed aboard on special occasions when naval vessels are at anchor. Among the passengers we can discern

(in the bows) a peak-capped young midshipman and, just beyond the umbrellas, a naval officer. Behind the funnel sits an infantryman wearing the forage cap typical of foot regiments. Perhaps he is bound for a spell of overseas service.

164

Dartmouth, Devon. In 1863 the initial training of naval officers was located on HMS *Britannia*, moored in the Dart estuary. The two old hulks connected by a wooden corridor gave boys a taste of life aboard ship and the daily routine was modelled, as far as possible, on that of life at sea. The vessels were scrapped in 1906 when the onshore naval college was built at Dartmouth.

163

164

165

166

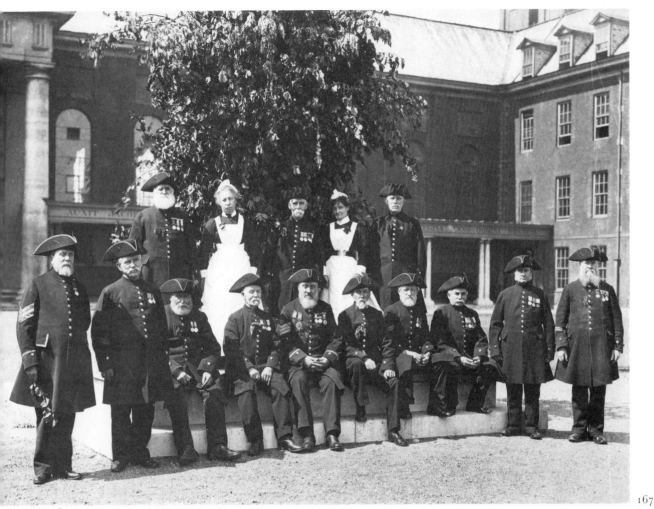

165

The Thames near Reading, Berks. Many Victorian boys were brought up on the exciting sea tales of Captain Marryat, such as *Mr Midshipman Easy* and *Masterman Ready*, and some undoubtedly conceived the romantic notion of 'running away to sea'. At the end of the nineteenth century it became possible to work out these fantasies by joining a company of cadets and receiving instruction in ships and sailing aboard a vessel such as the brig *King Alfred*. Many of these cadets went on to join the navy.

166

HMS *Hercules.* When the Admiralty finally accepted the need to build new ships they ushered in a bizarre period

of naval architecture from which would eventually evolve the *Dreadnought* of the Edwardian era. The period 1870–1900 was the age of the ironclads, massive ships with heavy armament and thick armour, but which had still not forsaken the use of sail. *Hercules* was one of the biggest of these new vessels. They may look rather ungainly to us but they filled many contemporaries with pride.

'All you who taxes pay towards the State,
Behold this craft, and own with wonder great,
That our Dockyard has credit justly won;
Its artizans skill'd men, second to none.'

Such were the sentiments expressed by one doggerel-writer at the launch of HMS *Inflexible* in 1876.

167

The Royal Hospital, Chelsea. These Chelsea Pensioners, sporting oak twigs on Oakapple Day in memory of Charles II, the hospital's founder, had lived to see great changes in the army. Some had fought in India and the Crimea. Some may even have seen service under Wellington. Doubtless they would have considered the 'modern soldier' as spoonfed and pampered – 'hospitals, hutted camps, reading rooms – whatever next!'

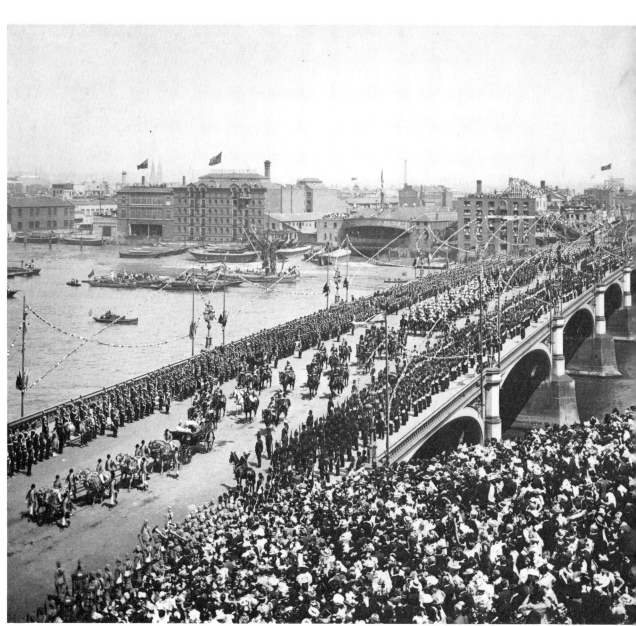

168

London Bridge. We end this section where we began it, in London on Diamond Jubilee Day. The old queen, after a short service outside St Paul's, was driven across to the south bank of the Thames, escorted by her loyal troops, and toured some of the poorer parts of the city. 'A never-to-be-forgotten day,' Victoria noted in her diary. 'No one ever, I believe, has met with such an ovation as was given to me … Every face seemed to be filled with real joy.' Apart from everything else, 22 June 1897 was a day of military pageantry. Four days later it was the navy's turn. The Spithead Review, at which the Queen was represented by Prince Edward, mustered the largest number of warships ever assembled in one anchorage, including over forty ironclads. The sight prompted the magazine *Vanity Fair* to eulogize: 'We are a great people and we realised it on Saturday as we never realised it before.'

7
TWO NATIONS?

When Disraeli, in his novel *Sybil*, made the comment that the 'Privileged and the People formed Two Nations' he was not laying down a programme for egalitarian social reform; the very idea would have repelled him. He was for improving the conditions of the underprivileged, not for abolishing social structures. Those structures were in reality, as he knew, much more complex. In 1868 Robert Baxter, a political writer, attempted to classify the bulk of the population in terms of income:

Class	Annual Income	Number
Upper	£5000 +	7,500
Upper Middle	£1000 – 5000	42,000
Middle	£ 300 – 1000	150,000
Lower Middle	£ 100 – 200	850,000
Lower Middle	Under £100	1,003,000
Skilled Labour	—	1,123,000
Less Skilled Labour	—	3,819,000
Agricultural Workers and Unskilled Labour	—	2,843,000

[R. Baxter, *The National Income*]

Although society was definitely pyramidal the gradation of wealth was much more gradual than a 'two nations' argument would suggest.

Throughout the next thirty years the living standards of most people improved. There were many reasons for this. Food prices fell while wages (especially among those workers organized into trade unions) rose. Public facilities improved enormously. The new local authorities provided free libraries, better sanitation, stricter housing standards and recreational facilities. In fact government, both central and local, was assuming greater responsibility for the provision of services. This change was made slowly and reluctantly because it involved increased government expenditure and more bureaucracy but also because it infringed the Victorian belief in free market forces and the encouragement of individual initiative. However, it became increasingly obvious that the health, education and general well-being of the nation could not be left to charitable individuals and organizations. Very little of this state aid was financed from increased taxation. Income tax, accepted by 1860 as the principal revenue earner, stood at 1s 4d (approx. 7p) in the pound in that year, was subsequently reduced, then rose to 1s 3d at the end of the century. What happened was that improved trade and prosperity automatically increased the amount of money paid in taxes.

The 1867 Reform Act gave the vote to a large number of urban working-class men and the cynical whisper ran round the corridors of Westminster, 'we must educate our masters'. Hitherto most schools had been controlled by two religious societies, the Church of England, National Society and the Free Church, British and Foreign Schools Society. Each received some state aid, but neither could cope with the recognized demand for a broadening and deepening of primary education. In 1870 a new Education Act set up local boards

empowered to build schools where necessary. Six years later primary education became compulsory to the age of twelve. Along with these moves went an expansion of secondary and adult education – universities and technical colleges. Francis Frith observed these moves with approval and saw them as leading to a progressively more intelligent nation:

'. . . the thing to be done now is, if possible, to work up the average intelligence of the race to a better standard, so that the next generation may *start* from a higher level. If improved education does not improve the radical, transmissible mind stuff of the nation, but merely aims at making the most of each individual lump of dullness, it will be comparatively useless and weary work.'

But there still remained abject poverty in both town and country. Prolonged unemployment meant penury. Thus thousands of men and women who had little or no paid employment sought other ways of supplementing their income – fishing for shrimps, selling water to thirsty wayfarers, odd-jobbing, knife-grinding, anything that ingenuity and desperation could set their hands to. For the only alternatives were the workhouse

169

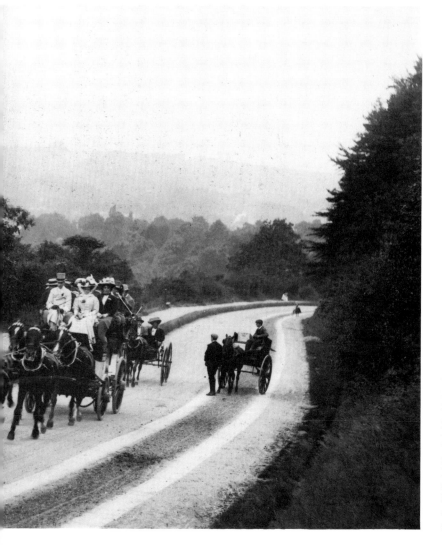

Reigate, Surrey. Social divisions, as we have already noticed, were extremely marked in the country. The 'quality' travelled in style. This fine carriage with its liveried outrider and six gleaming horses is something to which the man with his horse and trap can never aspire. This elegant equipage must have been well-known to the Friths who lived – altogether more modestly – nearby. In his *True Story of My Life* Francis affected a distaste for such display: '. . . ostentatious vanity defeats its own purpose, and is besides disagreeable to good taste, and painful to the *amour propre* of others'.

[167]

and poor relief. The administration of the Poor Law had improved vastly since Dickens's day. Then, conditions had been made deliberately unpleasant to dissuade people from applying to the parish for aid, in the belief that they would then stand on their own two feet. By 1871 it was generally realized that, for most of the destitute, the mere act of seeking relief was humiliating enough. In that year the administration of the Poor Law came under the local government boards. Conditions steadily improved in the work-houses and people were helped to live on out-relief where possible. But old attitudes die hard and poverty was still regarded as a disease whose sufferers were to be treated in isolation.

Francis Frith and his colleagues travelled the length and breadth of Britain, photographing their fellow-citizens and their surroundings. They were not consciously making any social comments but the pictures they took inevitably formed a commentary in themselves of the complex, colourful tapestry that made up British society.

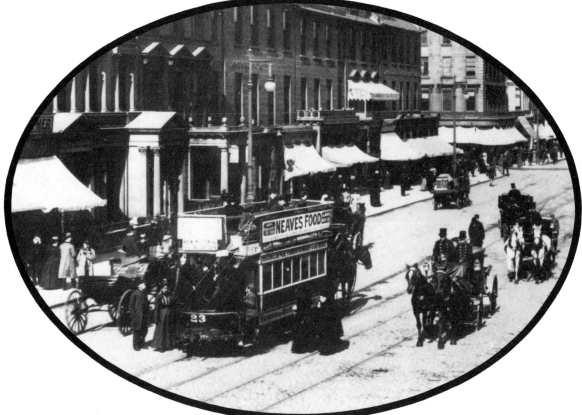

170

Edinburgh. In town, too, rank asserted itself in the modes of transport people used. In Princes Street, Edinburgh, society ladies went shopping or made calls in their carriages. Others caught the horse tram. An increasing number of young men went about by bicycle. Most ladies as yet regarded it as im-practicable or unseemly to gather up their voluminous skirts and teeter about the city streets on two wheels.

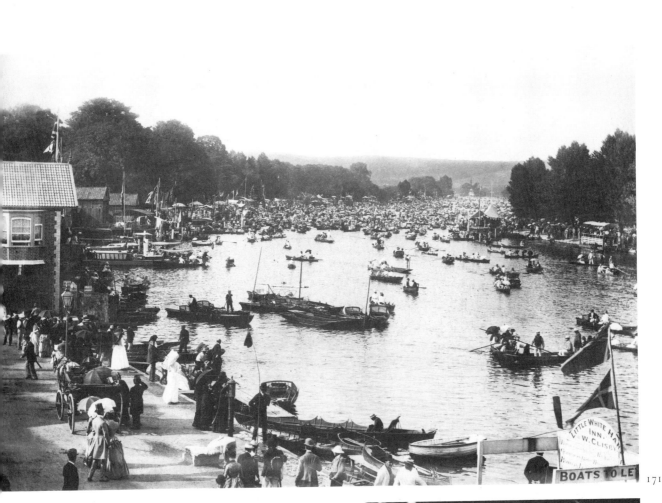

171

Henley-on-Thames, Oxon. From such photographs as this one gathers the impression that, though class divisions were very clear, people were less self-conscious about them. All sorts and conditions of men and women gathered for Henley Regatta, from the elegant, top-hatted gentleman in the left foreground to the capped and shirtsleeved spectators whose background is clearly very different. Everyone seems to be here for a good time, to take a genuine interest in the racing and to take a turn on the river. The regatta had not become the esoteric social event that it was later to turn into. Can this have been because the well-to-do did not feel that the social order was under threat and, therefore, had no need to be defensive and exclusive?

171A

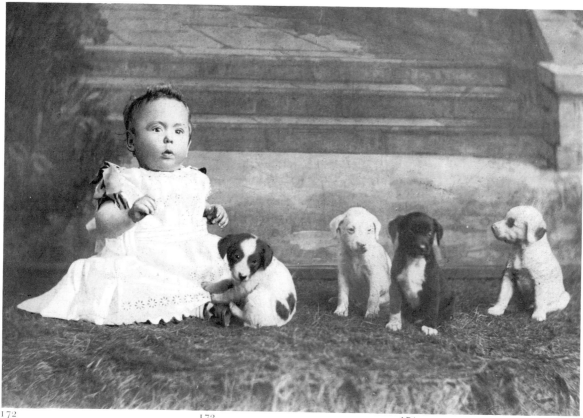

172

'*Where's our dinner?*' This is probably
the kind of portrait Mr Maralski (see
no. 174) went in for. It is certainly
very uncharacteristic of Frith, who
did little studio work or, at least, little
of this sentimental work for public
consumption. The attitude of parents
towards children is one of the most
telling indications of social status.
Middle- and upper-class boys and girls
were pampered, and dressed in special
clothes and looked after by servants.
They enjoyed security and, though
they might be spoiled by over-indul-
gence, yet they were able to enjoy
being children. Mary Ann Frith
adored her family: 'My sweet little
Helen came to us on Thursday evening
the 22 Feb 1872 – the dear children
came into my room the next morning
all wonder and excitement to see the
new little sister. It is so nice to have
three little girls and three little boys.'

173

Whitby, N. Yorks. Some boys and girls
had little childhood at all. Families
were large, the means to care for them
scanty. For these fishermen's children
the only places to play were the streets
and the harbour, both of which had
their danger. Presents and treats were
few and far between and parents had
little time or energy to gush over them.
More often than not it was the older
children who had to look after the
younger because mother was working
or having another baby.

174

York. This view of Peter Gate in York
provides a sombre example of the
realities of life for many people. At
first glance (and this is doubtless what
caught the photographer's eye) it is
an attractive prospect of a medieval
street leading to the minster. Only
when you look more closely do you see
the shop signs of the pawn-broker and
the dealer in second-hand clothes –
men who played a prominent part in
the household economy of the poorer
citizens. Notice how the gas lamps are
used to carry advertising and also the
delightful sign of the brushmaker.
'Maralski's Portrait Studio' on the left
of the street at the end indicates that
commercial photography has come to
stay.

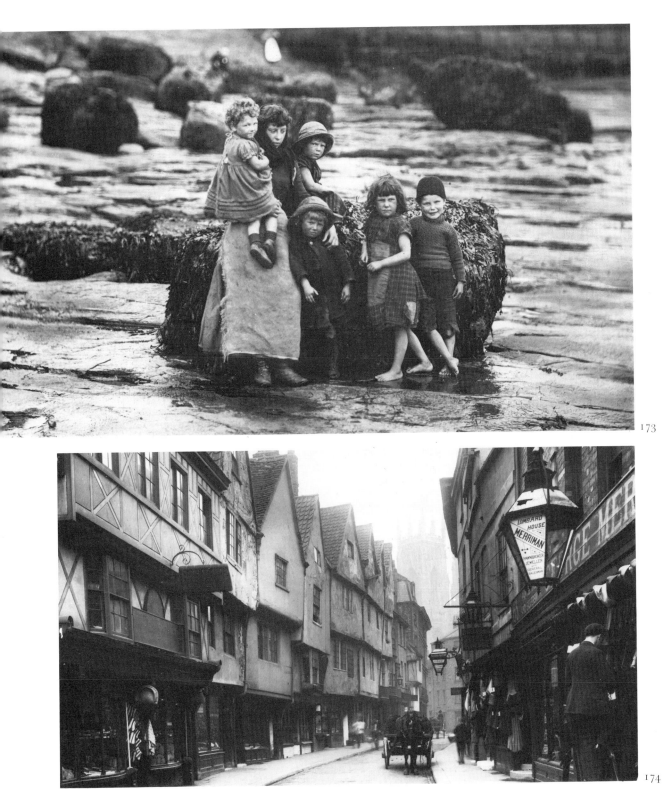

173

174

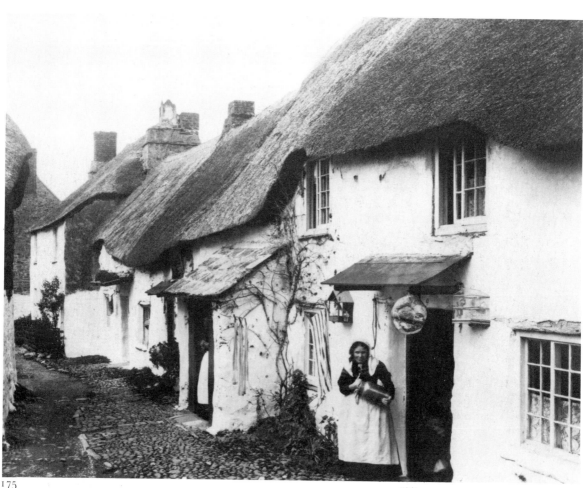

175

175

Hope, Devon. We do not know the name
of this lady but it is likely that her
ancestors had also lived in this terraced
cottage for generations, as much a
part of the nation's story as the Lucys
of Charlecote, although she would not
have been aware of the fact. She did
not have the responsibility of a mansion
and an estate to keep up. The daily
washing and the constant polishing of
her few possessions filled much of her
time. When the menfolk were away
fishing hers may have been a lonely
life; but she had her little cage birds
for company.

176

Levens Hall, Cumb. The topiary gardens
at Levens Hall were laid out in the
1690s. Two hundred years later they
were still being cared for by a large
staff for the exclusive pleasure of the

household. It was a delectable atmos-
phere in which the spirit could soar
and the mind enjoy tranquillity. For
those who were privileged to spend
much of their time in such pleasant
surroundings this place must have been
a very heaven on earth. Men and
women who lived in such surroundings
and had their needs catered for by
servants had time and energy (or
should have had) to devote to higher
things. Francis Frith certainly resented
that portion of his life that he was
obliged to devote to building up a
business: '. . . the mechanical, money-
making portion of those ten or twelve
years of my life. . . . I regard as an utter
blank. . . . The necessity for close atten-
tion to business . . . left me little time
for study or reading. Thus, no doubt,
it directly impoverished my mind.'

177

Charlecote Park, Warwicks. The Lucy
family had lived at Charlecote since it
was built in the mid-sixteenth century.
In the nineteenth century they could
afford to carry out considerable im-
provements and changes to the house.
The family, like the house, was a per-
manent part of England's history. To
the Victorian head of the family it
must have seemed inconceivable that
it could ever be otherwise. Unham-
pered by excessive taxes or death
duties, he looked forward to pass-
ing the estate on to his son, secure in
the belief that as long as the line sur-
vived there would always be Lucys at
Charlecote.

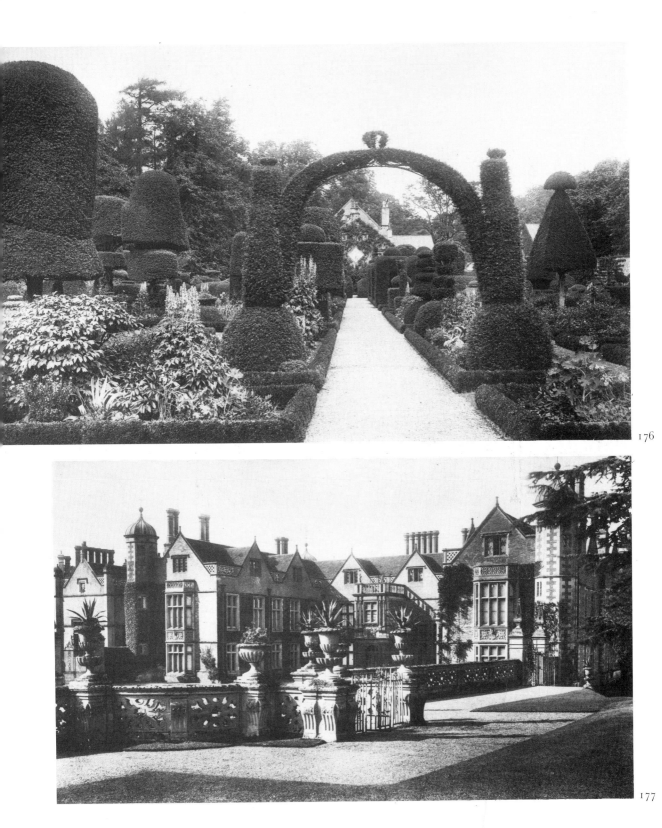

176

177

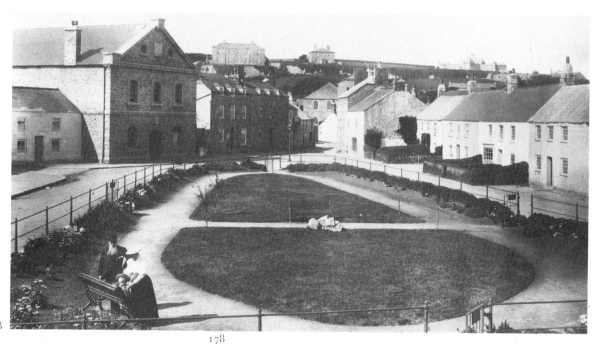

178

178

St Mary's Gardens, Scilly Isles. The need for pleasant open spaces in towns and cities was recognized by municipal authorities, as we have seen. It was not only in the new industrial centres that parks and gardens were laid out.

Wherever houses had sprawled and crowded out grass and trees the need for lawns and flowers exerted itself – and little railed-off enclosures of peace were created.

179

Downham. Some children were lucky enough to grow up in the country where their souls could breathe. These youngsters seem none too happy at being asked to stop their play and look at the camera. The girls wear smocks to protect their dresses (laundering thick clothing was an arduous and laborious business) and, of course, bonnets to keep the sun off their faces. The odd one out on the right looks like a bit of a rebel.

180

Whitby, N. Yorks. Others did not have their conception of the world formed in such pleasant surroundings. These bare-foot lads grew up in dingy back yards. It is unlikely that in later years they ever knew anything other than the sordid struggle of making a living. Not for them the leisure to wander in pleasant gardens or to spend hours in study and contemplation of the higher realities.

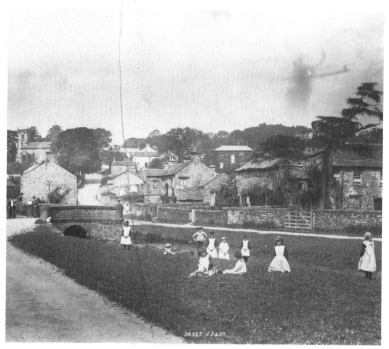

179

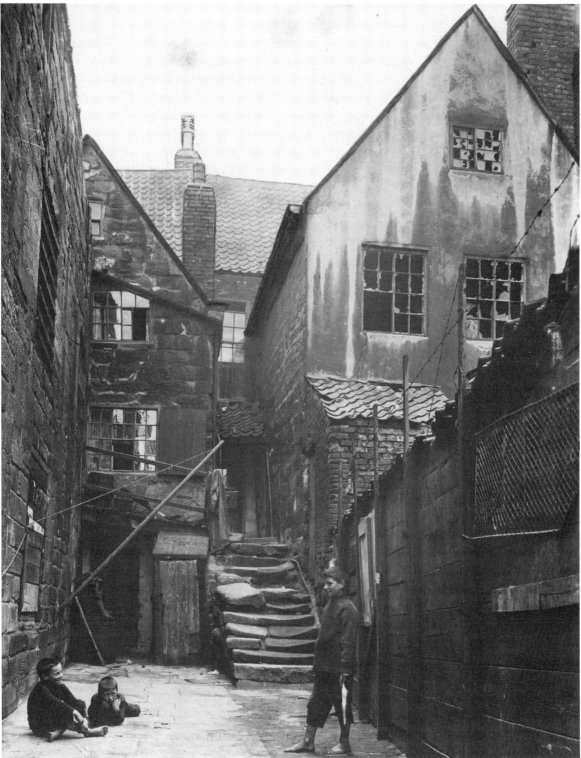

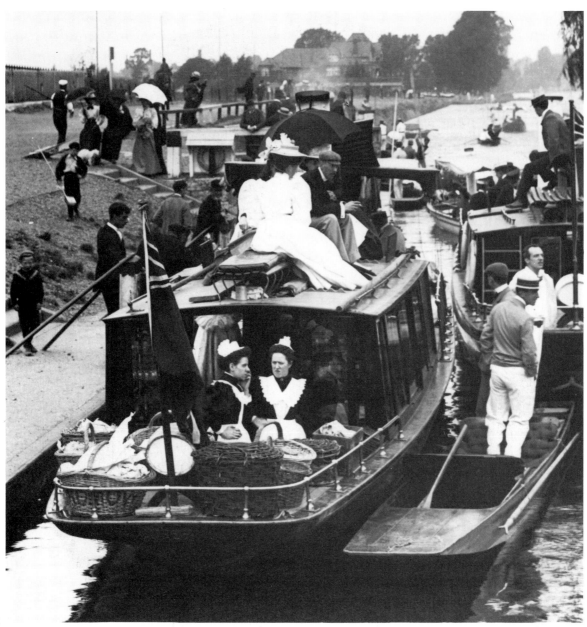

181

Moulsford, Berks. The River Thames, as we have noticed before, teemed with life. Day trippers, fashionable week-enders and holidaymakers were drawn to it in large numbers. What is particularly interesting here is the smart launch party who have taken their maids along to serve the picnic lunch. And what a lunch! Hampers full of food and china, a crate of lemonade and a barrel dispensing – what? Life for the servant class was not, apparently, one of continuous drudgery. Lovers of *Three Men in a Boat* will recall what happened when a photographer appeared at Wallingford lock: 'Everybody . . . seemed to have been suddenly struck wooden. They were all standing or sitting about in the most quaint and curious attitudes. . . . All the girls were smiling. Oh, they did look sweet! And all the fellows were frowning, and looking stern and noble. . . . So I faced round quickly, and took up a position in the prow, where I leant with careless grace upon the hitcher, in an attitude suggestive of agility and strength . . .' with disastrous results!

[176]

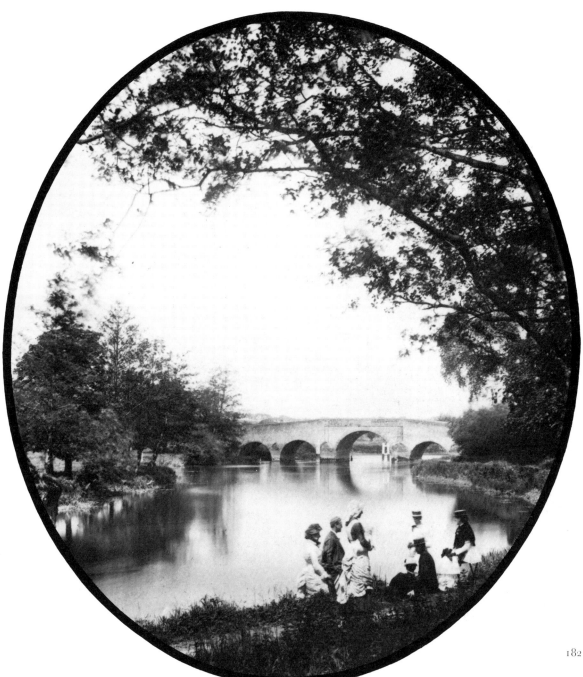

182

Sonning, Berks. Another picnic scene and, again, the maid is there to look after her employers. This is, very probably, a Frith family group. In a caring household the servants were almost part of the family and shared much of the life of their 'betters'. When Francis and Mary Ann passed a pleasant day at Furness Abbey in the summer of 1878 they did not take any staff but 'the next day our two servants, Sarah and Annie, spent the day at Furness Abbey and Barrow'.

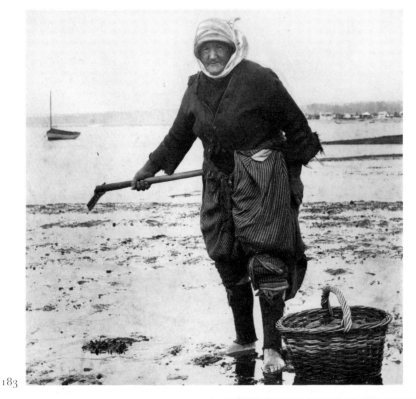

183

Haslemere, Surrey. The variety of street traders in both town and country was considerable. Men and women plied sundry crafts – knife-grinding, peddling, collecting old clothes, rat-catching and water-carrying. Piped water was still a luxury and there were no vans dispensing ice creams and ice lollies. Thirsty travellers were grateful to find a water-carrier with his sturdy little wagon and barrel of well or spring water.

183
Exmouth, Devon. On the flats at low tide this woman, prematurely aged by a hard life, rakes the mud, gathering cockles which she will either sell herself to visitors or supply wholesale to a local fishmonger. Perhaps her husband is a fisherman. Perhaps she is widowed. Either way, the cockles help her to eke out a living.

184

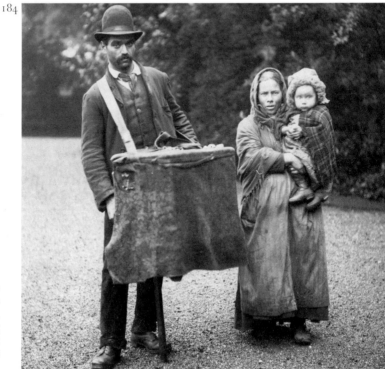

184
Whickham, Tyne and Weare. The barrel-organ player walked the streets entertaining people for pennies, his ragged wife and child doubtless encouraging some passers by to dispense a quick and easy charity. This family was photographed near Newcastle.

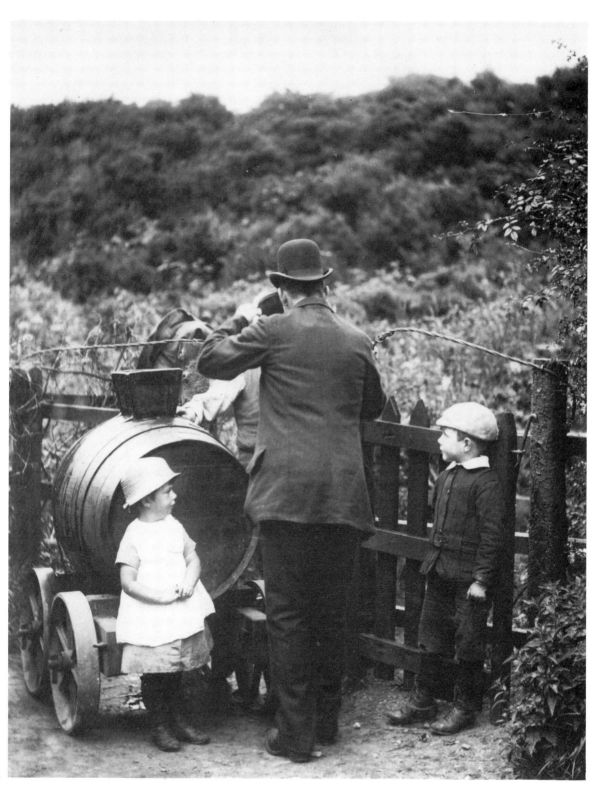

185

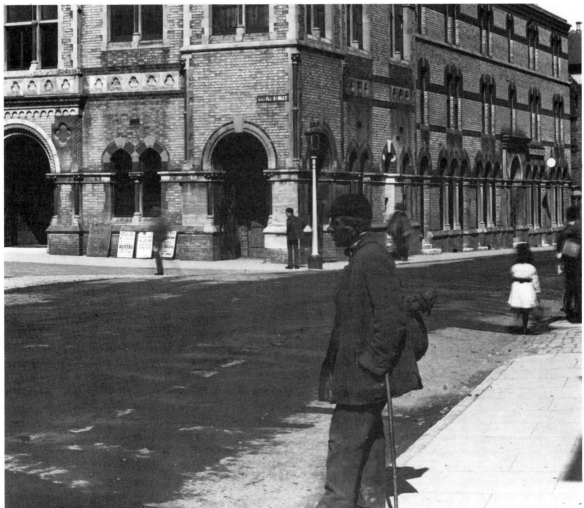

186

Farnham, Surrey. There were those who reached the bottom rung of Victorian society and took to the tramp's life, keeping body and soul together by begging or finding odd-jobs in farms or doing a little gardening. The only alternative was to return to your own hometown and apply for admission to the workhouse. Although conditions in most of these institutions had much improved, the stigma of living 'on the parish' remained and many vagrants kept on the move to avoid this ultimate humiliation.

187

Rhyl, Clwyd. Child mortality fell drastically during the nineteenth century but by 1900 it was still claiming about a quarter of the juvenile population. There were still no cures for many childhood diseases and scarcely a family in the country – high or low – was spared sporadic visitations. The Friths were no exception: 'Since I last wrote in this book it has pleased God to take our youngest darling, dearest Clement to Himself; he left us on the 3rd April 1877. . . . Our four younger children commenced with whooping cough in May – dear Mabel was very ill with pleurisy and inflammation. She was in bed twelve days and kept upstairs three weeks.' [Frith Papers.] Growing concern manifested itself in the building of children's hospitals like this one at Rhyl. Much of the 'cure' involved fresh sea air, hence the balconies. But excessive sunlight was still considered harmful, so awnings were erected to keep out the glare.

188

Beddington, Greater London. The bringing of all aspects of the poor law and public health under local authorities enabled each area to make provision for the needs of its own people. Some councils were more diligent than others, so that care of the needy was not uniform over the nation. At Beddington an old house was turned into a female orphanage. Here the girls were taught, cared for and prepared for a life in service.

187

188

189

Beckenham, Kent. Only those able to pay fees could ensure secondary education for their children. There was a move throughout the period to open more boarding and day private schools. The Abbey School at Beckenham was one example. Caps and striped blazers marked the social difference between these boys and the sons of less wealthy parents. Yet it would be wrong to accuse all the founders of secondary schools of aiming to preserve a social élite. Rather they were trying to fill an educational need that neither the state nor the older public schools met. For example, in 1876 the governors of Harrow School established a day school and gave it the name of Harrow's sixteenth-century founder, John Lyon. Its objective was to fulfil Lyon's original wish of providing education 'for the poor boys of Harrow and district'.

189

190

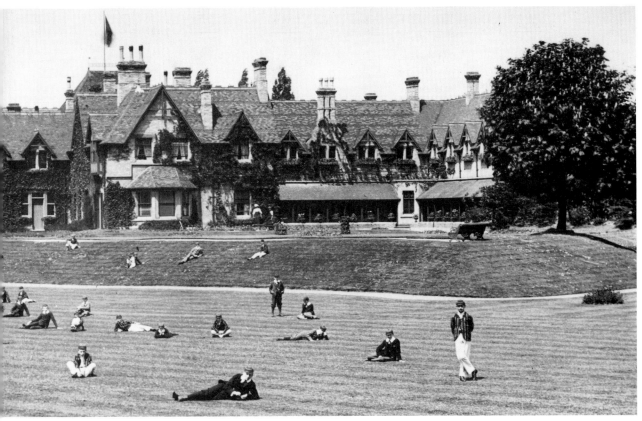

190

Bolton, Lancs. The board of governors proudly pose outside their 'higher grade' school. In 1870 the Forster Education Act allowed elected school boards to be set up in all areas to provide schools where there was inadequate voluntary school education. In 1876 a further Act made schooling compulsory to the age of twelve and empowered inspectors to ensure that children were sent. For some families this was quite a hardship as all education was fee-paying. Not until 1891 was elementary education made free. Even then, the better local authority schools were empowered to continue making a charge. These were the 'higher grade' schools. In these there was a higher teacher-pupil ratio, the curriculum was wider, and better standards were aimed at. The schools catered for brighter pupils and it was hoped that many of them would go on to secondary education.

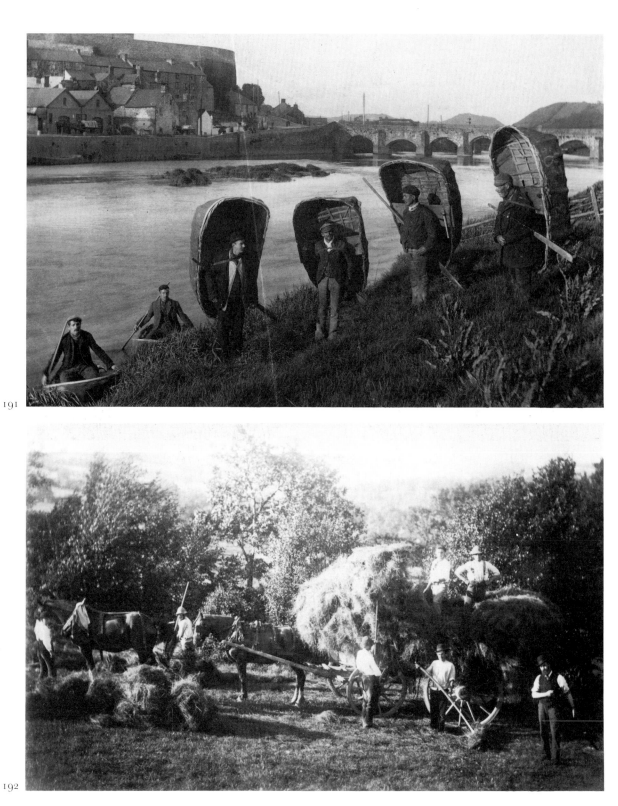

191

192

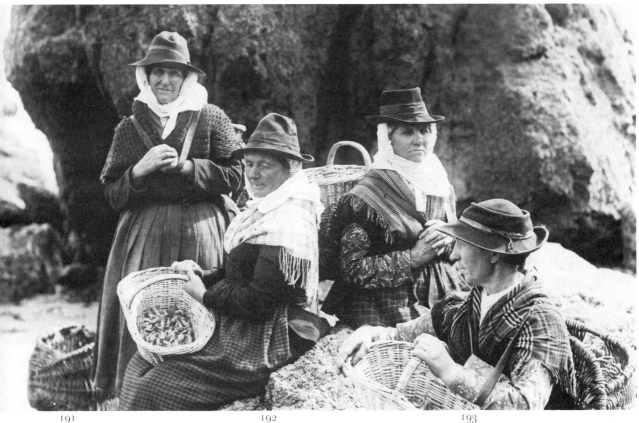

191
Carmarthen, Dyfed. Returning to a consideration of how people earned a living or supplemented their income, we encounter these splendid Welsh coracle fishermen. These lightweight, ancient craft made from strips of wood covered with skin had a very ancient origin and were traditional in Wales. Handling them was very difficult.

192
Longdene, Salop. This 'idyllic' harvesting scene points the paradox which makes nonsense of slick socio-economic classification. The men in this picture were among the lowest paid workers in Britain yet their lot was preferable to that of many better-off industrial employees who envied them their open-air life.

193
Tenby, Dyfyd. This splendid group portrait, once more finely composed, shows yet another way of adding to the family budget. These South Wales fishwives went shrimping with small nets, filling the baskets on their backs, and returning to sell the catch on the beach and the quayside.

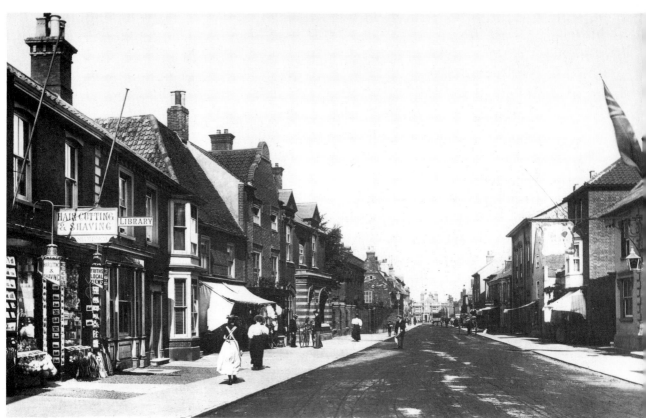

194

194

Southwold, Suffolk. Southwold grew from a fishing village into a genteel resort during the second half of the nineteenth century. It became a town of shopkeepers, hoteliers, boarding-house keepers, retired businessmen, maiden aunts and people of modest independent means – in other words, that wide spectrum of English life that sociologists call 'middle class'. In this picture we can see smart but sensibly dressed young ladies, a maid out on some errand, wearing a bonnet with her uniform, a young man showing off a drop-handlebar bicycle to some friends, an aproned shop assistant and discreet shops, one offering 'Frith's Local Views' for sale and another, intriguingly, providing 'Baths For The Hire'.

195

Clovelly, Devon. The best way to cope with the steep, narrow, cobbled streets of Clovelly was to use pack-donkeys. This wily local seems to be either an odd-job man or a carrier (perhaps a bit of both). Most of the cottagers seem to have cottoned on to the possibilities of the tourist trade, offering 'Good Beds', 'Views of the Neighbour-hood', 'Tea and Coffee' and 'Refreshment Rooms'.

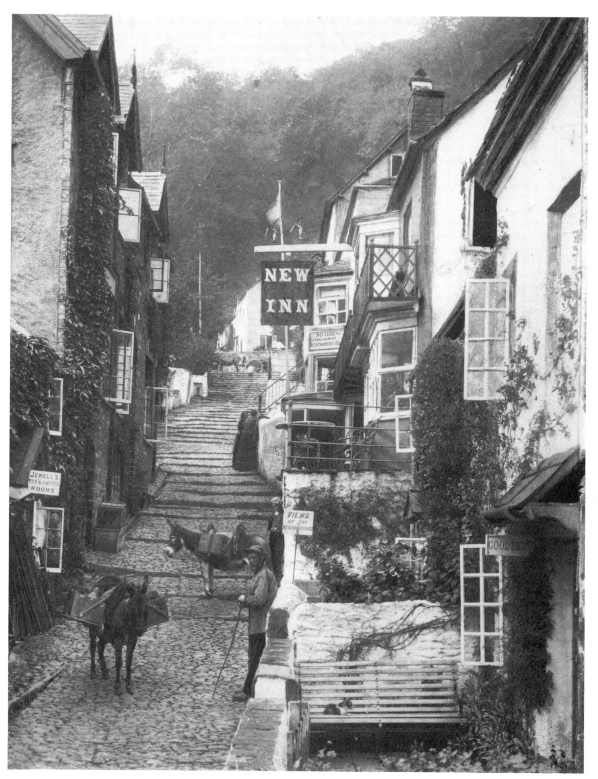

195

196

197

196

Burwash, E. Sussex. What a motley bunch of children. Note the stout boots and ill-fitting clothes which suggest hand-ons from older brothers and sisters. Some older boys and girls are looking after the toddlers (bundled into hand carts). They are not a very smart crowd but neither do they seem to be impoverished.

197

Princetown, Devon. The inmates of Dartmoor prison cannot have been very used to having their photographs taken. These were the nation's worst criminals, for in 1850 Dartmoor became Britain's major centre for long-term prisoners. Since transportation came to an end around the same time Dartmoor was well used. Treatment was harsh by modern standards. Wardens were armed and prisoners were often chained. These men were social outcasts and little thought was given to their possible rehabilitation. Yet crime – particularly violent crime – was on the increase. Since criminal detection was in its infancy many offenders went scot free (e.g. Jack the Ripper). Thus there was a tendency to 'fling the book' at men who were convicted.

198

Dublin, Eire. If there were glaring class divisions in British society it may have been a comfort to some to know that, in the end, all men are equal. This remarkable photograph may seem a gruesome one with which to end. If so it is because we are very different in our thinking from our Victorian ancestors. They lived much closer to death. Life expectancy was shorter. Epidemics occasionally carried off large numbers of people. Funerals were elaborate. Pious Victorians looked beyond the grave to the joys of heaven. So when Frith's man was in Dublin, when some remarkably-preserved bodies were found and subsequently interred in the crypt of St Michan's church, he did not recoil from setting up his camera.

198

Index

(The numbers after each entry refer to *pages*)

FRANCIS FRITH 1822-1898

he illustrations in this book come from
The Francis Frith Collection which today constitutes a
unique archive of over 300,000 photographs, many of which
date back to the starting point of 1860.
The Collection enables many people to experience
the atmosphere of Britain in Victorian times in the very towns
and villages where they or their ancestors originated.

If the thought of going back into your own history and heritage
intrigues you, please contact our archivist, stating which towns or villages
(maximum three please) are of interest. We will then search our archives
and send you references of the views available
together with full details of our product range.

THE FRANCIS FRITH COLLECTION, CHARLTON ROAD, ANDOVER,
HAMPSHIRE SP10 3LE TELEPHONE: 0264 53113/4